THE SECRETS OF
DELLSCHAU

THE SECRETS OF DELLSCHAU:
The Sonora Aero Club and the Airships of the 1800s

By Dennis G. Crenshaw

In collaboration with P. G. "Pete" Navarro

Illustrations by Pete Navarro

A True Story

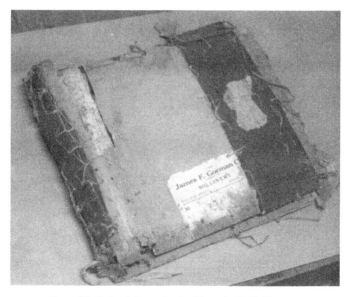

One of Dellschau's Scrap Books. Photo by P. G. Navarro.

ANOMALIST BOOKS
San Antonio * New York

An Original Publication of ANOMALIST BOOKS

THE SECRETS OF DELLSCHAU:
The Sonora Aero Club and the Airships of the 1800s
Copyright © 2009 by Dennis G. Crenshaw
ISBN: 1933665351

Book design by Seale Studios

For information, go to anomalistbooks.com or write to:
Anomalist Books, 5150 Broadway #108, San Antonio, TX 78209

In Loving Memory of
Betty Jean
1948 - 1998
My wife for 35 years

And for
Jeff Braun,
Thanks for everything

Visit
www.SecretsofDellschau.com

Table of Contents

Part 4
The Wonder Weavers Findings:
"A Stock of Open Knowledge"

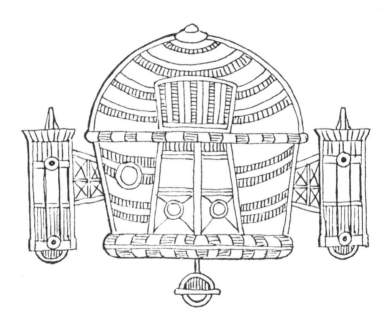

Fig. P.1. The Aero Gander; aka ,the Aero Goosey. The world's first aircraft?
Drawing by P.G. Navarro.

A Bit of History According to Dellschau

After today they'll laugh no more. Today my machine is going to fly.

— Adolf Goetz

MARIPOSA GROVE, CALIFORNIA, 1858

Adolf Goetz stepped out of the dim, shady coolness of the forest into the bright warm sunshine of the open field. The large clearing he had entered was completely surrounded by thick virgin timber.

The Yosemite Valley must be the most beautiful place in California if not in the whole of America, he thought, *what a fitting place to create history.*

The remoteness of the area meant that few people had ever seen the majestic vistas that were prevalent there. Of course, the isolation was the very reason this spot had been chosen to test fly the Sonora Aero Club's latest experimental craft.

Adolf stopped at the side of a small, clear, bubbly spring; bent over with cupped hands and took a drink. The water was freezing cold, and delicious. As he stood up he sucked in a deep breath and filled his lungs with crisp, clean air. He let his eyes wander to the far end of the grassy meadow. The Mariposa Grove, a forest of giant redwoods, made up the tree line in the distance. The dark greens and deep reds of the stand of ancient trees made a sharp contrast against the aqua-blue backdrop of a cloudless sky. He paused and took in the beauty of the scene for just a moment.

Finally he let his eyes settle on the object sitting in the middle of the clearing. He looked lovingly at the awkward contraption anchored to the ground. He noticed that his ground crew had positioned the ungainly looking flying machine in the dead center of the natural landing field. He was happy with the starting point they had selected. And best of all, everything felt right this morning.

The others laugh and say the Aero Goeit looks like a cross between a hot air balloon and a gypsy wagon, he thought, *but after today they'll laugh no more. Today my machine is finally going to fly.*

As he rushed through the rich green grass toward his aircraft he observed

the movements of his three partners puttering around the *Aero Goeit*. They had arrived a day earlier, selected the landing field, and prepared for today's flight. He knew they had started at daylight making necessary last-minute minor adjustments to the pulleys, ropes and unusual-looking pieces of machinery that all combined made the aircraft work.

As he came within shouting distance of the first member of his ground crew he cheerfully called out, "Great day for flying, Charlie." Charlie, a slim young man with a drooping mustache, hardly looked up as he mumbled something back.

Adolf instantly tuned out the sour man's answering murmur. He hardly paid any attention to Charlie Dellschau's negativity anymore. No one in the club did. *Dellschau is a genius when it comes to drafting others ideas*, he thought, *but a conversationalist he isn't.*

"How about you, Peter, wish you were going up today?" Adolf asked the other member of his ground crew.

Peter Mennis gave a final tug to one of the anchor ropes, took the ever-present pipe out of his mouth, and smiled back at Adolf.

"I'm always ready to go up," Peter Mennis answered before jamming the pipe back in his mouth and puffing out a cloud of white smoke.

The small black dog at his feet turned around at the sound of Adolf's voice and came running up to him, barking and wagging his tail.

"Bet you want to go up again too," he addressed the terrier as he stooped over and started petting the friendly dog vigorously.

"Looks like she's ready to go," Peter called out. Adolf looked over at Charlie who was just walking up. Charlie nodded his head. Adolf nodded back and turned his attention away from the small dog.

Adolf looked up into the airship, letting his eyes settle on Rex Weber, the young man setting quietly and comfortably in the pilot's seat. Adolf raised his right hand in greeting, then gave Rex Thumbs up.

The confident pilot reached over and activated the mechanism that injected the liquid fuel into the *gasar chamber* where it would be converted into *NB gas*. As the gas filtered through the machinery and air bags, the ungainly looking machine began to rise from the ground, straining at the anchor ropes. Rex quickly activated the *air pressure motors*, then grabbed the rudder-like device and shouted to his ground crew, "Okay, let go the anchors."

Peter and Charlie quickly released the pinions that held the Aero Goeit to Earth. As soon as the taut hemp ropes attached to the airship's anchors became slack, the huge flying craft began to rise quickly.

Gaining altitude, it began to drift towards the line of tall redwood trees

100 feet away. The pilot made the proper manual connections in order to inject additional fuel into the gasar chamber and prepared to maneuver the ponderous aircraft over the fast-approaching tree line. With the air pressure motors on full power and the NB gas expanding the copula of the colorful airship to its fullest capacity, the machine should be able to rise easily and fly over the 150-foot-tall giants. The craft navigated perfectly, responding to the slightest movement of the rudder. The aeronaut headed confidently toward the tree line and felt the aircraft rise gently as it approached the beautiful trees, which were sloping gradually up a slight incline. As he came within yards of the nearest trees he increased the air pressure in order to clear the tallest of them. He wasn't worried at all. The Aero began to glide smoothly over the tops of the first trees. The *Aero Goeit* will clear them easily, he was thinking, when suddenly he felt a strong, heart-wrenching jerk. He had made one slight miscalculation. He had forgotten to take into account the *ballancier*, the barrel-shaped device that hung below the aircraft. This device, which was secured both fore and aft to the undercarriage, was suspended from a rope about 12 feet lower than the body of the airship and was used to stabilize and balance the huge craft.

The ballancier had become entangled in the upper branches of one of

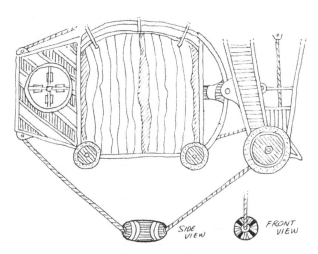

BALLANCIER - An example from one of Dellschau's Aeros. The GOEIT.

Fig.P.2. Pete Navarro's hasty rendering of a cutaway of a portion of The Aero Goeit. Note Rex Weber's ballancier hanging below the main body of the Aero.

the California giants. The aircraft had suddenly been arrested in its forward motion. Ironically, the *ballancier* was the very reason Rex was piloting the Aero that day. It was his invention and today's flight was the test run, not only for Goetz's new Aero, but for the new balancing device as well.

From the center of the open field 100 feet away, his three companions stood and watched helplessly and in horror as Rex Weber fell headlong over the edge of the airship's small control platform. As he felt himself fall, the young man grabbed for one of the support railings, missed, and plummeted to the ground. When his friends reached the site they found he had broken his neck and was quite dead. On that beautiful spring morning in 1858, Rex Weber became the first fatality of an aircraft disaster ... At least that's what Texas artist Charles A. A. Dellschau claimed in the story he had painstakingly hidden in coded messages scattered throughout the thousands of drawings of flying machines he produced at the turn of the 20th century. These aircraft, he stated, were secretly invented and flown by his friends and himself in the mid-1800s; all were members of a secret organization he called the Sonora Aero Club.

The Researcher and His Art

Wonder Weaver you will unriddle my writing ...

— C. A. A. Dellschau

For almost 30 years Pete Navarro owned, or had full access to, all of Dellschau's known works. Pete spent every spare moment he could with the drawings. He used his talent as a professional commercial artist to isolate and draw mirror images of individual detailed pieces of the machinery and the components that made up Dellschau's flying machines. During his many hours of studying the 12 books that Dellschau had bound his mysterious drawings into Pete found the key to a secret code. A code cleverly devised by Charles Dellschau to tell a story. A story of secret socialites and futuristic flying machines like something out of Jules Verne.

The story of Adolf Goetz and his *Aero Goeit* as reported above is just a small part of that story. But, is the story of Rex Weber's death due to a fall from an airship an unknown historical fact — or is it just one man's illusion? As unbelievable as it sounds, is it possible that a group of men were designing and flying airships in total secrecy as early as the mid-1850s?

C. A. A. Dellschau's drawings have become highly collectable and rather pricey. The 12 books have now been broken up into individual pages and framed, and are selling in top galleries across the country for as much as $25,000 for a single page. As time continues to pass the pages will spread further and further apart. Never again will anyone have access to all of them together for a close study. Pete Navarro had that access and took the time to study Dellschau's work. Was it fate? Call it fate or something else. But, whatever it was that brought Pete and Charlie together one thing is for certain ... In his work Dellschau addressed a future "Wonder Weaver" who would decipher his story. Pete Navarro was that Wonder Weaver.

All the known facts about Dellschau, the Sonora Aero Club and their fantastic flying machines will be found in this book including many of Pete's exact duplicate sketches of interesting parts of Dellschau's wonderful flying machines re-printed directly from Pete's 15 Field Journals in which he not only made on-site sketches of as much of the detail of Dellschau's machines and writings as he could, but he also kept meticulous notes of meetings with the particulars.

The portions of *The Secrets of Dellschau* having to do with Pete Navarro and

his quest for the truth are true. Pete's story is presented just as it happened. During Pete's research he kept meticulous notes on everything he did during this time, including word for word quotes from anyone he interviewed. All the drawings, rough sketches and photographs were made by him at the time of investigation. Pete gave me access to over 5,000 pages of information. I have included as much original material as book length would allow. However, to make a more readable book I did fiddle with the timeline a bit. It took Pete 27 years to complete his study of Dellschau. During that time he accumulated thousands of pages of notes and hundreds of drawings. We only have this slim book in which to present his findings. Streamlining time seemed to be the answer. However, I must admit that in the Dellschau portion of the book I used my writer's prerogative. The general outline of Dellschau's adventures in Sonora are based upon Pete's research and Dellschau's own writings. The background and dramatization have been added.

Dennis G. Crenshaw
April 21, 2009
Jacksonville, Florida

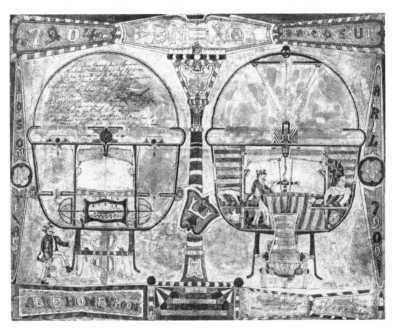

Figure P.3. A black and white photo of C. A. A. Dellschau's plate 1904, the Aero Honeymoon. From the P. G. Navarro Collection.

Part 1

Dellschau Discovered

One man's junk is another man's treasure.

— Unknown

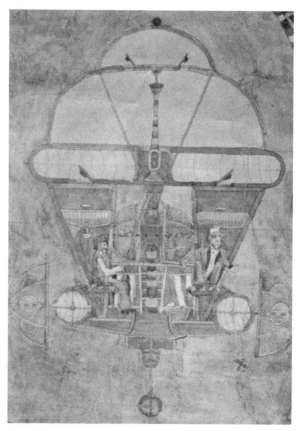

Fig 1.1. A black and white close-up of Dellschau's Aero Hunter.
Photo by P.G. Navarro.

CHAPTER 1

Rescued from the Dump

Who knows, today I might even find a genuine antique piece to sell in the shop.

— Fred Washington

HOUSTON, TEXAS, 1968

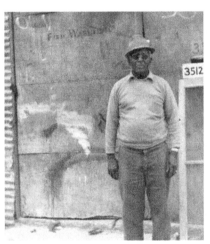

Fig. 1.2. Fred Washington standing in front of his workshop where the Dellschau books were stored. Photo by P. G. Navarro.

Fred Washington liked to tell people he was in the antique business. He operated out of two small shops near downtown Houston, Texas. One was The OK Trading Post, located on Washington Avenue, where he sold his antiques. The other was a warehouse and workshop around the corner on Barnes Street. The two buildings were just a block apart in the area of Houston referred to locally as the underbelly of the Heights. Fred spent most of his time in the workshop on Barnes restoring old furniture. However, on a bright sunny spring day in 1968 he left the shop early in the morning. His destination was a small private dump just north of White Oak Bayou. He often rooted around in the local dumps. Much of the furniture he repaired and resold he found discarded at one or another of the city's dumps. And today he felt lucky. As he started towards his pickup, his pace quickened. *Who knows, today I might even find a genuine antique piece to sell in the shop*, he thought as he turned on the ignition of his truck.

He hardly noticed the sights and sounds along the familiar route as he drove past the cheap restaurants, resale shops, used car lots, junkyards and old boarding houses that made up the neighborhood. Fred Washington was a rather serious person, highly intelligent, articulate and attentive to detail. That,

combined with a large dose of good old common horse-sense, made him a sharp businessman. He had only one real passion in life … finding treasures in the discards of a wasteful society.

Fred had been poking around the dump for over an hour. Just enough time for him to get used to the pungent sweet smell that all dumps seem to have in common. Someone had once told him it was the smell of decay.

So far he hadn't found anything worth carrying to his pickup. But he wasn't discouraged. The day was young and he was outside. What more could a man want? He let his attention be drawn to two blackbirds that were screeching at each other as they fought over a scrap of red cloth. *Just like humans*, he thought, shaking his head in amusement … *fighting over nothing.*

He reached up, took his hat off and used it to shade his eyes. With his other hand he took an oversized handkerchief out of his pocket, shook it once, then reached up and wiped the beads of sweat off his forehead. He noticed a large trash truck backing up 50 yards away. He could hear the big hydraulics whining as they lifted the heavy steel box high into the air. As gravity and momentum began to move the load of refuse down and out of the dump-bed he noticed several oversize scrapbooks slide off the top of the load. A few pages had come lose from their bindings and were fluttering to the ground. Even from 50 feet away he could see the loose pages contained colorful drawings of some kind. His curiosity was aroused. As he worked his way across the dump trying to get to the books he noticed that another scavenger, like himself, had already reached the fresh load of refuse and was busy gathering up the books that had sparked his interest. By the time he reached the spot the other man had already carried the books to a beat-up car parked nearby. Fred reached him just as he was placing the last of them in the trunk.

"What did you find over there, Brother?" Fred asked.

"Don't know. They look like old coloring books to me." The other man frowned, as Fred stooped over the open trunk to get a closer look.

"Mind if I look at them?" Without an answer he was already reaching into the man's trunk and was flipping pages.

"Guess not," the man mumbled as he begrudgingly accepted the situation.

After looking at a couple of pages of what looked to him like fanciful drawings of some type of hot air balloons Fred had a gut feeling that this was something that could be worth money to someone. Maybe a lot of money.

"What you want for them?" Fred asked.

"Hell, I don't know. I just found them, haven't had time to think about it yet."

"I'll give you a hundred bucks for them," Fred said, as he reached into his wallet and pulled out five twenties.

The man stared at the money for a minute. "You want them that bad … sold. I'll even help you load them into your truck. You can have those, too," the scavenger said, pointing towards a cardboard box full of old papers. "That box came down with the old books."

Without another word the man took the money from Fred's hand, loaded his arms with about half of the large, heavy books and headed towards Fred's pickup truck. Fred looked at the box and wondered what kind of papers might be in it. *Oh well*, he thought, *I paid for it, I might as well take it, too. I'll find out later what's in the box.* So without even opening the flaps, he placed the box on the stack of remaining books, wrapped his arms around the awkward load, and followed the other man over to his truck.

As Fred left the dump he glanced over at the stack of old books and the cardboard box on the seat in the cab beside him. He could just make out an old envelope hanging out of the cardboard box. *Looks like a utility bill to me,* he thought. He was beginning to wonder if he'd gone crazy. A hundred bucks for a bunch of old decaying drawings of hot air balloons and a cardboard box full of someone's old utility bills. And his own electric bills not even paid yet … *I am crazy,* he thought as he pulled out of the dumpsite and joined the mid-morning traffic.

Upon arriving back at his shop Fred went in and cleared a place on a small out-of-the-way workbench. Then he returned to the truck and in two trips carried the heavy books and box of papers inside. He stacked his find on top of the table then covered them with an old paint-stained tarp. He figured he'd take his time later and make a thorough study of what he had bought.

The first chance he had he started looking methodically through the books and the contents of the box. The books were actually a series of drawings that had been bound together into book form. The binding materials were unique, using string, glue and newspaper stock. The artist's name, C. A. A. Dellschau, was included in every drawing. In looking through the old letters, newspaper clippings and papers in the cardboard box he noticed that the name Dellschau was on many of them. But most of the papers were old receipts, business letters and envelopes containing the name and address of Selzig's Saddlery Store in downtown Houston. There were also some receipts for purchases made at department or millinery stores. Most of these contained the names and addresses of two women.

With this information in hand he made a brief effort at trying to find out what he could about the origin of the books, and who their previous owner might have been. No one he contacted appeared to have any interest in the artwork or to know anything about Dellschau, the artist.

His own interest dwindled. In time Fred needed the workbench for another

project. He placed the old books under a pile of scrap carpet remnants and covered the whole pile with a large canvas. There they remained, undisturbed for a year.

It was in the early spring of 1969 when three college students, two boys and a girl, showed up at Fred's workshop. They were from nearby St. Thomas University. The two young men hung back and looked on awkwardly as their female companion approached Fred.

"Sir, my name is Mary Jane … Mary Jane Victor. We just left your store over on Washington Street. The man there told us you might be able to help us. He told us you have lots of stuff in your warehouse, and we were wondering if you might have anything that has to do with flight? You know, stuffed birds, old airplane models. Stuff like that."

Fred's eyes widened at the mention of things that fly. His mind instantly turned to the strange books he had bought the year before.

"Why you want to know?" Fred asked her, his curiosity aroused.

The young girl continued to be the spokesperson. "We're putting on an exhibition at our school. We want to exhibit anything that has to do with flight."

"Step back here." He motioned for the three young people to follow him back into the gloomy paint-thick smell of the interior of his workshop. "I might have something that's just what you kids are looking for."

Fig 1.3. One of Dellschau's mysterious books laying open in Mr. Washington's shop. Photo by P. G. Navarro.

With the young people looking on he began to forage through a pile of old carpet remnants and boxes full of unidentifiable junk. Finally he removed two old ragged-looking books from the pile.

As the three students crowded around and started looking through the pages of the strange books they grew more and more excited. What they saw were page after page of odd looking colorful drawings of what appeared to be flying machines. But flying machines like none they had ever seen during their study of the history of flight.

"Mr. Washington, would you donate these books for our display?" The young spokeswoman asked.

Fred realized that this just might be what those old drawings needed, exposure. If the right people saw the display he might be able to sell some of them and realize a good profit. He'd already decided the odd books had to be valuable. At any rate, it was better for interested people to see Dellschau's artwork than for it to be hidden away under a bunch of junk in his workshop.

"Tell you what," Fred said, "I'm not gonna give them to you. But I will loan you a couple for your exhibit."

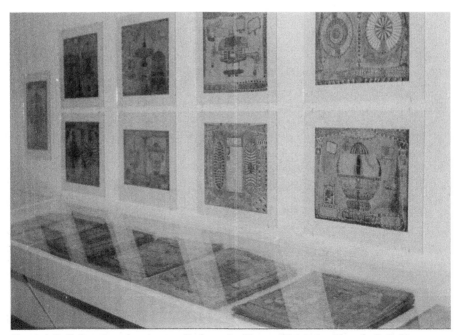

Fig. 1.4. Dellschau Aero drawings on display at St. Thomas University. Photo by P. G. Navarro.

Strange Orb of Light

I had no trouble picking out such advanced mechanical devices as retractable landing gear, compressed air jets and very unusual navigational equipment, all done with the pointed detail of an engineering draftsman.

— Pete Navarro

HOUSTON, TEXAS, 1932

Shortly after dark on a quiet midsummer night in 1932, three young boys had just crossed a vacant lot in front of their homes and were walking along the next street over. They were heading for a small drug store to buy some candy and bubble gum with a little change they had scrounged up. The section of East Houston where they lived was sparsely populated and not as busy as it is today. On that particular night the streets were very quiet with no other people in sight. They walked along the dark, tree-lined street clowning around, as small boys will do.

Just as they started to cross a shallow ditch in order to take a short cut to the store, a strange shimmering round object appeared in the night sky above them next to a large pine tree. It scared the two younger boys so badly that they immediately ran away down the path. Twelve-year-old Pete Navarro, however, perhaps more curious than afraid, stood his ground wondering what the strange light could possibly be. His first thought was that it might be someone up in a nearby tree playing a joke on passersby by shining a large spotlight on them. He quickly ran around the tree to see if someone was hiding up in the branches. The light instantly disappeared. There was no one there.

As Pete grew into manhood he often thought of, and wondered, just what he had seen that night as a small boy. But he didn't dwell on it, and the memory became submerged in the depths of his sub-conscious mind. By the early 1940s he was applying his talent for drawing and painting in the pursuit of a career as a commercial artist. During World War II he found himself in the Marines, where he remained until the end of hostilities. After the war he married his wife, Millie, and continued to work as a commercial artist and in graphic arts.

Pete was living in Washington, D. C., in 1947 when reports of flying saucers began to make news across the country. On January 8, 1948, newspapers

Fig. 2.1. A Strange Orb of Light. Drawing by P. G. Navarro.

nationwide carried a startling story, many on their front pages. According to reports released by the U. S. Air Force the day before, a parachute-shaped light had been sighted in the sky above western Kentucky near Godman Air Force Base. National guard pilot Capt. Thomas F. Mantell, Jr., returning to Godman after a training flight in his P-51 Mustang fighter plane, was ordered to pursue and to try to identify the strange object. Mantell radioed Godman tower that "It appears to be a metallic object or possibly reflection of sun from a metallic object, and it is of tremendous size." Hoping for a closer glimpse, Mantell continued climbing toward 25,000 feet even though his airplane wasn't equipped with an oxygen mask. He lost consciousness and was killed in the ensuing crash. The description of the orb of light that was given by Capt. Mantell just before he and his plane were destroyed was similar to the object Pete had seen in 1932. He began to wonder if the object he had observed 16 years before might also have been one of the elusive, so-called flying saucers. He began conducting his own extensive research into the flying saucer phenomenon in his spare time.

By the early 1960s, Pete's artistic talents had led to owning and operating

the Supreme Graphic Arts Company, a successful Houston, Texas, company which specialized in designing letterheads, logos, illustrations for advertising literature and magazine covers. Pete's busy company also supplied plates and negatives for lithographic printing. His spare time was still spent looking into the realm of strange things in the sky, by now commonly called Unidentified Flying Objects, or UFOs for short.

One of the things that had caught his interest were old newspaper reports about a wave of elusive flying machines the size of sailing ships seen in the skies above American cities just before the turn of the century. The newspaper reports referred to these objects as airships. As more and more of these reports were discovered, the whole series of sightings became known as *The Great Airship Mystery of 1896-97*. He began to wonder if these unexplained airships could be the same objects as those now known as UFOs.

In May of 1969 an article appeared in the *Houston Post* which sparked his interest. The article told of an exhibition being held at Jones Hall on the campus of the University of St. Thomas.

The exhibit was called *The Sky Is The Limit* and was *related to the universal concept of sky and space as depicted in works of art, including mechanical aeroforms as represented by aircraft and other aerial devices.* What caught his eye was a fascinating halftone reproduction of a weird flying machine included with the article. After reading the following passage he knew he had to see the exhibit:

> *Perhaps the most amazing part of the entire exhibition is the visual diary kept by Houstonian C. A. A. Dellschau around 1911, where he provided page after page, volume after volume, of abstract patterning as a setting for his drawings and collages of balloons and pre-war [World War I] aviators.*

Pete, being a professional artist with a special interest in things that flew, became very interested in viewing these strange works of art by an artist-collector of news clippings relating to aviation. He also wondered if this visual diary, as the works of Dellschau were called, could have anything to do with the mysterious 1896-97 airship sightings.

The Dellschau drawings were the centerpiece of the exhibit at Jones Hall on the campus of St. Thomas. Two of the old and somewhat ragged books were displayed under glass in the middle of the floor of the small exhibition hall. They were sitting side by side, each open to representative pages. The old brittle pages of the book contained drawings made in bright watercolors, and yellowing news clippings, all related in some way to flying. He recognized immediately

that the pictures might only represent one man's fantasy, yet they contained details of construction and methods of operation which were obviously ahead of their time. He had no trouble picking out such advanced mechanical devices as retractable landing gear, compressed air jets and very unusual navigational equipment, all done with the striking detail of an engineering draftsman. Pete became instantly mesmerized by what he saw and left Jones Hall knowing he would return.

Indeed he did return to the exhibit several times during its short period of display. Each time the staff had turned the books to different pages. The more Pete saw, the more he wanted to see. He fired off a letter to Lucius Farish, a researcher in Arkansas, whom he had been helping investigate the mystery airships of the late 1800s.

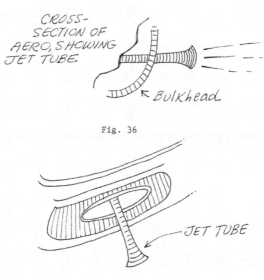

Fig.2.2. Jet tubes as presented by Dellschau. Drawings by P. G. Navarro.

In spite of the fact that the books had impressed him highly and he had a strong desire to look through them at his leisure, other commitments kept him occupied. It was several months later that he received a return letter from Farish, who was writing a history of the mysterious airship sightings. Pete had sent Farish several stories he had collected from the local newspapers, one of which was a story from Conroe, Texas. An article dated April 23, 1897, told of an airship that presumably landed at a ranch near town. Three strangers had walked into the local hotel at one o'clock in the morning and announced that they had been traveling in an airship; that they had flown from San Francisco and were on their way to Cuba.

One of the men at the hotel, a Major Donahue, said that he felt as if he had interviewed natives of the moon as he had heretofore scoffed at the idea of an airship. But now that he had seen it with his own eyes and watched it rise majestically from the earth, illuminated by brilliant electric lights and plowing its way through space, his skepticism had vanished.

"Of course," Farish wrote, "the aeronauts were widely assumed to be 'inventors' who had designed and constructed their airship in total secrecy, no one had paid that much attention to their appearance."

Could there have been airship inventors flying around in their machines as early as 1896? There was a lot of evidence pointing in that direction. And if this was true, then how much of a stretch was it to have them experimenting with them some 40 years earlier? Pete started thinking along this vein and decided it was time to find out more about this man Dellschau. Who was he? And why his interest in airships? Had he read reports of the mysterious airships which had sparked his imagination into making his own version of the elusive machines? Or was he simply inspired by the speculation that was prevalent at the time in the invention and development of flying machines?

Pete also realized there just might be a slight chance that the books of drawings and clippings contained information or reports pertaining to airship sightings. *Who knows*, Pete thought, *Dellschau might even have been one of the secret inventors.*

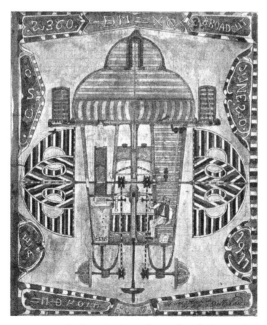

Fig. 2.3. Black and white photo of Dellschau's Plate 2360. The P. G. Navarro Collection.

CHAPTER 3

A Quest Begins

You can imagine things that seem to be real happenings in
your mind, but it's just your imagination working overtime.

— Fred Washington

HOUSTON, TEXAS, 1969

Pete's first step was to contact the University of St. Thomas.

"That display was over long ago," he was informed by a pleasant female voice over the phone.

"Do you know who might have the books, ma'am?" Pete asked.

"Yes. Mrs. DeMenil, the Art History Director of Rice University, bought the books from their owner, Fred Washington. He had graciously lent them to us for our exhibit."

"Is it possible to speak with Mrs. DeMenil?" Pete asked the friendly staff member.

"I'm sorry, Mrs. DeMenil is out of the country right now on an extended tour. However, I believe that Mr. Washington has several more of those books. And I believe he said they were for sale also."

Pete could hardly contain his excitement. More books!

"Do you know how I can get in touch with Mr. Washington?"

"Yes, if you'll hold for a second, I'll get his address for you."

Pete held the phone tightly to his ear and set forward in his chair. There were *more* books. He had to see this man, Mr. Washington.

Pete drove over to the outskirts of the Heights. The helpful lady at St. Thomas had given him two addresses: one was 2518 Washington Avenue and the other was 3512 Barnes Street.

As he drove up Montrose he wondered if Mr. Washington would let him look at the books he still had in his possession. Better yet, maybe the junk dealer wouldn't want a lot of money for them and he could buy them. But money was tight. With his business and a growing family, expenses were already too high. Realistically, he knew he probably couldn't afford to buy them. But, he wanted access to those books. He gripped the steering wheel with determination. One way or the other he was going to see those books.

The O.K. Trading Post was located in a block of small, run-down-looking "Ma and Pop" type businesses. The old, well-used one and two-story buildings looked as though they leaned against each other for support. Facing this commercial area from across a cracked and litter-filled street were the first houses in a tract of an equally run down residential area. Two young boys stood on the sidewalk and watched as Pete got out of his car and walked up to the obviously closed store. He peeked through one of the barred windows to see what was inside. It was too gloomy and dark to make out much of the interior, so he turned back towards his car.

"Mr. Washington is over yonder at his other store," one of the small boys offered as he pointed vaguely over his shoulder using a dripping Popsicle as a pointer.

Following the directions of the small boy, he found Mr. Washington at his workshop and storehouse on Barnes Street. Pete introduced himself. Fred Washington was a black man in his early 60s. He had a stock of gray hair and stood about 5' 9" tall. Perched on his head was a porkpie hat. Washington greeted him with a smile. After wiping furniture stain from his hands with a piece of rag he reached out and shook Pete's hand.

"What can I do for you, sir?"

Pete looked around at the junk-filled warehouse. Except for the work area at the front of the store and a small path leading into the dark confines of the back of the building, every inch of the old building's space was filled with broken furniture, pieces of lumber, old paint cans, pieces of ornamental wrought iron and just plain junk. The sickly smell of paint, thinner, and chemicals was almost unbearable. He smiled back. "What do you do here, Mr. Washington?"

"I refinish furniture, which I sell. I also sell antiques. Which you looking for ... furniture or antiques?"

Pete saw that he was dealing with a shrewd, intelligent, no-nonsense type man, and he instinctively knew the best approach was to get right to the point.

"I'm interested in those books you lent to the University of St. Thomas for display."

"I sold those books to Mrs. De Menil. Sold her three of them. She gave me five hundred dollars each for them. But, I've got eight more just like them. They're for sale too for the right price."

"Can I look at them, Mr. Washington?"

"If you stop calling me Mr. Washington you can. My name is Fred. And you've got to help me dig them out. They're back there under a pile of other stuff," he said, indicating the back of the building with a sideward movement of his head.

Fred led the way to the back of the warehouse and a five-foot-high pile

of mostly carpet remnants and cardboard boxes full of odds and ends. He motioned for Pete to follow as he climbed atop the pile and started moving boxes and digging down in amongst the pieces of carpet.

"Come on up." Fred looked back at him. "The books are down in here. You can help me look."

Once they had dug the eight books out of their makeshift nest, Fred placed a square of plywood loosely on top of some wooden crates to make a small table where he could place one of the books for viewing. Picking one of the old books at random he gently placed it on the makeshift examining table. With a flourish he motioned for Pete to come stand beside him and take a look.

Visibly excited, Pete reached down and felt the Dellschau book. It was a large book, about 15" wide by 19" high, and about three to four inches thick.

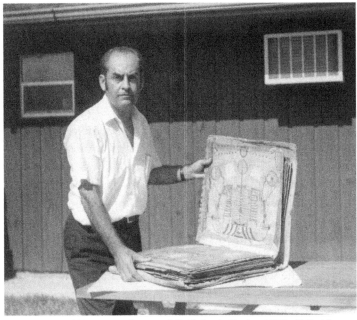

Fig 3.1. Pete Navarro with one of Dellschau's Books. 1970. P.G. Navarro Collection.

Some of the pages were sticking out every which way as though someone had hurriedly picked up the loose pages and stuffed them back in haphazardly. The cover, which at first glance looked like leather, was actually made out of cardboard. A veneer of blue-colored cheesecloth had once been spread over the cover, but the material was now just tatters. He carefully opened the book and began to look at the strange drawings. Up close and without the glass of the museum display in his way the drawings were even more dramatic.

"OK if I make photocopies of some of the drawings?" He questioned Fred.

"Sorry, I can't allow that. It wouldn't be fair to Mrs. De Menil. Nor would it be fair to the person who buys these books." Fred looked at him in a questioning way.

Pete just nodded understandingly and went back to studying the page he had turned to.

Fred continued in the same vein, as if he needed to make it very clear that unless he saw some hard cash make its appearance, a look at the books was all he was going to allow.

"Mrs. DeMenil paid me five hundred dollars each for those three books," he explained, "Of course, if you bought some of them yourself, then you could do anything you want with them."

That much was obvious. Pete glanced at Fred and wondered who had set the price for the books, the art director Mrs. DeMenil, or cagey Mr. Fred Washington.

"How much would you want for the remaining eight books, Fred?"

"If a person was to buy all eight at once, uh … I guess I'd let them go for four thousand bucks. Cash, of course." he replied.

Just as Pete had figured. No way under the sun could he afford to pay that much money. Eight or nine hundred perhaps, but certainly not four thousand! Millie would beat him over the head with a club if she knew he was even considering paying any amount for some old ragged scrapbooks.

Fred spotted Pete's disappointment. "Tell you what. You can come by here and look at the books anytime you want … but no pictures or photo copies are to be made."

Pete smiled and almost uttered a silent prayer of gratitude. Things were really going his way. He would be able to study the contents of the books, even if in this manner he would only accomplish a small portion of his intended mission. Now, he turned his attention to the artist himself … C. A. A. Dellschau.

"What do you know about the man who made these," Pete pointed at the open book.

"I've done a bit of investigating," Fred answered. "Found out some stuff. But that Dellschau, he's a real mystery man. Nobody I've talked to about him seems to know hardly anything about Mr. Charles Dellschau." Fred motioned for Pete to follow him. They wound their way back through the piles of junk towards the front of the store where Fred had a couple of beat up, metal folding chairs leaning against the wall. With a practiced snap he unfolded them.

"Have a seat Mr. Pete." Fred pointed towards one of the chairs as he settled down in the other, "Sometimes it does a body good just to set down."

Both men got comfortable with Fred taking a minute to adjust a bent leg on his chair. Then he leaned in closer to Pete as if preparing to disclose some lengthy bit of gossip he had managed to dig out regarding the mysterious C. A. A. Dellschau.

"I wanted to know about Dellschau too," he began. "So first I went to the library and looked through the City of Houston directories. I checked as far back as 1907. There was no C. A. A. Dellschau listed. In fact there was no C. A. A. Dellschau listed anywhere at all in that library. So I continued to search in other likely places that I had found mentioned in some papers that were in a cardboard box that came with the books."

"Do you still have the box with those papers?" Pete asked.

"No I don't." Fred replied. "And I don't rightly know what happened to that box. I just never could find it after the one time I poked around through it looking for information. Maybe someone working here threw it out with the trash."

Pete looked around at the junk filled building. *How would a person decide what to throw out in all this clutter,* he thought.

"But you did find out something about him, right?" Pete asked.

"Yes, a little. I found out that he lived in the attic above Stelzig's Saddlery store on Preston in downtown Houston. Then someone else said he lived with a sister-in-law, but I don't know where."

Fred reached into his back pocket and pulled out an old beat up wallet. He opened it and removed a folded-up newspaper article. "Here, read this," he said, handing the piece of paper to Pete, "this piece out of the newspaper tells all that's known about our Mr. Dellschau."

He noticed that the story had been clipped from the *Houston Chronicle*, the city's afternoon newspaper. It was another story by one of the staff news writers about the Dellschau Airship drawings that had been exhibited at the University. As he read through the article Pete mentally filed away pertinent information. *1919 ... a man began drawing detailed models of air machines ... in the next 15 years Dellschau ... would complete enough drawings to fill a dozen scrapbooks. Each drawing was carefully laid out, drawn on a grid and water-colored ... a page of news clippings of the day might be included along with the sketch.*

He took notice that the reporter hadn't touched on the fact that the drawings of the many functional parts of Dellschau's airships seemed to be workable mechanical components. Granted most represented the block-and-tackle, rope-and-pulley type of engineering design used in the construction of sailing ships of his day, but they did look totally functional.

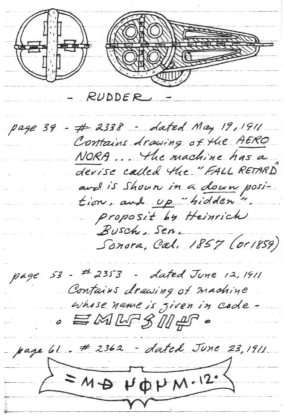

- RUDDER -

page 39 - # 2338 - dated May 19, 1911
Contains drawing of the AERO
NORA ... the machine has a
devise called the "FALL RETARD"
and is shown in a down posi-
tion, and up "hidden".
proposit by Heinrich
Busch, Sen.
Sonora, Cal. 1857 (or 1859)

page 53 - # 2353 - dated June 12, 1911
Contains drawing of machine
whose name is given in code -
o ☰ M ⌶ Ƨ ∥ ⊹ o

page 61 - # 2362 - dated June 23, 1911
☰ M Ɖ ↳ Φ ↳ M · 12 ·

Fig 3.2. Pete Navarro's Journal #XIV, Page 159. Note the
1800s nautical look of the rudder and the coded messages.

Pete read on.

According to the article the students who had worked on the project had discovered that Dellschau had lived with a member of the Stelzig family named Helena Stelzig. Dellschau was her mother's stepfather, according to her, and he lived with them. Pete also learned from the article that Dellschau was originally from Germany and had worked at the Stelzig Saddlery Company. Helena explained that his drawings were just a hobby; that Dellschau didn't talk much, spending most of his time working on his drawings.

He stopped reading for a moment. *Well*, he thought, *that certainly told him quite a bit about the man, but he still wondered about the purpose behind the making of all those drawings.*

"Fred why do you think Dellschau spent so much time on all those drawings?"

Fred looked kind of surprised that Pete had asked for his opinion.

"That's a good question Mr. Pete. I've spent a lot of time thinking about it." Fred grinned. "As you are finding out, those old books have a way of growing on you. Sometimes I can visualize our Dellschau stooping over his books. Working while the city slept, oblivious to anything around him."

Fred took his hat off and rubbed his head. "The thing is ... he would have had to work constantly without any let-up ... and sustained an impossible pace to be able to make so many drawings during the short time period that is represented by the dates in the books. I mean ... was it a hobby? More like an obsession, I'd say."

Pete thought on that for a second. "Maybe he had a story to tell and was afraid something would happen to him before he told it."

"Could be, could be," Fred agreed as he leaned back and thought about that while Pete finished reading the article.

He read that a nephew of Helena Stelzig, Leo Stelzig Jr., remembered looking through Dellschau's books in his aunt's attic when he was a young boy.

"Listen to this, Fred," he began reading from the article aloud, *"Dellschau's thinking was like Buck Rogers. He did not draw about going to the moon but he was far thinking. He had a knack of knowing what was going on in the future."*

"This Dellschau was an interesting man," Pete remarked as he handed the clipping back to Fred.

"Go ahead and keep it," Fred waved the offered piece of newsprint away. "But that's enough of this foolishness. I've got to close up shop and go home." He slowly got up from the chair and adjusted his hat. "You come on back and look at those books anytime you feel like it, Mr. Pete."

"Thanks, I will," Pete said as he started for the door.

"Pictures of imaginary flying machines," Fred remarked as Pete was stepping out the door, "that's all Dellschau left. You know, you can imagine things that seem to be real happenings in your mind, but it's just your imagination working overtime."

Pete had started to wave as he walked towards his car, but he stopped instead, then turned back to face Fred. "You know Fred, that might be a good analogy for describing Dellschau's work."

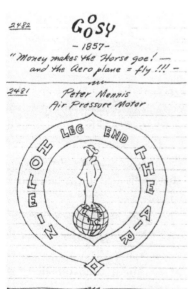

Fig. 3.3. Notes from P.G. Navarro's notes regarding Plates 2482 and #2481.

As he drove home through the darkening streets of Houston Pete thought, *but then again, it might not be an analogy of the man's work.* He had a gut feeling that there was more to Dellschau and his work than an over-active imagination. And there was something that he himself had said during the conversation with Fred. What was it? Something about Dellschau telling a story? Then it hit him. Those books didn't just contain a series of random drawings of imaginary futuristic flying machines.

Be it fact or fiction Dellschau had bound his drawings into books because they told a story. A story that Dellschau had somehow, for some unknown reason, hidden within the drawings. Pete had to know that story.

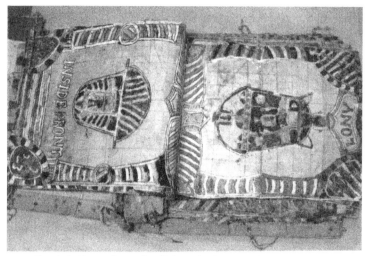

Fig. 3.4. Photo of one of Dellschau's books. Photo by P. G. Navarro.

CHAPTER 4

Dellschau Remembered

You know, it's really too bad no one took notice of Dellschau's books back then. Some of those flying ships might really work.

— W. D. Fox

HOUSTON, TEXAS, 1969

The following Sunday, Pete drove over to the address of the Stelzig Saddlery Store on Preston Avenue. To his surprise the old store where Dellschau presumably worked on his drawings was still standing. Even more surprisingly, it was still owned by the Stelzig family. However, it being Sunday, the store was closed. He returned the next day and talked to H. L. Stelzig, Sr. who was busily engaged in some transactions behind the counter. He was friendly enough, but when Pete told him he was seeking information concerning Dellschau, Stelzig's demeanor changed to one of a person who was tired of the subject. "I'm too busy to talk to you about Charlie Dellschau," he said, "But, you might want to talk to my sister Helena." Stelzig scribbled an address on a scrap of paper and offered it to him. "Here's her address."

He thanked Stelzig and turned to go. A man who had been standing nearby approached him as he was going out of one of the side doors and offered his hand for Pete to shake.

"I'm W. D. Fox. Howdy," he said as Pete returned his handshake.

"I couldn't help but overhear your conversation about old man Dellschau," he explained," I might know a little about him that might be of interest to you."

Fox invited him to step outside onto the sidewalk where the customers in the store could not overhear them.

"My mother was a Stelzig," Fox said. "I remember having seen some of old man Dellschau's drawings as a small boy. His attic room was full of books and pictures having to do with aviation."

"So did Dellschau actually live up in the attic?" Pete asked the friendly man as he pointed towards the Stelzig store's upstairs windows.

"Oh, no," Fox explained, "Dellschau didn't live above the store. I think

36

he worked here at one time, but he never lived here. He lived in the attic of Helena's house. It's been a long time since he lived there though. Dellschau died about, oh, 45 or 50 years ago."

He shook his head sadly, "You know, it's really too bad no one took notice of Dellschau's books back then. Some of those flying ships might have really worked."

Pete thanked Mr. Fox for this bit of information and decided that he should make an effort to see Helena Stelzig as soon as possible. Fox had informed him that she was a very old woman and in feeble health. However, the main thing on Pete's mind was not so much the search for the identity of the artist, but the study of the books and drawings. He was sure that it was there that the true story and purpose behind them lay hidden. He believed the books contained numerous items of information pertaining to airship designs that might actually work, regardless of the fact that some of the designs were of such ponderous and awkward construction that they couldn't possibly have gotten off the ground.

Pete knew without a doubt he wouldn't rest until he was able to examine Dellschau's books in minute detail. He also realized that he would never be able to pay the amount of money Fred Washington wanted for the books, and since Fred had invited him to come back and look at the books anytime he wanted, he was going to take Fred up on his offer. He was going to spend all the time he could at the workshop looking through the books. He was also determined to obtain a copy of one of Dellschau's airship designs to send to fellow researcher Lucius Farish for comparison with other airship drawings and descriptions of the 19th-century mystery airships. He had decided the only alternative to making a photocopy was to make a detailed sketch by hand.

Fred Washington was busy fitting a new leg onto an old dining room table when Pete walked into his cluttered workshop. Seeing Pete he quit what he was doing and smiled. "Hi, Mr. Pete. I see you're back to have another look at those books, I bet."

He smiled and nodded. "Yeah, and I'll be here for as long as it takes to figure them out. Or I wear out my welcome, whichever comes first."

"You'll always be welcome here, Mr. Pete. I'd like to know about them myself."

"Well, what I'd like to do right now is make a couple of sketches of those airships if it's O.K. with you."

Fred took his hat off and ran his hand through his hair. "Well, I don't know about that, Mr. Pete. Are you going to sell them?"

"That's not what I had in mind," he replied. "I only want to make some sketches to send to a friend in Arkansas to use for comparison." Pete went on to

explain to Fred about the mysterious airship sightings of the 1890s and about Lucius Farish's research. He explained that Lucius was interested in looking for a connection between those sightings and Dellschau's drawings.

"Any sketches I make will be my own, and will not in any way take from the originals," he explained.

Fred gave this some thought for a minute. "I'll make a deal with you," he finally said. "You can make your sketches. All I ask is that I share in any money made off them if you sell them, or use them to illustrate any story. Of course, if the books were yours, you wouldn't have to share with anyone, would you?"

The consummate salesman, Pete thought. This gave him an opportunity to make an offer that he could afford. "How about selling me one of the books as a starter?" He asked Mr. Washington. "I'll give you sixty-five dollars for any one of the books you want to sell."

"No way!" responded Fred. "I'll have to have at least 500 dollars for each book."

That settled the question about the prospect of buying the books for the time being. Pete decided that he'd better be content with being able to study the books at Mr. Washington's place and work on the sketches he had agreed to let him make.

Pete began to make regular trips to Fred Washington's workshop. Upon slow and careful examination of the material contained in the amazing books he grew more and more excited. His hunch had been right. These were not just books of drawings of imaginative airships and news clippings. Each page also contained messages. Messages that were written in horribly misspelled English, German and some form of code written in what looked like ancient mystic runes. There was no doubt. Dellschau was trying to convey something to anyone who would take the time and had the inclination to figure it all out. That only made Pete more determined than ever to solve what he now thought of as "the secrets of Dellschau."

He'd also reached another conclusion. One book alone would not reveal Dellschau's secrets. All the books together were needed to complete the puzzle and acquire the key to the solution of the riddle of Dellschau's books. But what did it all mean? Pete had no idea.

He took his growing number of sketches, notes and drawings home to ponder over them in his study. He showed some of the notations and sketches to his brother, Rudolph. Rudolph was of the opinion that Dellschau must have been an artist or draftsman who made patent drawings for inventors. He expressed his belief that he had been an engineering draftsman working with a group of aeronautically minded inventors. He felt the group probably

presented Dellschau with schematic layouts or ideas so he could make the completed drawings of their various aircraft designs. He thought that perhaps, after having obtained all these ideas and diagrams, Dellschau may have retained copies of them and then later used the ideas of others for his own use.

Pete thought differently. He felt that the airships were just fictional aircraft created by the advanced thinking of Dellschau. Sort of like Jules Verne who had written of airships, submarines and other fantastic machines; only Dellschau used drawings instead of words. Yet the detail of the working components still fascinated him. He thought of how many of the features embodied in each airship design, whether in full-face or in cross-section view, seemed to represent a functional piece of machinery that actually worked. Of course, the one thing that had to be taken into consideration in the study of the drawings was the fact that these airship designs were original designs. There had been no prototypes to go by, although the system of ropes and pulleys and other nautical-like devices as shown on Dellschau's airships may indicate that these were borrowed from their known use on sailboats, and perhaps even hot-air balloons.

He continued his studies. One of the most obvious things, as he had already noted, was the use of bad English and the equally atrocious spelling. It was clear to him that Dellschau must have been a foreigner or an immigrant to America. Because of the vast amount of German words he used, he was sure that the belief that Dellschau was of German descent was a fact. He decided it was time he called on Miss Helena Stelzig.

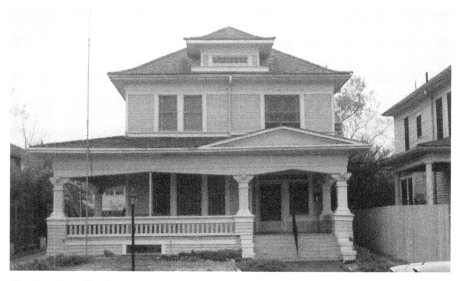

Fig. 4.1. The Stelzig house at 302 Stratford St., Houston, Texas. Photo by P.G. Navarro.

The house was a modest, unobtrusive two-story with a large wide porch across the front and down the left side. Two pillars flanked the doublewide front steps that led up to the front door on the right facing the street. It was located on a quiet residential street, surprisingly close to Pete's business location. Pete parked his car, went up to the front door, and knocked. For a few minutes there was no answer although he had the feeling that someone was peeking out at him from one of the tightly closed windows. Just as he was ready to turn and leave to perhaps return another day, the door was opened just a crack.

Through the partially opened door he could just make out a stout woman in a white uniform looking out at him. After telling her who he was Pete asked to speak to Miss Stelzig. The woman told him that Miss Stelzig was unable to come to the door, and that she was indisposed and couldn't be disturbed. She introduced herself as Mrs. Williams, the in-home health-care person who took care of Miss Stelzig, an invalid. "I've been taking care of Miss Stelzig for a long time," she said.

"Perhaps you can tell me something about Mr. Dellschau. I understand he used to live here. I just need you to answer a few questions to help me with my research on him," he said.

Still looking at him through the slit of the mostly closed door, she asked, "And what research might that be, Mr. Navarro?"

"Well, I'm really interested in the books he made ... "

"Oh, the airplane books. How do you know about them and who has them now?"

He decided to keep the knowledge of the books that were in the possession of Mr. Washington to himself so he told her a partial truth. "They are at Rice University."

He felt she was about to close the slightly open door on him at any moment so he quickly asked, "How old was Mr. Dellschau when he died?"

Mrs. Williams turned around and looked back inside the house. He heard her repeat the same question to someone else who was somewhere in the room. From the sound of the female voice that answered he could tell the person who was behind the wall to the right of the door was quite old. *Probably Miss Helena Stelzig*, he thought.

Mrs. Williams once again turned and peeked out at him. "He was 92 years old when he died," she answered.

"Did he live in this house?"

Mrs. Williams narrowed the slit on the door a bit more, "Yes. He lived here until the day he died. He lived in a back room where he did all his work on those airplane books. He lived here with Miss Stelzig because of the goodness

of her heart. There is nothing of his left in that room though. It's used as a utility room now."

She said all that with a tone of finality and was apparently about to close the door all the way when Pete suddenly heard the barely audible female voice from inside again. Mrs. Williams turned her head to the side and listened to what was being said. She then nodded and turned to him and asked, "How did Rice University acquire Mr. Dellschau's books?"

"Someone found them in a dump," he explained, "and the University eventually bought them from the man who found them."

"Well, you aren't the first person who's been asking about the old man and his drawings. We can't understand all of this interest in him, and to tell you the truth, we really don't know too much about him." With that Mrs. Williams started to close the door all the way.

He quickly asked another question, "Do you know if Dellschau ever lived in California?" He had come across several mentions of California in the odd

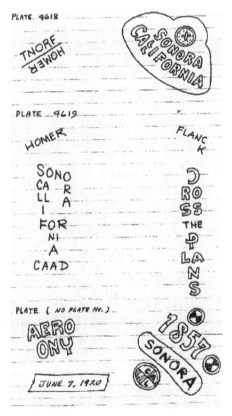

Fig. 4.2. A page from P.G Navarro's field journal with mentions of California as seen on many of Dellschau's drawings.

writings in the books.

Mrs. Williams once again turned her back to him and mumbled something to the unseen old lady behind her. He once again heard the low sound of the voice from inside. However this time he could hear her answer very plainly.

"No. He never lived in California. He lived in Houston."

Mrs. Williams, with her head still turned away from Pete asked the person inside, "But he could have lived in California at some time in his life, couldn't he?"

"Yes he could have … before he came to Houston," Miss Helena Stelzig replied. "He was originally from Germany." With that said, Mrs. Williams finally closed the door.

He drove home thinking about what he had just learned. He felt that he had found out all he was going to from the people who knew Dellschau. At least for the time being. To find out more, he knew it was time to begin the long, dreary work of looking through public records. However, he felt that he was finally starting to uncover the story of the mysterious C. A. A. Dellschau.

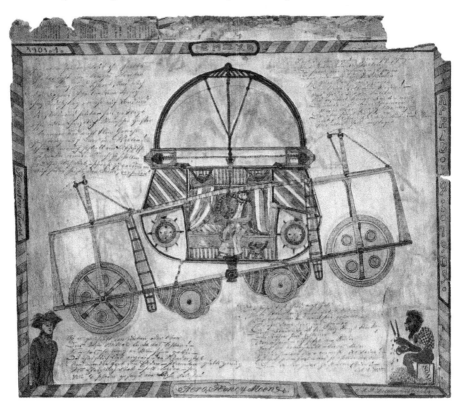

Fig. 4.3. Dellschau plate 1901 showing a side cut-a-way view of the Aero Honeymoon. P.G. Navarro Collection.

Chapter 5

A Crack in the Code

Dellschau was just an old man with nothing but time on his hands. Just plain foolishness, I've decided.

— Mr. Fred Washington

Houston, Texas, 1970

After talking with Mrs. Williams at Helena Stelzig's home, Pete drove over to Mr. Washington's workshop. The double front doors were closed and latched from the inside. Pete knocked on the door. A young man in an Afro haircut came to the door and let him in.

Off to one side Fred's helper was spray-painting some wooden panels. Fred was gluing the front panel onto a dresser drawer on a small workbench just inside the door. He looked up as Pete entered and smiled, nodding a greeting, "Hi there, Mr. Pete. I'm pretty busy right now. Think you can find those books by yourself?"

"Sure, no problem," Pete answered as he headed towards the back of the cluttered building. First he had to remove a big pile of rolled-up canvas and some plastic sheeting to get to the books. He took one of the books from the pile and looked around for a place to set it. The small makeshift table he always examined the books on before was being used by the painter. He found a large piece of cardboard on top of some upholstery samples and opened the book there. Standing amid a pile of ornamental ironwork, stacks of old pop bottles and other junk Pete began to study the first page. He had already looked through this book before, but only briefly. This time he took his time, drawing sketches of interesting items and making brief notes in his journal.

All the doors and windows were closed to keep out the winter chill, and although a ventilating fan was on it didn't seem to be performing very well. The painter kept on spraying and the air was full of paint spray. *How can they stand it?* Pete thought, as he began to feel lightheaded. He noticed that Fred kept going in and out of the front door. *Probably to get fresh air*, he thought. He would have given anything to be able to study the books in a more pleasant atmosphere, but he thought beggars couldn't be choosers.

Finally, he could take it no more. He needed some fresh air.

"OK if I open the door a crack?" he asked the painter.

"Sure, go ahead," the painter answered with a smile.

After that it wasn't so bad. He continued his work.

He began to make a few sketches, and Fred walked over, "You making some more sketches to send to your Arkansas friend?"

"Nope. There are for my own use. I'm gathering as much information as I can to try and figure out the purpose behind all this work."

Fred walked away shaking his head, "Dellschau was just an old man who had nothing but time on his hands if you ask me. Just plain foolishness, I've decided."

Pete became so engrossed in his work he didn't realize that several hours had gone by. As he reached the last pages of this particular book he noticed that several of the pages were stuck together. He didn't want to tear them so he left them alone. Suddenly he realized he had reached a milestone. With the inspection of the final page he had made as detailed a study of all eight books as was possible for now. He felt that he had already taken enough notes and had spent enough time making sketches. Now the material he had collected needed to be studied and analyzed. Of course he still hadn't looked at the three books in Mrs. DeMenil's possession, but he would face that problem later.

While he had been reproducing sketches and making notations from Dellschau's work, he hadn't really tried to analyze the information. His only concern during that process was to reproduce as much as he could for later study. Now that he had the information, he was anxious to thoroughly examine it.

Several days later Pete sat at his desk in his study and spread out all his notes and drawings in front of him. It was time to tackle the coded messages and try to make some sense out of the information he had gathered from the books. He decided to work on the symbols and obvious writing first. Though he wasn't ready to reach any conclusions yet, it was clear to him that Dellschau had hidden much of what he had to say in several forms of code. Some of them were anagrams, as well as something akin to acrostics.

This involves a transposition cipher: a method of writing certain information which the writer may or may not wish to have uncovered or deciphered. In transposition ciphers the letters are altered in

PLATE 4558

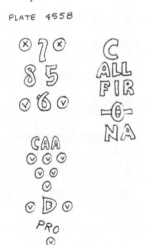

Fig. 5.1. Transposition ciphers from Plate 4558.

44

relative position. It was this type of code that Dellschau had used to write the word *California*.

Another form of code that seemed to appear in Dellschau's works was a substitute cipher. He had substituted symbols for letters. A simple yet efficient way of hiding messages from anyone who did not have the key.

He reached over and selected a sketch of what he felt was one of Dellschau's substitute messages.

PLATE 4504

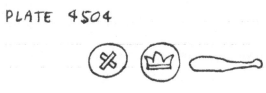

Fig. 5.2. This translates to "Aero Club."

He had run across several mentions of an *Aero Club* in Dellschau's drawings. He was sure that in this drawing Dellschau had meant for the "X" and the crown to symbolize the word *AeRoy* and that the picture of the club was self-evident. Therefore he felt comfortable with the belief that this drawing symbolized *Aero Club*.

Pete felt good as he leaned back in his chair. He had started to break the code. Not enough to come to any conclusions, but he knew now that Dellschau's story contained information about an Aero club located in California. He glanced over at the clock on the wall. Eleven p.m. Where did the time go?

Oh, well, he thought, *tomorrow's another day.*

Several days later, Pete's brother Rudolph came over to visit, and he and Pete retired to the study.

"So, anything new on Dellschau?" Rudolph asked.

Pete told him about the two small pieces of the puzzle he had put together. As he and Pete began to discuss this, along with the other information Pete had discovered, they began to form a somewhat hazy picture of events and activities that may have actually taken place, and of things and places that may have actually existed.

One of the speculative conclusions they came to was that Dellschau may have been a member of a brotherhood or society of intellectuals called *The Aero Club* who had pooled their ideas with the objective of creating a navigable flying machine. Another was that the club might or may not have been successful in designing and constructing a machine that would actually fly. Their airship designs may not have been the most aerodynamically sound constructions, for some of the designs are veritable monstrosities, but they agreed that the men had to be given credit for being visionaries. There was no precedent for them to go by. In the 1850s, the only flying craft was the balloon, but it was not navigable. The balloon was used mostly for observation purposes during war times. It could be maneuvered only in ascending and descending

by the use of ballast, and was prey to the whimsies of the wind. Methods of propulsion and means of controlling the flight had been tried, but without much success. Therefore the members of Dellschau's Aero Club were treading on virgin ground when they proposed ideas that were fantastic for their times and certainly would be amazing even today if some of their proposals were known and applied now.

The Navarro brothers had also arrived at the conclusion that the experiments had been conducted in a remote area in California, probably northern California. And if the Aero Club had eventually been successful in designing and building a working model of one or more airships, that they, for whatever reason of their own, had decided to keep the secret to themselves.

"Or Dellschau created a world of fantasy, peopled by characters who flew around in weird airships and designed all sorts of aeronautical devices and aircraft," Pete remarked as the two brothers went downstairs to join their families.

Rudolph stopped on the stairs and smiled over at his brother, "At any rate, he sure has us thinking, doesn't he?"

Pete laughed.

The next chance Pete got to work on the Dellschau material he started looking through his notes and sketches, searching for any mention of California or any place names that he could establish as being located in California. He ran across several notations about "Sonora."

One of the entries he had jotted down came off of plate 2002:

GOOSEY
Sonora, 1857, California

Fig. 5.3. Field notes for plate 202 from field journal #XV .

He reached the conclusion that the club was a Sonora-based organization. Later data proved him right. The actual name of the organization was the Sonora Aero Club.

As the pieces of the Dellschau puzzle gradually began to fall into place, he began to get a more coherent picture of the activities of the Sonora Aero Club. He also found Columbia, California, mentioned in several of his notes, including a page containing two drawings of an aircraft called the *Aero Immer.* The caption read *"Columbia, Call. 1858."* *Call.* was Dellschau's abbreviation of California. Also on this plate was a coded message that he was later able to decipher as reading *"A fine flyer."*

He also had noted an entry from plate 2646 that read:

AERO DORA - S-C 1858
August Schoetter Builder and Owner
Burnt in Columbia Fire

He got out an atlas to see if he could locate a town in California named Columbia. There was no such town listed. Finally, he felt he'd found something that didn't fit. Maybe Dellschau's story was starting to break down. *Maybe,* he thought, *the town was just a fabrication of Dellschau's fertile mind.* And if the town didn't exist, then Dellschau's whole story was probably a fantasy. He decided to check further. The next day he went to the library and checked a California road map. Without any trouble he found Columbia. It was located about five or six miles north of Sonora. His skepticism was starting to change. Maybe there really was something to Dellschau's claims.

Fig. 5.4. and Fig. 5.5. More Examples of Dellschau's coded writings from P.G. Navarro's field journal.

Three Books Become Four

I find [the Dellschau Books] *fascinating ... something on
the order of Jules Verne's creations.*

— Zorina Najarian

HOUSTON, TEXAS, 1970

Pete decided it was time to try to get a look at the three books that Mrs.
DeMenil had purchased. On February 18, 1970, he called Rice University. A
female voice answered the phone.

"I'm sorry sir, Mrs. DeMenil is too busy to talk to you right now. Maybe
I can help."

"Well, possibly. My name is Pete Navarro, and I'm doing research on C.
A. A. Dellschau. I was trying to get an appointment or make arrangements
to look at some of his art work that I understand is in the possession of Mrs.
DeMenil."

"Oh. In that case you need to talk to Zorina Najarian. She's the curator in
charge of the art collection. Shall I connect you with her?"

"If you would please. And thank you."

He was put on hold for several minutes and then Mrs. Najarian picked
up the phone, "Hello. I understand you want to see our Dellschau collection.
Might I ask, do you want to look at them for personal reasons ... or do you
have another purpose?"

"Actually, I'm researching the mystery airship sightings during the turn
of the century and I was hoping to find either some news clippings included
in with the books or at least a mention of them. And to be honest with you
,I find his work very fascinating and would also like to see them for my own
satisfaction."

"Yes. I know what you mean. I find them fascinating also, something on
the order of Jules Verne's creations. Hold on, Mr. Navarro, I don't see any
problem with letting you examine them, but I would have to get Mrs. DeMenil's
permission."

She was only gone a minute and when she came back on the phone she
asked him if the next morning at 10 o'clock would be convenient for him.

"That will be fine," he answered. He would have gone at any time she suggested. "And thanks."

"Fine, then. See you at 10 tomorrow. Good day, Mr. Navarro."

Pete was driving up the winding driveway to the DeMenil house at 10 sharp the next morning. The house was actually a mansion with very large well-manicured and landscaped grounds. He continued up the driveway to the back yard where there was a large parking lot. The grounds were completely enclosed by a high brick wall.

A gardener who was trimming a small bush directed him to the collection room. A young woman who was working at a small desk just inside the door stood up as he walked in.

"You must be Mr. Navarro," she said as she stuck out her hand.

"Just call me Pete," he replied as he shook her hand. "And you must be Mrs. Najarian."

She smiled back at him, "And you can call me Zorina."

He looked around at his surroundings as Zorina went toward the back of the small room. He noted that the room was just as cramped as Mr. Washington's warehouse but was brighter and far more cheerful. Obviously, the room was the place where Mrs. DeMenil's collection of art objects and antiques were sorted and cataloged. Various woodcarvings, African masks and oil paintings lined the walls or were lying on the floor and on several tables scattered around the room. The shelves along the back of the room contained old books as well as sculptures and figurines of obvious ancient vintage. He spotted the Dellschau books right away. They were all individually wrapped in semi-transparent plastic and were stacked on top of one another on one of the crowded shelves in the back of the room. He noticed that one of the books was thicker than the others while another was much thinner, being only about one-and-a-half inches thick. Zorina reached up on the shelf and brought down the thicker book. He also noticed surprisingly that there were actually four of Dellschau's books stacked on the shelf. Fred had said he sold Mrs. DeMenil only three. The only thing he could figure out was that two of the books must have been stuck together at the time of the transaction. *Looks like cagey old Washington lost out a little,* he thought with a silent smile.

Zorina placed the book on a table in front of one of the large windows that composed one side of the small collection room.

"There you go, Pete. I'll be right over there at my desk if you need me for anything. Take as long as you wish." Zorina smiled at him as she went back to her own work.

As he began to study the pages he was pleasantly delighted to find that

many of the pages in this book contained accounts and notations in plain English, unlike those still in Fred Washington's possession which were mostly in code or German. Also the dates of the plates in this book dated back to April of 1908, a full year before any of the earliest dates in Fred's books. He was hoping that some of the other books in this collection might even be older.

Once while he was engrossed in the book Mrs. DeMenil came by and looked over his shoulder.

"Do you plan on writing about Dellschau's work Mr. Navarro?" she asked.

Pete told her the same thing he had told Zorina: that he was researching the airship sightings from the late 1890s.

Mrs. DeMenil nodded, "I'm glad someone is interested in Dellschau's work. I'm always happy to open our collection for inspection to anyone who is interested. Spend as much time as you want with them, and come back as often as you wish."

"Thank you Mrs. DeMenil," he answered with a smile.

She smiled back and walked away.

After spending three very productive hours with this, the first of the DeMenil books, he bid Zorina goodbye. She told him he could look at the books anytime, but to please call first.

As he drove away from the DeMenil mansion he was extremely satisfied. It sure was a difference examining the books in such a pleasant atmosphere compared to the conditions at the Washington workshop. He planned on returning to study the other three books as soon as possible.

Four days later he called Zorina and asked if he could come by and look at another of Mrs. DeMenil's books.

"Actually tomorrow might be a better day, Pete. I've got two people coming over to work with me today, and it would be rather crowded in here, if you know what I mean."

He told her that would be fine, thanked her and hung up. He then decided that since he couldn't look at the other DeMenil books he'd go by and visit with Mr. Washington for a bit.

He arrived at Fred's workshop and for the first time since he'd been coming Fred wasn't working on a project. He was alone at the shop sitting in one of the folding chars just outside the doorway. As Pete parked his car he noticed that Fred seemed to be in deep thought. However, when he looked up and saw Pete getting out of the car, he smiled.

"Hello, Mr. Pete. How are you this fine day? I suppose you want to look at those books again?"

"Not today, Fred," he answered as he closed the car door and walked over

to stand in front of his friend, "I just stopped by to see if you'd take 200 dollars for one of those books."

Pete was surprised he'd said that. The words had just come out of his mouth. He hadn't even thought of that until he'd made the statement.

Fred laughed, took off his ever-present hat and rubbed his head. "You sure have a one track mind, Mr. Pete. Tell you what. I'm feeling generous today. You got a deal. But only one, I still need 500 for the others. And it'll have to be cash, of course."

Pete was totally delighted and surprised at this turn of events. He quickly took his wallet out of his pocket and counted 200 into Fred's outstretched hand.

Book #(PN)2

sketch of
one of Dellsohau's
books -
Containing plates -
Starting from plate # 2301 dated Mar. 22, 1911.
to plate # 2399 dated Aug. 22, 1911.

- CONTENTS OF BOOK -
the above book has 96 pages (or plates)...
Some of the information on those plates
have already been listed elsewhere. (see.
pages 89 - 96, Book XIII). Additional
information follows:

Fig. 6.1. Drawing of the first Dellschau book P.G. Navarro bought from Fred. Washington.

Once Pete arrived back at home he went into his study and sat down at the desk with his first Dellschau book before him. For several minutes he simply sat quietly, staring down at the book. Then he slowly and carefully opened the cardboard cover. Pete stopped and took a deep breath. These books might have answers to the long list of questions Pete had accumulated in his mind. He very carefully began to examine the book in detail. Later he recorded the

information in one of his growing number of journals.

> *The plates (or pages) are bound between covers of heavy cardboard which is reinforced with more cardboard along the edges, then sown together with heavy thread. The cardboard seems to have come from boxes (probably from Stelzig's Saddlery store). The binding is held together with shoelace material. There is also a heavy string with a metal washer tied to the end that looks like it may have been used as a bookmarker.*
>
> *The inside of the front cover is lined with purple-colored cheesecloth. A blue shoe lace is inserted on the front cover near the binding … Its purpose is not quite clear to me but it looks like it might have been intended as a sort of handle.*

After several hours of examination, Pete put his treasured book away and returned to studying the information he'd compiled from the first of Mrs. DeMenil's books. Unrealized by him at the time one of the first items he'd come upon and copied from the largest of Dellschau's books was the first half of the key to the code system. It was located in plate 1637.

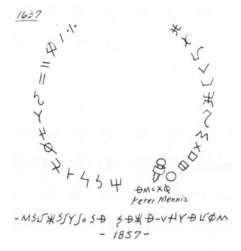

Fig. 6.2. The "symbol" half of Dellschau's code was located in plate 1637.

He had thought it was just another of Dellschau's fancy notations in code.

On February 24, Pete returned to Mrs. DeMenil's house to continue his examination of her books. Zorina was not there when he arrived, but Mrs.

DeMenil's personal secretary gave him permission to go into the collection room and look at them. He spent about two hours perusing the remaining three books but found no news clippings which made reference to the mystery airship sightings.

However, he had found lots of other data among Dellschau's notations, drawings and news clippings that he found absolutely fascinating. One of the most intriguing illustrations from any of the 12 books was located on the first page of the second book he'd examined in the DeMenil collection room.

There was no plate number for this drawing, which appeared to be some kind of emblem; the center piece was comprised of Dellschau's code symbols. The significance and interpretation of this emblem was still very enigmatic, although he was sure that the tail feathers in it must signify flight. Pete realized that there was no more putting it off. He had to tackle the "Big Question" to get any further into Dellschau's secrets. He had to work on and break the code.

With that in mind he called his brother Rudolph and told him of his purchase of one of Washington's books. He also invited him over to the house to examine it and help him work on the code the following weekend. Rudolph agreed.

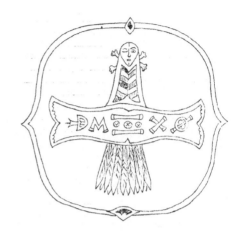

Fig. 6.3. Unnumbered and enigmatic coded symbol from Pete Navarro's field journal #XV, page 41.

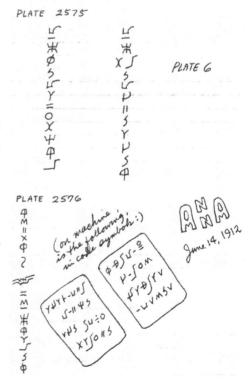

Fig. 6.4. More of Dellschau's code from plates 2575 and #2576.

CHAPTER 7

Another Mystery Solved

I don't think Dellschau was an Engineer able to design an actual flying machine. I mean, he was a good draftsman all right, and some of his stuff was way ahead of his time. But, what he drew was only fancy ideas.

—Tommy Britton

HOUSTON, TEXAS, 1970

Pete decided to let the code rest until Rudolph came over the next weekend. The next morning he got his camera, climbed in his car, and drove over to Miss Helena Stelzig's house on Stratford Street. He was hoping to get her permission to take some pictures of the house and maybe even an interior shot of the room where Dellschau used to work.

A lady Pete had never met before answered his knock. She appeared to be in her early 40s, and was quite charming.

"Can I help you?" she asked pleasantly.

"Yes, I'd like to speak with Mrs. Williams please."

The lady smiled, "Wait right here, I'll get her."

Mrs. Williams came to the door and as soon as she realized who Pete was said,

"I don't have anything else to tell you that I haven't already told you."

Pete smiled his most charming smile. "No. No. I didn't want to ask you any questions. I just wanted to ask permission to take a couple of pictures of the house and maybe …."

Before he could finish and without another word, Mrs. Williams turned and walked away leaving the door partially open. Pete heard her call the name "Helen."

The lady who had first opened the door returned.

Once again she smiled at Pete pleasantly as she came out on the porch closing the door behind her, "I'm Helen Britton, Helena's niece, how may I help you?"

Pete told her of his interest in Dellschau and explained his views regarding Dellschau and his work.

'Yes. I know all about those books. I found them to be quite intriguing myself. What did you want to know?"

"Well, something that puzzles me," Pete said, "was how did they end up in a trash dump? No one seems to know, or will admit to knowing how they got there."

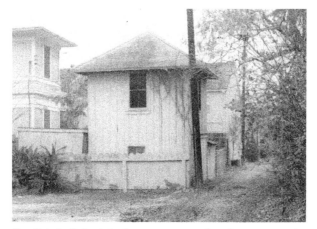

Fig. 7.1. Dellschau's books were once stored in the room over this garage behind the Stelzig house.

Mrs. Britton smiled. "I think I can answer that question for you. From what I understand, my younger brother Tommy found some of those books in the room above the garage back there behind the house and took them over to his house on Taft Street. According to Aunt Helena they must have been thrown away after there was a fire over there and a crew was sent to clean the house. Aunt Helena is positive that they weren't thrown out of this house, although she admits that the room over the garage had been cleaned up once and a lot of stuff discarded. But it is the family's belief that they were thrown out from the house on Taft Street. At any rate, those old books sure do seem to be causing quite a lot of excitement."

"What do you think of Dellschau's art work?" Pete asked curiously.

"I think grandfather was somewhat of a genius, always have. I always thought that what he drew and wrote about was way beyond his time. Unfortunately, no one seemed to notice or realize that back then. Most of the family just thought of him as an eccentric who whiled away his time drawing pictures of imaginary airships."

Mrs. Britton was silent a moment as though reflecting on what she had just said.

"You know I had a long talk with Aunt Helena about grandfather because of all the rigmarole over his books. She told me she has a Bible that belonged

to grandfather Dellschau. She said it contains the only history of the family from that far back. She also said there are other books in the rooms above the garage. Some contain more of his drawings and some are diaries which she said explains what the drawings and his writings are all about."

Pete immediately wanted to know more about these books that no one else seemed to know existed. He was aware from his studies of the 12 books he had looked at that there was the very real possibility that more picture books existed … but to think that there were possibly diaries that explained everything was very exciting.

"Do you think it would be possible to look in that upstairs room for those other books?" Pete asked.

"No, I'm sorry. Aunt Helena is very frail and has a hard time getting around. Unless she feels well enough and strong enough to go to the garage room herself, no one can go up there. She is very old and you know how old people like to protect their privacy. She'll probably let you go up there sooner or later though, when she feels better and can find the time. It takes a little time before old people decide to do things, you know.

"You might want to talk to Tommy though. He lives over on Taft. He might know where there are some more books. Be sure and tell him what you have learned and about the secret codes. He might not be aware of their importance. He's somewhat of a scholar and might be interested in knowing about these things. Give me your phone number and I'll let you know if I find out anything about the other books."

Pete could see that she really did feel bad about not being able to let him go into the back rooms, so after giving her his phone number and getting Tommy Britton's address from her, he thanked her and returned to his car. Glancing at the slip of paper she had given him Pete was surprised to notice that Britton's address was located only a few doors down and across the street from his graphic arts company. What a surprise!

That night he called Tommy Britton. A young male voice answered the phone.

"Can I speak to Tommy Britton please?"

"Which one?" The young voice asked, "I'm the son, Tommy Jr."

"Must be your dad then," Pete answered. He was pretty sure the voice he was hearing was too young to be the person he wanted to talk to.

"Just a minute." Then Pete heard the young man holler, "Dad, you're wanted on the phone."

After a couple of minutes an older voice came on the line. The voice sounded like a good-natured person and seemed to be interested in what Pete had to say. When Pete told him he was calling in regards to C. A. A. Dellschau,

whom he believed was his grandfather, Tommy said, "He was an in-law." After a short pause he corrected himself and said that Dellschau was actually his "step-grandfather."

"Did you ever take some of Dellschau's books from the house on Stratford Street?"

"You mean my Aunt Helena's house? Yeah, I took some of them. I don't recall how old I was at the time … maybe seven or eight years old. They were stored upstairs over the garage at my Aunt's place. I figured I was the only one who was interested in those old books, so I took them home. I always did like to collect books and I still read a lot. I took them to my mother's house which is two doors down from where I live now."

Upon hearing the address of Tommy Britton's mother's house, Pete was totally taken back. The house he was talking about was directly across the street from his place of business.

This is too weird, Pete thought, *this stuff is sure getting close to home.*

Pete explained that they had ended up in a dump and now there was a lot of interest in them.

"They must have gotten thrown out when they cleaned my mom's house," Tommy said.

Wow, Pete thought, *if I'd walked out the front door of my building the day they were put out for the garbage truck and seen them in front of the house, I probably would have gone over and looked. I could have had all of them right then.* Pete felt this was the strangest coincidence yet in the whole scenario of Dellschau's books.

Pete shook his mind off his private thoughts. "What do you remember about Dellschau?"

Tommy told him that he remembered that his Aunt Helena used to go into town to the art store to buy watercolor paints and other supplies for him.

"If I remember right she studied art at one time, but I don't think she ever helped him with his drawings," he said. "She just had a big heart."

He also told Pete that he used to see Dellschau whenever he visited his aunt's house.

"Dellschau never talked to me much," he explained. "Although he didn't seem to mind me entertaining myself by looking at the books and drawings."

He remembered Dellschau as being a thin person and described him as being "sloppy." He said Dellschau seemed to have some kind of nasal trouble; his nose dripped constantly. He also informed Pete that Dellschau didn't have a mustache when he knew him, although he had seen an old picture of Dellschau when he did.

"You know, there is a possibility that the drawings he made might be

designs of actual airship models," Pete informed Tommy.

"Nah. I don't think so. I don't think Dellschau was an engineer able to design an actual flying machine. I mean, he was a good draftsman and artist all right, and some of his stuff was way ahead of his time. But what he drew were only fancy ideas. I do think the old man had a gift of some kind and that he had a very advanced and active imagination. But his drawings were just imaginary."

After a few more minutes of talk, Pete thanked him and hung up. He'd gained a bit more knowledge about the man Dellschau. But what he couldn't get over was the fact that Dellschau's works had never been moved more than a short distance during their existence. It didn't have anything to do with the mystery he was exploring, but it was a piece of interesting information.

Fig. 7-2. Map of area involved in the Investigation of Dellschau and his work. Map by P.G. Navarro.

Chapter 8

Pete Breaks the Code and Fred Washington Gives In

Mr. Pete, I sure do hate to let them go ... I think that someday Dellschau's drawings are going to be worth a fortune. But sometimes today is more important than tomorrow. And besides, if anyone deserves them, you sure do ... looks like them old books is finally yours.

— Fred Washington

Houston, Texas, 1970

The following weekend Pete and his brother Rudolph retired to Pete's study as soon as they could break away from the family. After Rudolph had a chance to look through the book that Pete had bought from Fred Washington he became as excited as Pete.

"Now I see why you have become obsessed with these books. I'm like you. We've got to break this code and see what it's all about," he stated as he studied one of the pages with Pete's large magnifying glass. Although he'd taken some of Pete's material home with him he'd not had any success with the code either. After Rudolph had gone home with his family, Pete decided he was going to break this code or else.

Over the next few weeks Pete and Rudolph discussed the possibility that a lot of the information pertaining to the workings of the aeros and the men who designed the unusual flying craft was hidden in the symbols and anagrams located quite extensively throughout his books. They began to offer each other their individual interpretations of some of them. Many with logical connections were easy to decipher; the men were reasonably certain they had figured out their proper meanings. But they also began to suspect that many others were only decorative.

Rudolph suggested that a large number of the designs or vignettes might be of a nature akin to ancient symbolic writings. "It's possible these ancient symbols make use of graphics that can possibly be translated by someone who has studied such writings," he said.

One of the most widely used symbols in the book was the **X** within a circle. The **X** was one of the first symbols in Dellschau's book that Pete considered as deciphered. Rudolph was in agreement with his brother that the **X** stood for *Aero*.

It also occurred to them that the circled **X** might possibly indicate a body or mass which might be moved by the application of force. The symbol for that unknown force was the circled **V**. This symbol appeared along with the circled **X**.

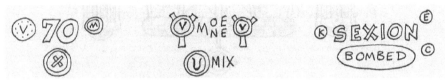

Fig. 8.1. Example of circled X, V and other letters.

Of course, Pete and Rudolph both agreed that this was only conjecture on their part and a completely different meaning was possible. They were positive, however, that the **X**'s and **V**'s had some significance in Dellschau's work.

Fig. 8.2. More examples of circled letters.

In plate 2612 Dellschau gave the **X** special prominence by inserting it within the ciphers, which Pete was almost positive, stood for the Aero Club.

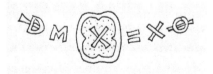

Fig. 8.3. Circled X inserted in center of
ciphers Pete felt stood for the Aero Club.

To add to the significance of the use of the **X** in the above cipher Pete noted that the **X** here was in a more-or-less frame, while elsewhere throughout his work, Dellschau usually enclosed the **X** in a circle or double circle; sometimes

having a series of dashes or dots all around it as above the drawing of a skull and dagger that Dellschau displayed on plate 2613.

Fig 8.4. Circled X with Skull and Dagger

There was further reason to believe that the circled **X**'s and **V**'s have a special meaning as Pete found many other symbols and letters circled throughout Dellschau's work. Many were used in conjunction with other figures or numerals which surely must have conveyed some kind of message.

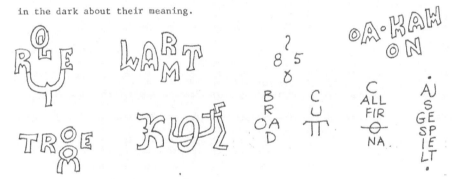

Fig. 8.5. Some examples of anagrams from Dellschau's drawings. Some are easy to read while others have never been deciphered.

Pete also noted that Dellschau seemed to have delighted in using a multitude of self-designed anagrams or acrostics in the telling of his story. Words or phrases in which the letters have been transposed or put in positions that would make it difficult to read the words.

Putting everything else aside, Pete started studying Dellschau's code in minute detail. He had already assumed that the Sonora Aero Club had to be a secret brotherhood, or possibly a branch of a secret society. He first made a search of esoteric writing samples of known secret societies. While he found a resemblance to some of these characters, it was obvious they were not the same.

Fig 8.6. Dellschau's symbol for the letter "E".

After several days of trying all different combinations he realized that one of the symbols appeared more often than any other. He was positive that this symbol represented the letter "E," the most-used letter in the alphabet. Finding

the symbol for the "E" was the crack in the code Pete had been searching for.

However he had not been able to figure out any of the other symbols until he came upon a notation which consisted of a group of eight symbols using only four of Dellschau's distinctively different symbols. There was a group of three, a space, and then a group of four. The symbols were under a heading reading *Press Blooms.* which was Dellschau's name for news clippings. Realizing that Dellschau had a habit of writing in scathing remarks regarding the subject of news clippings, such as *Hum Bug* or something to that effect, Pete assumed that two groups of symbols must contain some such similar remark. After studying them for awhile he came to the conclusion that the message must contain two words. And that these two words must be *NON SENSE.*

Pete was positive that *non-sense* was the proper decipherment of these coded words, since they reflected some of the opinions and comments that Dellschau had used throughout his books in reference to certain news accounts. He was positive that the other symbols, besides the one representing the letter "E" were the letter "N," the letter "O," and the letter "S." Pete sat back in his chair and smiled to himself. Not only had he finally identified four of the symbols, but also established something he had believed to be true about Dellschau's code all along. It was a substitution code. The letters of the plain text were replaced by certain symbols. Once he had discovered these four replacement symbols it was a relatively easy matter to decipher the rest of the symbols in Dellschau's code. Pete stayed up until the wee hours of the morning working on and deciphering Dellschau's complete coded alphabet, including symbols denoting repeat or double letters, others used for punctuation and some that represented the sounds of certain German prefixes.

There was one more thing he wanted to do before he put the books aside

Fig. 8.7. The above symbols are featured on almost all of Dellschau's drawings. Translated, they become NYMZA.

for the night. He pulled out the Dellschau book he'd bought from Washington and opened it to the first page. His eyes fell on the symbols that appeared on almost every plate. Pete quickly made a duplicate sketch of them in his current journal.

Next, using the key to the code as his guide, he translated the symbols into letters. They turned out to be a series of letters, which he wrote under the symbols. NYMZA. He looked at the weird word. Was it an acronym ... some kind of initials? He was too tired to work on it now, but he was pleased with the night's work. He'd finally broken the code. Dellschau's story was his.

Pete sat back and looked at his handy work. It had all been so simple that after the first four letters he felt foolish for not being able to figure it out sooner.

After a few minutes he yawned, switched off his desk lamp and went to bed. Yet something was bothering him. As tired and sleepy as he was, he couldn't go to sleep. What was it?

Suddenly he sat up in bed. He quietly got out of the bed, being careful not to wake his wife Millie who had been sleeping for hours, and returned to the study. After turning the lamp back on he quickly leafed through one of his journals. There it was. The page he'd copied from Mrs. DeMenil's first book. He'd had it all along … the symbol key to Dellschau's code. He quickly filled in the letters each symbol had replaced.

The date was March 11, 1970. It had taken 15 months to break the code. *Now the work starts*, Pete thought. *Translating all those paintings into what Dellschau had to say isn't going to be easy, but we'll do it.* He almost laughed as he walked back to his bedroom and quietly slipped under the covers beside Millie. *Dellschau, I will know your story.* Life was good.

The next day Pete decided to share what he had found with Fred Washington, so he drove over to the workshop. When he walked into the cluttered building he noticed Fred was sitting in one of the chairs looking gloomy.

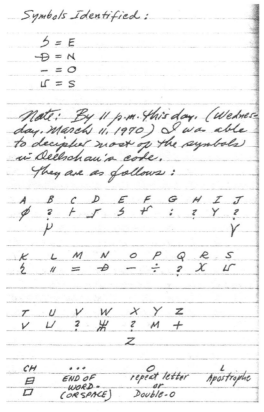

Fig. 8.8. The Key to Dellschau's Code from Pete Navarro's Field Journal.

"How you doing, Fred?" Pete asked as he sat down in the other folding chair beside Fred.

"Not too good today, Mr. Pete, bills due. No money."

"Oh, I'm sorry to hear that. I just dropped by to let you know I finally

broke the Dellschau code."

"Hey, that's good to hear. You've been working hard on it for a long time, so I'm glad."

Nether man said anything for a minute. *He sure looks down*, Pete thought.

"Fred, would 500 dollars help you out of your predicament?" Pete took out his wallet and slowly removed five 100 dollar bills from it.

"It sure would," Fred said, his eyes never leaving the bills Pete was holding in his outstretched hand. "What do you have in mind?"

"Even though I can't really afford to do it, I'll give you 500 for the remainder of the books."

Fred took his hat off and rubbed his head, then replaced the hat. He didn't say anything for several minutes.

"Mr. Pete, I sure do hate to let them go for that. I think that someday Dellschau's drawings are going to be worth a fortune. But sometimes today is more important than tomorrow. And besides, if anyone deserves them, you sure do."

Fred reached over and took the five, crisp 100 dollar bills out of Pete's hand.

"Mr. Pete, looks like them old books is finally yours."

With all eight books now in his possession, and having access to the DeMenil books, it would still take Pete several years to piece the story together. The secretive Dellschau still had a lot of tricks up his sleeve. Sometimes he would start a sentence on one plate then skip a few plates and finish the sentence on another. Much of the hidden writing was in German. Pete decided his next move was to have the German translated.

Fig. 8.9. A page from Pete's journal showing more of Dellschau's coded writings.

64

CHAPTER 9

German Translations

[Dellschau's written] German shows a decided foreign element that is not natural for a German speaking his native tongue.

— Mr. Walzem, Dellschau's German
writings translator

HOUSTON, TEXAS, 1970

The oldest of the Navarro brothers, Roy, had also been bitten by the Dellschau bug. In April he came to visit Pete. Pete showed him the Dellschau books and some of the coded passages he and Rudolph had been able to decipher, which were in German. It was then that Roy mentioned Mr. Louis Walzen, his drafting instructor when Roy worked for the Pacific Railroad, who now was learning how to do electrical diagramming.

"Maybe he can help us. Not only is he of German-Lithuanian extraction," Roy explained, "and speaks German, but he is also acquainted with German script."

Roy knew this because the instructor, when teaching the class how to put in the specifications and other information on the electrical diagrams, had even showed them (as a matter of comparison) what German script looked like.

Roy suggested that perhaps they should contact Mr. Walzem as he might agree to translate some of the German writing in Dellschau's books. He arranged an appointment with Mr. Walzem for the following Sunday.

Pete and Roy arrived at Mr.

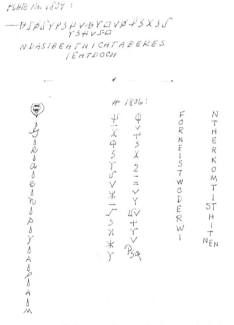

Fig. 9.1. Dellschau's code once broken, included messages in German.

Walzem's house at around five that evening. Mr. Walzem and his wife were engrossed in watching a TV program when they arrived.

"You fellas mind waiting until this show is over before I take a look at what you have?"

They told him they didn't mind and joined the Walzems in front of the TV set. They ended up watching two 30-minute shows. Pete was beginning to wonder if they would have to watch TV all night when Mrs. Walzem came to their rescue by turning to her husband and saying, "You better turn the TV off."

He turned the TV set off and asked them to go into the next room where he and his wife cleared the dining room table. Pete placed the Dellschau book he'd brought with him on the table. Then the four of them gathered around and started to study the pages which contained the German writing. It was not an easy task for Mr. Walzem or his wife (she also knew German) to read the script for some of the writing was very faded. Besides that, Mr. Walzem told them, a lot of the writing was in a more ancient style of script than that which he was acquainted with.

It has already been established that Dellschau's language was difficult as well as deficient, but the content and meanings of most of his notations seem to be clear enough. There are several passages, which are definitely nebulous, and it is hard to understand what he is trying to convey, but that may be due to the fact that he wrote in riddles. He would write incomplete messages, which are actually small portions of a larger message. The small, incomplete messages would then be spread out over several plates and appear to the casual examiner only as fragments. However, if you take the time to put these fragments together you can get the whole message he was conveying.

Even so, neither Mr. Walzem nor his wife were able to give the Navarro brothers a complete translation of any of the passages from several of the pages. They also had difficulty in identifying certain letters because of the peculiar way in which they were written. Another reason was that they did not understand the meaning of certain words, which Mr. Walzem thought might be peculiar to the time when the author lived the events in the book, e.g., slang words. Another problem, he explained, was that the language used by Dellschau was "archaic" German. Besides that, it was written in what they claimed was "crude" language.

"Many of these letters are done in a matter that is now obsolete," he explained. He told Pete he needed a German dictionary, but unfortunately he didn't have one. However, Pete could see that the German couple were trying hard to translate the passages. Mr. Walzem was scanning the writings with a large magnifying glass, although his wife needed no such assistance.

Mr. Walzem was 83 years old but very spry for his age. It seemed to Pete that he and his wife were a very congenial and affable couple, but they seemed to be having a problem agreeing on the contents or meaning of some of the notations. Mr. Walzem said that one of the passages seemed to be a letter written perhaps to his (Dellschau's) mother. He didn't tell them what the letter said. Pete found out later that Mr. Walzem was reluctant to give the brothers a complete translation of many of the notations because he thought they were too vulgar.

"What amazes me," Mr. Walzen remarked as he studied one of the drawings with his magnifying glass, "is how much this looks like NASA's Lunar Module."

Pete, looking over his shoulder, noticed that he was looking at plate 1910, a drawing of the Aero *B* which had a landing gear which retracted upon contact with the ground either through the use of a hydraulic system or some sort of spring action. Pete had noticed this before. The Aero *Honeymoon* was another drawing that also gave this impression.

It was getting late, so Pete agreed to let them keep several pages from the book and give them time to read the German notations at the couple's leisure and try to figure them out.

Pete returned to the Walzem's two days later and left a German-English dictionary to help them with their translations. He waited a week and then called Mr. Walzem to find out how it was coming along.

"I'm sorry Pete," he explained, "I've been very busy with other things and haven't really had time to give those pages the attention I want to. We're also having a hard time reading Dellschau's old style of writing, but I am curious myself and will get to it as soon as possible. I'll call you as soon as I have something definite."

Six days later Pete received a phone call from him.

"Good news Pete. We've been able to translate some of it, why don't you come on over later today."

Pete arrived later that afternoon to find Mr. Walzem raking leaves in the front yard.

He leaned his rake against the side of the house and greeted Pete with a smile. "Come on in and I'll show you what we've been able to read."

The page he'd been working on was still laying on the dining room table

According to the Walzens, Dellschau's German seems to be a bit stilted, as though it was not his original language. Although it may have been the language he spoke, they felt it might have been that he had adopted German as his second language.

"His written English shows a definite German style, or accent, in his

pronunciation and use of the language. Even his German," Mr. Walzen explained, "shows a decided foreign element that is not natural for a German speaking his native tongue."

Mr. Walzen, who was an electrical engineer, said his personal impression of Dellschau was that, although he may have been a good artist or draftsman, he evidently did not have enough technical knowledge to write things down well or accurately. He also thought that Dellschau wrote in a vulgar and silly manner because he was either uneducated, or because he was trying to inject humor (although it was a rough type of humor) into his narrative. The spelling was also bad, he complained, even in German.

He and Mrs. Walzen showed Pete some of the translations they had been able to do, but admitted they had left parts of some of the passages untranslated because they felt what was in them was "not nice." Mr. Walzem said that they contained some "pig filthiness" which he did not care to translate.

The following are a few of the translated writings.

From plate 1901:

> In the old times … the warrior used a circle, a man lance and … in the country the bow and arrow. When war say deathknell was upon land and water! And today are censored.
>
> You Christian beings haters. Cannon and small guns in war, on land and wave! Give me quick an airplane sublime … the enemy's may destroy.
>
> You Christian love – hard to understand on violent Earth. The enemy 'thrashed.'
>
> If it happens from under or above, the bad middle let us praise! So it was as long as there were people! You Christian love reach for the wanderplace, and wander away from earth. Planets there are enough where Christian love shall be as we say so nicely in Book Selag.
>
> The trip costs a lot of money, and also borrowed money. We go when it pleases us and when it is safe. Whoever goes … and that is the way … For over and through the blue there is no way. There is no way, _____ are alone. Being alone you sit at the rudder. Say you long for the world, dear Luder. Show the line before you. You pull it hard and so it will be. Then down it will come to Mother Earth.
>
> Let the big men beat themselves with clubs or air balloons. There we have nothing to say. Then we have nothing to say. Then each makes the living from it. I must have my say so. The little

people will stay with us … and the good says the teaching. Money quiet the fight, and first with war balloons. Therefore everything more than ever toward new machinery. My Aero Honeymoon. The above does the marriage. One with passenger … cat, woman, and man, with only his provisions."

As can be seen from the above, there still remains a lot to be clarified and better interpretations to be made. Here are a few others:

> *Ah the very fine cannon has spared us dear people. What fright I have received. Luder, we are safe now that we have been spared by the bullets. Yes, the clouds weakened their path.*
>
> *Sir, the sailors here Gekisher (was hysterical). He was loud, but not as the crow or rooster. Now, after a few years, this will become a legend. The noble men will know what an Aero they have flown. Not us. The fog-horn has saved many a word.*
>
> *I have plated this machine, not like FOB, with his wet gliders. As given in our gliders, and so go better and faster.*
>
> *Again … on … up to heaven's path!* (plate 1904)
>
> *Robert (Nixon) you are right … Dr. Weisbach can fly now.* (plate 2615)

Once Pete studied the extracts from Dellschau's German language notations, he noted that most of them were written in a mystic and rather philosophical tone. Even those that have been written in English, despite the bad spelling and grammar, seem to have a quality that bespeaks of unfamiliarity with either language. Perhaps this was done with a deliberate intent to confuse.

This posed another mystery.

FREWILISCH SEIN FRET SUDIREN
SOLANG ICHCAN LASTDIED EUG
IERIG NRATFEN WEHRSRRA
ET DE L GEHŠRTDER PREIS.

⸺

YOU UIL WUNDER UEIER DIE SECHAIFT
ENTRAETSELTIHR MEIN STOIOEFWIS
SENGEHTZUEN DEWIE ALLESANDER
ETEDOCHICH WILL VERSWCHENZU
WETZOU

ARBEITEN

In Plate No. 2047:
Translation of coded message may read:

ONE VOLUNTEER FELL AND BURNED, So
I CAN REPORT BY INSTALLMENTS
THE COST.

OR

ONE VOLUNTEER FELL AND BURNED, So
NOW I CAN, PIECE BY PIECE RECORD
THE COST.

Fig 9.2. German messages translated from the Dellschau code.

Press Blooms

As actual historical aviation achievements took place, Dellschau incorporated these accomplishments into his notebook pages in what he termed 'press blooms.'

— William Steen, Frame Maker, The Menil
Collection of Fine Art, Houston, Texas, 1998

HOUSTON, TEXAS, 1970S

One thing that the scrapbooks contain in profusion is newspaper clippings from both English and German language newspapers. Dellschau entitled the pages, or plates, containing news clippings *Press Blooms*. Some of these clippings contain interesting and enlightening information of special interest to students of aeronautics or aeronautical history. Examples of these news clippings show not only the interest Dellschau had in things aeronautical, but also his interest in anything that was strange or out of the ordinary. Why Dellschau used news clippings in his drawings is unknown, but they may contain clues that might add pieces to the overall puzzle. For that reason we have added several of the most unusual.

In plate 2368 Dellschau included the following news clipping:

Escaped In Balloon
Daring Pickpocket Deluded Officer By Sojourn In The Air
Sayre, Okla. July 1 – A pickpocket closely pursued by the town marshal leaped into the basket of a balloon near here today just as the aircraft was leaving the ground and [the thief] sailed away to safety.
The balloon had been filled with gas and the aeronaut, George Harvey, was in the basket ready to start, when the marshal discovered the pickpocket taking a purse from the pocket of a citizen whose attention was centered upon the balloon. The marshal attempted to catch the thief and the pursued man ran and leaped into the basket as it cleared the earth. At the height of several hundred feet the thief drew a revolver and warned Harvey not to release the ripcord until he was ordered to do so. After the pair had traveled fifty miles the

Fig. 10.1. A page of Dellschau's book featuring "Press Blooms." Photo by P. G. Navarro.

unwelcome passenger gave the word and the balloon was lowered.
Ten feet from the ground the thief leaped from the basket and ran.

A newspaper clipping in plate 1814 from the *Kansas City Times* dated 1908:

> *What The Helicopter Is*
> *The machine that Edison says will solve Aerial Navigation*
> *Inventor calls it the Aeromobile*

From plate 1803:

> *The birds laugh at man's aviation except the owl, who is nodding wisely, knowing from the fishes that man, who invented sea ships can invent airships"*

Plate 1801 contains a cartoon showing a postman flying across the ocean with a two-cent stamp holding up the craft; this caption reads: "An airship that works."

In plate 2340 is a very interesting news clipping dated May 21, 1911:

Mystery of High Seas
Liner Celtic Passed supposed Remains of Airship

Queenstown – May 20 – The White Star Liner Celtic, which arrived here today from New York, reports having passed the supposed remains of an airship yesterday in latitude 45.51, longitude 25.10. This was estimated to be 618 miles west of Eastnet. The only airship not reasonably accounted for is the dirigible America, which Walter Wellman and the five members abandoned last October in their attempted flight across the Atlantic. Wellman and his men were picked up 450 miles east of Cape Hatteras by a steamer.

It should be noted that the reported location of the airship's remains mentioned is in the middle of the area known as the Sargasso Sea, the long-acclaimed graveyard of ships. Also stated in the news story was the fact that the crew of the airship was picked up 450 miles east of Cape Hatteras, North Carolina. Both the Sargasso Sea and the area where the crew were rescued lies within the area popularly called The Bermuda Triangle, a triangular-shaped area that extends from off the coast of Florida through the Caribbean to Bermuda. This area has been reported to be a mysterious place where many aircraft and ships of all sorts have reportedly been disappearing without a trace for many decades.

The crew abandoned the airship *America* in October 1910. Yet the wreckage of the airship seen seven months later was reported to be some 500 miles farther east of that location. The problem is that the ocean currents in this area move northeasterly and the wind blows westward in the mid-Atlantic Ocean. Was the reported airship remains actually from the *America*, or was it something else that was seen?

The above incident gives food for thought and reason to speculate upon other items that are to be found among the news articles collected and included by Dellschau in his books.

Dellschau inserted the following newspaper report into his artwork in plate 5102:

Paris Postcard May Prove Clue To Missing Ship

Washington – June 24, 1921 – a clue which may reveal the facts of at least one of the 20 "vanishing ships" was being followed by government investigators today. A colored postcard mailed from

Paris to the mother of a member of the crew of one of the vessels that disappeared in the vicinity of Cape Hatteras constitutes the bit of evidence. The mother says the writing on the postcard is that of her son.

Investigators today refused to reveal the name of the man supposed to have sent the postcard and asked the name of the vanished vessel be withheld for the time.

Officials point out that the postcard may have been mailed by someone rather than the missing sailor and signed with his name. They probably will ask the Paris police to aid in their investigation.

In plate 5046, dated April 28, 1921, is the following news clipping:

Seaplanes Search For Speedboat And Five Persons

Miami, Fla. April 22 – Seaplanes and boats left Miami at day break today to search the waters between here and the Bahamas for Web Jay, wealthy Chicago broker and a party of four, who were believed to be missing at sea in a small speed boat. The craft left Bemini in the Bahamas Sunday for Miami.

There is also a news clipping in one of the few pages of Dellschau's books that is not numbered. The headline reads: *No Trace Yet Found of George K. Wilkinson Or Other Occupants Of Navy Bag.*

This story tells of the loss of a Navy balloon under the charge of G. K. Wilkinson of Houston, Texas. The balloon had been later found floating in the Gulf of Mexico 20 miles from St. Andrews. St. Andrews is about 150 miles east of Pensacola, Florida. No trace of Wilkinson or his men had been found. An interesting coincidence in a story containing many such coincidences is that Wilkinson's father, J. W. Wilkinson, lived at 206 Stanford Street in Houston. This was just one block from Dellschau's residence at 306 Stanford.

In plate 5054, dated May 1921, there is a news clipping that tells of a ray that could be used to lighten metal and would replace radium. The story reads:

Odic-Activity Ray To Conquer Air, Replace Radium, Discoverer Declares

Pasadena, Cal. May 16 – The Odic-activity ray, more powerful than the x-ray or the radium ray is to completely conquer the air …
The story goes on to tell of how *"the giant sky-liner, equally*

luxurious and comfortable as an ocean liner, could be a possibility and probability of the near future. This was claimed by Professor Edgar L. Hollingshead of Pasadena, California, discoverer of the ODIC-ACTIVITY RAY, which will make metal light as a bubble and may take the place of radium for medical purposes.

"It has the property of causing a change in the weight of metal and had caused it to become permanently cold … beyond the possibility of it ever being heated.

"It makes opaque rocks transparent and photographs can be taken through a solid sheet of lead by using these rays. It has also changed water, instantly, into its primary gases – hydrogen and oxygen.

"Applied to metal, it makes it lighter than air and does not lose any of its strength … and may be used to "build the sky-liner" of the "near future" according to Hollingshead … "and the cost is trifling."

Another interesting story about scientific discoveries that Dellschau used in one of his plates tells of an individual who had apparently discovered principles of perpetual motion. This news clipping is to be found in plate 1983. Parts of the yellowing newspaper clipping was missing and some of the words were not legible, but Pete was able to get the gist of the printed article.

Big Industrial Revolution Is At Hand If This Invention Pans Out As Per Claim
Air The Only Power Needed
Goodbye, Says Busby, To Coal, Wood, Oil and Other Fuel

Cincinnati, Ohio – Aug. 28, 1909 – Busby, formerly of Birmingham but who has recently made his home in Cincinnati, has just been allowed a patent in Washington on a device which he claims will revolutionize the world's industry. If Busby is able to substantiate his claim, and he has sheaves of testimonials and comments … to back his story and opinions … he has discovered the long sought principles of perpetual motion. The latter is, however, a term that he eschews, because he says some ridiculous schemes have been propagated under it.

Busby's invention is a system that compresses air and then applied it as power to machinery. He claims that his invention will compress air, and derives its power from the compression of air

itself. It is a system of ... and vacuums through, and into which air is driven and expelled. He asserts that no other form of power is needed and that the future ... through the use of his invention will have no need of oil, wood, nor other forms of fuel.

The compressed air device is attached to any ordinary engine. Busby claims that he has succeeded with compressed air where Nikola Tesla failed with liquid ... Thousands of men have been working on this very thing for yearsThere is no other invention and none in history with so far reaching possibilities.

While it can be seen that Dellschau was most interested in news items concerning aeronautical events and scientific developments having to do with motion, he also had a keen interest in the development of armaments and weapons of war. One item of interest is the article to be found in plate 3228 dated December 16, 1914, concerning a secret weapon that had been kept locked away for 100 years.

According to the article England has three times considered using the dreaded *Dundonald Destroyer*. The report states that both civil and military authorities have revolted at the thought of the "*wholesale slaughter*" that would result from its use.

Supposedly the secret of this appalling weapon is locked up in sealed vaults in the Tower of London and only three people know what it is. It was discovered, or invented, by Thomas Cochrane, tenth Earl of Dundonald, who many considered to be the greatest inventor of his time.

Experimenting with gases and chemicals he suddenly appeared in 1846 before the Admiralty and demanded the appointment of a committee to appraise his new invention. The Royal Committee that was appointed reported that Dundonald's Destroyer would do all that he claimed. However, the report urged that it be kept secret, lest some other power get their hands on it and use it for the annihilation of England.

In 1857 another investigating committee reported that "beyond a shadow of doubt Dundonald's Destroyer would not only defeat, but could also destroy, sweep out of existence, annihilate any hostile force." They further stated that to use such a devastating weapon would be contrary to the principles of warfare. Thus, the formula for its manufacture and operation were sealed up in a vault and was never to be used.

As the aviation industry began to expand, and more and more stories about aviation and aviators began to spread, Dellschau filled his books with even more of the news clippings. It finally reached the point where there were hardly any of his drawings on some of them, with the exception of his usual fancy

borders with which he decorated all the plates.

During World War I he filled some of his books with nothing but war pictures taken from newspapers. Many of these were pictures of aircraft and World War I aviators. One clue as to what is true and what is fiction is the exclusion of any newspaper or magazine articles having to do with the many reports of "mystery airships" during the turn of the 19th century. It seems that somewhere in this collection there would be at least one article having to do with these much written of sightings. Yet nowhere in the 12 books did Pete find a single line devoted to this part of history.

Interspersed among all the news clippings and drawings were notations and cryptic writings from which Pete was able to put together the story of the events that took place in Sonora in the mid-1800s. It was a story that Dellschau obviously wanted to tell, but for some reason was reluctant to write down openly.

Well-known writer/researcher Jerome Clark may have summed it up the best in his article on the mystery airships for *Fate Magazine*:

> *Dellschau was of two minds about what he was doing. On the one hand he wanted his 'secrets' known; on the other he seemed afraid to speak directly. So he compromised and wrote in a fashion aimed to discourage all but the most determined investigator. He was writing for an audience. If not for one in his own day; for one in some future period.*

During the many years of studying Dellschau's works Pete had filled 19 journals with minute notes and exact duplicate sketches of many of Dellschau's renderings. Once he had studied all the notes, he next had to arrange his findings into proper order to make sense out of it all. There finally arrived the day Pete knew just what Dellschau had to say. It was a fascinating story. And Dellschau's "Wonder Weaver," Pete Navarro, was ready to reveal Dellschau's secrets to anyone who cared. But he still wondered, *Is Dellschau's story fact or fiction?* He realized that his quest was far from over.

Part 2

Dellschau's Story

You will … Wonder Weaver … You will unriddle these writings. They are my stock of open knowledge.

— C. A. A. Dellschau, plate 2048

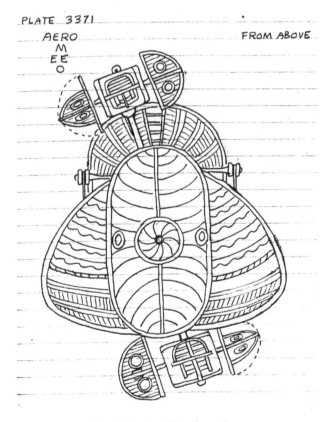

Fig. 11.1. Aero Meeo from above.

CHAPTER 11

America Calling

Gone to see the elephant.

— Gold Rush saying

Charles August Albert Dellschau was born in Brandenburg, Prussia, on June 4, 1830, to Heinrich Adolf Dellschau and Frederike Wilhelmine Franke Dellschau. He was the second of eight children. By the age of 17, Dellschau was already interested in anything aerial.

He spent any spare time he could in a clearing near Muehlberg flying kites, and studying wind currents (or the effect of the wind) upon different types of aeroforms. It is at this early age that he began to envision the possibility of designing and constructing a machine capable of flying and navigating through the air. The young man was not alone in the experiments. He was an assistant to Frederich Wilhelm Schultze who, in 1837, had designed and built the Hydro-wheel auto Dellschau called the *Cripple Wagon*.

Early experiments with kites, as portrayed by Dellschau.

Fig. 11.2 A possible self-drawing of Dellschau as a young man in Germany.

Living close to the city of Leipzig, Germany — a book publishing center — it is very likely that Dellschau worked at and studied the art of book illustrating and binding, and also may have studied drafting. This would have helped him 60 years later when he designed and produced the Aero books.

Just why Charlie Dellschau decided to immigrate to America is unknown. It may have had something to do with the political and financial situation of the German States during the mid-1800s.

In 1848, Germany as we know it today did not exist. The area actually consisted of a group of small individual states, each with its own ruler, monetary system and laws. Many of the intellectuals of these loosely bound German States felt that they would be better off if they united under one flag. With this in mind the more outspoken ones gathered in Frankfurt to voice their opinions towards this goal. The group opted to offer the crown of a United Germany to the King of Prussia. He flatly refused and sent troops to crush this peaceful but illegal movement.

Dellschau could very well have been involved with this peaceful shot at revolution and decided that there might be healthier climes in the United States. Another reason for his leaving Prussia at the time was that after the attempt to unite Germany peacefully, war was sure to follow. Dellschau was fascinated with war, yet throughout his writings stated he was unequivocally opposed to war.

And war did come to Germany. In 1866, Prussia's Otto Von Bismarck beat Austria in a bloody war to gain control and unite the German states.

There is also the possibility that Dellschau immigrated to America simply to make a better life for himself.[1] The United States during the mid-1800s was a major destination for European immigrants seeking a new life. A new nation was being built. Jobs and opportunities were everywhere, and hardworking European tradesmen and businessmen were coming across the Atlantic in droves to get their piece of the pie. And then there was GOLD!

Gold was first discovered in California north of the small Mexican pueblo of Los Angeles beside a small stream in an unnamed canyon. History tells us that a vaquero, while out rounding up stray cattle, decided to eat his lunch under a large shade tree in the canyon. He stooped over to pull up some wild onions he found growing there to spice up his meal. Clinging to the root of one of the onions was a large nugget. (The canyon has since been named Placarita Canyon in honor of his find.) However, the locals kept the find a secret. So the small sleepy Mexican town of Los Angeles remained peaceful.

Not so a few years later, in 1848, when gold was discovered near Captain Johann Augustus Sutter's fort and mill on the American River in Northern California. Captain Sutter had come to the wilds of California with only one goal in mind … to build himself an empire. The discovery of gold ensured his goal and he made sure the word was spread far and wide. Gold in California! From all corners of the world adventuresome men and women heeded the call. The California Gold Rush was on.

Charles Dellschau could have made his decision to try his luck in America for any of, or any combination of, the above reasons. Or he might have traveled to the United States for reasons known only to him. At any rate, 25-year-old

Charles Dellschau, called "Charlie" by friends and family, boarded the ship *Prinz Albert* in Hamburg in 1854 and stepped onto United States soil in New York City on June 24. He was a short man, just 5' 3" tall, with auburn hair, hazel eyes and a fair complexion.[2] His destination was probably Galveston, Texas. According to an editorial published in the New Orleans *Picayune* and then picked up by the Galveston *Civilian* on July 28, 1867, there were more German immigrants going to Galveston than anywhere else in the whole United States.

> *These immigrants,* according to the newspaper report, *were a more industrious, enterprising and desirable population than those debarking at other ports in the Union. Every steamer leaving New Orleans for Galveston was crowded with Germans of some wealth who are going to Texas to select a future home.*

There were several reasons for this. Others, who had come to Galveston and found the population to be more tolerant of foreigners than many other areas of the country, had sent the word back to Germany. In addition, shipping companies had found it in their interest to publish guidebooks in German to be distributed in the German states telling of the advantages of immigrating to Galveston. By coming to Galveston the shipping companies were ensured of a return cargo of much-needed cotton. In fact, according to reports in the *Galveston Civilian* on October 7, 1857, and the Houston *Telegraph* two days later, "*emigration companies*" were formed in Europe to "*capitalize on the desire of Germans to come to Texas.*" One very successful such company was named "*The Texas & German Emigration Company.*" Dellschau was surely aware of all the publicity surrounding Galveston.

The next official word of Dellschau's travels is in the form of an application for Citizenship by Dellschau before the clerk of the District Court of Harris County (Houston) Texas. Houston is located just 50 miles from Galveston.

During the California Gold Rush of the mid-1800s critics called the whole thing a circus. It became popular to say of someone who pulled up stakes and headed for California to get rich that they had "*gone to see the elephant.*" The lure of California must have become too much for the young immigrant from Brandenburg, Prussia, as — according to Dellschau's own writings — the gold fields of California were his next stop. Charlie Dellschau had "*gone to see the elephant.*" He arrived in the boomtown of Sonora, California, sometime in 1857.

At that time the town was located right in the center of the action during California's Gold Rush. Immediately upon arrival in the booming mining

town he became heavily involved with the members of the Sonora Aero Club. The club may have already been in existence when Dellschau arrived, as hints indicate the club may have been established as early as 1855. Again, these suppositions are based on the narrative that runs throughout Dellschau's notebooks; no external, corroborative evidence has ever been uncovered that such an organization actually existed.

The reason for their selection of Sonora as the place to establish their secret club, if such it was, is still obscure. It probably had to do with the amount of privacy the area allowed. Settlers and adventurers were pouring into California from all points of the globe with gold in their eyes and a pan in their hand. Good, hard-working people came, along with outlaws, whiskey salesmen, card sharks and painted ladies. Preachers, bar owners, snake oil salesmen, cattlemen, noblemen and just plain folks came, too. All who made the hard journey to the gold fields had one thought in their minds: a quick fortune and the first transport home afterwards.

California in the mid-1800s was a young place. The formerly Mexican property had been admitted into the United States only five years earlier. There were few rules and regulations, and most of the new residents liked it that way. It was the Code of the West: Mind your own business and leave the other guy alone.

As Stewart Edward White wrote in "Gold!" (1913):

> *The miners did not differ from those of their class anywhere else, that is to say they were of all nationalities, all classes of life, and all degrees of moral responsibility. They worked doggedly and fast in order to get as much done as possible before the seasonal rains. When night fell the most of them returned to their cabins and slept the sleep of the weary; with a weekly foray into town of a more or less lurid character. They had no time for much else, in their notion; and on that account were, probably unconsciously, the most selfish community I ever saw. There was a great deal of sickness, and many deaths, but unless a man had a partner of a friend to give him care, he might die in his cabin for all the attention any one else would pay him.*

Under these conditions, northern California would have been the perfect place for such a group to remain unobserved — if they were careful. Whether Dellschau knew of the group known as the Sonora Aero Club before his arrival is not known. It's very possible that the ultra-secret group known as NYMZA sent him to Sonora for the specific purpose of working with the club. In several

places in his secretive writings Dellschau hints that he was a *"spye."* At any rate he quickly became an important member of the club, becoming both the club's draftsman and historian, again according to his own account.

The entire membership of the Sonora Aero Club probably converged on California for several reasons. They came not only because of the opportunity to enrich themselves, but also because California in the 1800s was an expansive place where such a group could work and experiment and not have to contend with curious people, regulatory laws and restrictions.

Columbia, just six miles north, was used by the group as headquarters for test-flying their aircraft since there was easy access to an area that was relatively flat nearby.

According to Dellschau, the Sonora Aero Club eventually grew to have a membership of some 62 associates. They worked in total secrecy and the rules of secrecy had to be strictly observed. Some (if not all) of them were also members of NYMZA, of which the Sonora Aero Club was but a small branch. Although NYMZA was involved in the financing of the experiments, that money was slow in being allocated to the group.

Members were not permitted to talk openly about their work or the Aeros nor were they permitted to use the Aeros for personal profit. Anyone who went against the dictates or rules of the society was summarily dealt with. There is the case of one member, Jacob Mischer, who was more interested in making money with his invention than he was in adhering to the rules of the society. He wound up dead. Was it accidental, or was he killed? Dellschau never says.

Why were the members so secretive? Assuming they actually existed, it should be remembered that during the 19th century and up until the early part of the 20th, scientists and inventors were prone to keep the results of their research and discoveries to themselves. Because of their reluctance to let others know of their successes, the club members may have missed the boat with their inventions. Once heavier-than-air craft (the airplane) had made its advent into the field it put an end to further expansion of the lighter-than-air craft as a leading type of air travel possibility. Of course, the dirigible and the zeppelin made their brief appearances in the history of flight but they were unable to take the limelight away from the airplane, which was taking one giant stride after another in its development.

Another reason the supposed Aero Club members may not have wanted to have their discoveries or inventions made known was a feeling of obligation. There are people in this world, particularly in the scientific community, who feel that they are able to control, or mold, some of the environmental factors affecting humanity. Some feel they owe a certain measure of responsibility to their fellow man. Consequently, if they feel their ideas or discoveries would

be a contributing factor in causing death and destruction to humanity, then they would rather keep the ideas or discoveries to themselves. At any rate, if what Dellschau claims is true, they were very successful in keeping their accomplishments a secret. But I'm getting ahead of myself. Dellschau's strange tale actually begins in the wild gold-mining town of Sonora, California, in 1856.

The next three chapters are my personal dramatization of the story that emerged from the years of research and study of Dellschau's cryptic writings. The descriptive parts of these chapters in regards to Northern California, Columbia, Sonora, the Gold Rush, and actual happenings during the mid-1800s are drawn from my research of the time and places, and *might* have been what happened. But then the exact details might be completely different. However, all the names used are the actual names of those passed down through history as being there at that time or the names of those involved in the Sonora Aero Club as found in Dellschau's writings. And more importantly, any information associated with constructing and flying the aero's came directly from Dellschau's writings.

Endnotes

1. According to Robert Dellschau, one of Charles Dellschau's descendants still living in Germany, *"For us in Germany, Charles Dellschau was just mentioned as someone who went away from Germany [to find his own luck]. No one in the family ever mentioned his life [after he left Germany] or his famous works."* (From an e-mail letter passed on to the author by Nancy Hixon, Assistant Director/Registrar of the Blaffer Gallery at the University of Houston, from Robert Dellschau).
2. Description from an Amnesty Oath given by Dellschau after the War Between the States (U.S. Civil War).

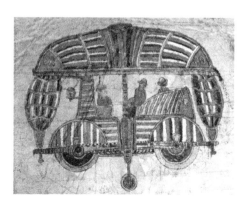

Fig. 11.3. Black and white photo of Dellschau's Aero Homer.
Note piston-action retractable landing gear. From the P.G. Navarro Collection.

CHAPTER 12

The Man From NYMZA

Finally NYMZA is taking the Sonora Aero Club members seriously.

— George Newell

SONORA, CALIFORNIA, 1856

Wells Fargo Agent Gene McDonald stepped out of his small office, pulled a gold pocket watch from his vest pocket and checked the time: 5:15 p.m. *Late as usual,* he thought. *The last stage of the day is always late when I'm ready to go home.*

He looked down Main Street hardly noticing the crowd of mostly men milling around the wooden buildings and canvas tents which made up the downtown section of Sonora, California. It was the summer of 1857. There were estimated to be about 10,000 or more people living in the area. It seemed to the stage-line agent as though half of them were out in the streets. Many were miners who had came to Sonora and her sister city, Columbia, with one goal in mind: getting rich. However, not everyone here was getting dirt under their fingernails while digging for the elusive gold. Gamblers, whiskey salesmen and many others were here to mine the miners, so to speak.

McDonald nodded to George Newell who was leaning up against the hitching rail in front of the Wells Fargo Building. George nodded back. George was not in Sonora looking to get rich. At least not off the valuable metal. Gold had nothing to do with it. His was a different goal.

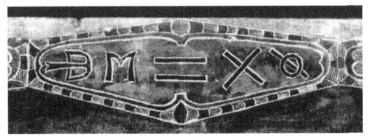

Fig. 12. 1. A half-tone negative view of the coded NYMZA as prominently featured on most of Dellschau's drawings.

At this moment George Newell was also anxiously awaiting the arrival of this particular stage. He had already met all three of the earlier stages. He reached into his shirt pocket and once again unfolded and reread the telegraph he had received four days before.

ARRIVING WELLS FARGO STAGECOACH SONORA JUNE 15TH STOP. PLEASE MAKE ARRANGEMENTS FOR MY LODGING. STOP. WE HAVE MUCH TO TALK ABOUT. STOP.
SIGNED,
CHARLES A.A. DELLSCHAU

George had been waiting for this moment for two years. *Finally NYMZA is taking the Sonora Aero Club members seriously,* he thought. He knew that, with the secret worldwide organization's backing and financial help, they could get on with their experiments and plans for building a flying machine that would astound the world. Dellschau was the man being sent to authenticate their claims and report back to NYMZA headquarters in Germany.

"Here comes the stage!" The shout drew George's thoughts back into the present as the Wells Fargo stage drew up in front of the depot. The mass of people who had been milling around in the street surged forward excitedly. All were hoping for a letter or newspaper from home.

George watched each passenger as they stepped down from the coach. He didn't have any problem picking out his man. Even without the secret sign Dellschau passed as he alighted, George would have recognized the foreign-born representative easily. Sonora was full of German immigrants and they all seemed to dress alike. All seemed to favor a black suit, white shirt and a big black hat. The newcomer was a short man with a serious look on his face. His mouth was a straight line under a newly grown, black, drooping mustache.

"Charles Dellschau?" George asked as he walked up to the stranger and stuck out his hand.

"Yes," Dellschau said. "And you must be Mr. Newell."

"Call me George," Newell said with a grin, "welcome to Sonora."

"And you can call me Charlie," Dellschau answered.

He sure is a serious-looking cuss, Newell thought as they shook hands. *I wonder if he ever smiles?*

"Did you get my letter?" Dellschau asked, getting right to the point, "Did you find me accommodations?"

"Sure did," George answered, "I checked you into the Grand Hotel. You have any baggage?"

Charlie pointed at two bags the driver had just placed on the boardwalk in front of the Wells Fargo office. George grabbed both bags and motioned for Charlie to follow. The two men threaded their way through the small crowd of onlookers. McDonald again nodded at George as he walked by them carrying the large mail sack towards his office. The shotgun rider walking at his side eyeballed the crowd with a sweeping glance.

"How was your trip over from Texas?" George asked as the two men walked the two short blocks down Main Street to the newly opened Grand Hotel.

Charlie shrugged his shoulders, dismissing the three-month struggle across Mexico from Brownsville, Texas, to Mazatlan on Mexico's West Coast and the hard voyage north up the western coast of North America. The whole ordeal was fading from his memory. Charlie's mind was focused on only one thing. *Did this man's group really have a machine that could fly?* He'd already spent time with the groups in New York and Texas and had been very disappointed. None of their claims had been true.

"Tell me, George. Have you really done it?"

George quickly glanced around, but no one was paying any attention to the two men. "Sure have, and tomorrow I'll take you over to Columbia and show you what we've accomplished. But first let's eat a good meal and get a night's rest."

Charlie nodded his head, even though he knew that he would eat little tonight and probably get no sleep al all. If it were true, if the Sonora Aero Club had really solved the secret of flight, tomorrow was going to be the moment he'd waited for all his life.

Fig. 12.2. *Peter Mennis and his dog.*

As the two men were having a quiet supper in the restaurant at the Grand Hotel a bearded man approached their table and slid into the empty chair at their table. He was wearing a bright red shirt and canvas trousers tucked into dusty, black, pointy-toed boots. From his smiling mouth extended a curved pipe. The smell of rich tobacco surrounded him. At his heels was a small black dog. *Cocker Spaniel,* Charlie thought.

"Evening, George," the man said.

George looked up from his plate. "Howdy Pete."

He looked over at Charlie. "I believe this

is the man you want to meet. Charlie Dellschau, say howdy to Peter Mennis. Peter's the man who started it all."

Charlie looked with interest at the smiling man. Charlie knew that Mennis was the man who claimed to have discovered a fuel that would enable a machine to fly. He also knew that Mennis was working on just such a machine.

Even though Charlie's mind raced with a million questions, he held his tongue. The three men sat and ate in silence, while the small black dog sat under the table watching every move Peter made expectantly. Every now and then he'd reach down and pass the dog a small tidbit of food. Talk of the Aero Club and their work was naturally forbidden in public. That went without saying.

They finally got Dellschau to tell them a little about his trip from Texas … the hot Mexican desert … the Indian attack, the bandits … the mule ride over narrow twisting trails through the Cordilleras Mountains. A hundred feet below, waiting for the slip of a mule hoof, wild water and sharp rocks. That quick route down meant instant death to both mule and rider.

Then the sea voyage up the western coast of Mexico and California. Low rations, stormy weather, seasickness and little drinking water. Charlie Dellschau told the story in a matter-of-fact, unexcited voice. More like a report than the adventure it surly must have been.

After their leisurely meal the three men said goodbye in the lobby.

"See you in the morning, Charlie. We'll get started about daylight, if it's alright with you," George said, then turned, without waiting for an answer, and followed Peter out the front door.

The three men were in the saddle before the sun rose over the nearby mountains. Despite his excitement Dellschau had gotten a good night's sleep. Even the sporadic bursts of gunfire from the streets of Sonora throughout the night hadn't awakened him.

Once out of town they started down a winding gravel road that ran along just below the foothills. On every side of the road, as far as the eye could see were signs of mining activities. The sun was starting to heat up, but the crisp, clean air was like a mind clearing narcotic. All three men breathed in deeply.

After several hours of riding up and down several small hills along a well-maintained road they reached the outskirts of Columbia. The mining town looked a lot like its sister camp Sonora except that it was a lot larger.

The town of Columbia, like Sonora, was a bedlam of activity. Miners crowded the streets. Freight wagons from Stockton and San Francisco hurried to and fro carrying all types of goods. The crack of muleskinners' whips, shouts of miners, and random gunshots could be heard. A bell rang in the distance. The boomtown was in full swing.

George led a winding path through the crowd of people and wagons that filled the main drag of town. As the three horsemen reached the other side of town George led them to the right and onto a small path leading towards the distant foothills. About a mile out of town the path turned left and passed between two large boulders. Suddenly two men stepped out from behind one of them. Both had on Mexican sombreros to protect them from the hot sun. Both also held carbine rifles at the ready.

"Howdy, George, Pete," one of the men greeted them as he recognized the two men. Both of the Mexicans looked questionably at Dellschau.

"This is Charlie Dellschau." George motioned towards Charlie. "He'll be working with us from now on."

Charlie nodded at the two men. Both waved back with their free hands.

The three men on horseback continued up the winding trail for a couple of hundred more feet. The path suddenly ended at the foot of a 200-foot cliff.

"Welcome to the headquarters and laboratory of the Sonora Aero Club, Charlie," George said as the three men dismounted.

Charlie noticed the entrance to a mineshaft a few feet away. As he followed George toward the hole Peter stayed behind, reached into a large mesh bag that hung from his saddle horn, and removed his ever-present small black dog. Once lowered to the ground, the dog raced off to sniff some brush to the side of the entrance into the side of the mountain, then followed them into the mine entrance.

As Charlie and his two guides walked into the mine shaft he noticed that it was at least 30 degrees cooler inside. It was actually cold compared to the 100-plus temperature of the outside. Dellschau realized that they were standing in a huge natural cave whose entrance had been widened to look like a man-made shaft. As Dellschau looked around he noticed that part of the enclosure had been partitioned off to make a sort of cabin. Several bunks lined one wall and a kitchen of sorts had been built into one corner. At the far end of this room was a wall made of logs with a wooden door in the middle of it. It was towards this door that George led Dellschau. George opened the door, and gestured for Dellschau to enter first.

Dellschau stepped into a well-lighted room and was totally amazed at what he saw. The laboratory would have done justice to any like it he had ever seen in Germany.

Along one wall was a long table that held beakers and bottles containing all sorts of powders and liquids. In one corner was a small machine, which was teetering about two feet off the ground as it strained at a couple of guy ropes tied to hooks in the cave floor.

Dellschau knew at once that he was looking at a small model of a flying

machine and rushed over to examine it closer. The machine consisted of a small box with hoses running out of it into a couple of balloon-looking devices, themselves connected by additional ropes and pulleys.

"How does it stay suspended in the air like that?" he asked his two hosts standing behind him with wide grins on their faces.

Peter became serious as he explained the weird device to Dellschau. "As you notice the basket is far heavier than those small balloons could possibly hold up with hot air. It's all due to the *NB* gas."

"*NB* gas? Is that the fuel you've discovered?" Dellschau inquired.

"Yes," Peter answered. "Actually I discovered it quite by accident. You see, I'm a mining engineer and experimenter. I was searching for a better way to extract gold from quartz when I left my solution in a small, sealed beaker to go get some lunch. When I returned my beaker was nowhere to be found. I searched under the table and all around. It seemed to have just disappeared. For some strange reason I looked up. And there it was, suspended against the ceiling of my shack. What I had discovered was an anti-gravity liquid. I told George and several of my friends about it and we knocked around a way to profit from my discovery. We decided a flying machine would be the answer. So, we formed the Sonora Aero Club to try and work out the details. We decided to keep it secret so no one else would discover what we knew and maybe build a machine first.

"What you see there, " he pointed towards the small machine, "is a scale model of my first flying machine, *The Goose*. As you can see we've already solved the problem of lift. What we are working on now is a way to make it move in the direction we want to travel.

"But we've run out of money. So George contacted some people in Germany … and here you are. Sunday we'll take you over and show you the almost finished full-sized Aero."

Dellschau was visibly excited. "Why wait until Sunday?" he asked.

"Because," George replied, "We don't want anyone to get suspicious of what we're doing. Sunday everyone will be in Columbia for the fight and no one will be in the area except members of our club."

"Fight … what fight?" Dellschau wondered.

"Most Sundays the townspeople of Columbia put on a fight between a grizzly bear and a bull. It is quite exciting and draws all the miners and people from all the mining camps. One is planned for this Sunday. We use that time to work on our Aeros," explained Peter.

"Aeros?" Dellschau asked. "You mean you have more than one?"

"Oh, yes. We're working on several … although *The Goosey* is furthest along."

Fig. 12.2. From plate 2426. Peter Mennis' Aero Goosey. Note coded messages at top of page.

NB Gas and *The Goose*

*The gas would have to be under extreme pressure for it to
move downward as well as upward throughout the ship.*

— C. A. A.Dellschau

COLUMBIA, CALIFORNIA, 1856

Church services were held early on Sunday morning in Columbia so
that the good people of the town could get their religion over early and get
off the streets before the wilder crowd took over. And the rowdies did take
over. By 9 a.m. the streets were filling up with the populations of not only
Columbia and Sonora, but the miners from the 15 or so other mining camps
from miles around. They came by horseback, buggy and mules. Those without
transportation walked. The fight between a grizzly bear and a bull had been
planned for a month and almost everyone in the gold field would be there.
The excitement built as the crowd gradually moved towards the edge of town
where the arena had been built. It was a simple affair consisting of a large
pit. A large circular fence had been erected to protect the spectators from the
ferocious grizzly and the equally dangerous bull. Behind this fence was several
sections of pyramiding seats. By 10 a.m. the grandstands were starting to fill
up, refreshments were being hawked, and strolling fiddle players were working
the noisy crowd.

A mile away in a box canyon near a flat meadow (the present site of the
Columbia Airport), a more serious group of men were meeting. They, too,
had come from the many mining camps scattered throughout the area. Their
meeting place was a huge barn-like structure on private land. A large fence with
"Danger Explosives" and "No Trespassing" signs prominently displayed every
few feet surrounded the building and grounds. A pair of no-nonsense-looking
individuals guarded the gate.

As Dellschau and his two companions stepped into the large hangar Charlie
was completely taken back. At intervals around the spacious building were
several Aeros that were obviously under construction. Each was in a different
stage of completion. A dozen men were working around and in the Aeros.

"Charlie, I want you to meet somebody," George addressed Dellschau as

Peter walked towards the smallest Aero. Charlie recognized it as *The Goose* from the smaller version back at the Club's headquarters.

George led Charlie towards a corner of the building that was fixed up as a small makeshift office. There were several cabinets, all open, and all with papers sticking from the drawers in a totally unorganized manner. Sitting behind an equally cluttered desk was a tall, slim man busy going through the piles of paper on the desk.

The man looked to be in his mid-twenties. He was dressed in the style of a storekeeper of the time. Charlie noted that his description could only be described as pointed. He sported a pointed chin over which was positioned an equally pointed nose. To round this pointed look out his large handlebar mustache equally pointed. Even the small round eyeglasses the man wore led in some strange way to this unusual pointed look. All of this was topped with a stock of curly brown hair. He looked up as George and Charlie approached.

"Howdy George," he said as he stood up. "And you must be our man from Germany."

"Actually, I live in Texas," Charlie mumbled as he shook the other man's hand.

Fig. 13.1. Peter Mennis and August Schoetler.

"Charlie, this is August Schoetler. He's president of the Sonora Aero Club."

After a few pleasantries, Schoetler went back to searching for whatever he was searching for and George led Dellschau over to Peter and his Aero.

"Well, Charlie, there it is, "Peter exclaimed as the other two walked up, "*The Goose.*"

The strange looking contraption was a rather small craft with a basket-like affair for the pilot. Located at both ends of the basket were rigid chambers obviously used to hold the secret fuel. From these chambers the *NB* gas flowed into the two balloons on either side of the pilot's basket. In the center of the basket, attached to a pole, were the air pressure motor and the fuel container. On the bottom of the craft was a stand-like platform, called the *falleasy,* which acted as a shock absorber upon landing. Beneath the platform were located two small wheels which enabled it to be moved when on the ground. Above all of this was an umbrella-like device which opened to provide shade for the pilot.

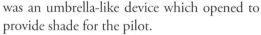

Dellschau stood and looked at the craft for several minutes. He felt a small shudder and got chill bumps on his arms. He knew instantly that this small, strange-looking craft would fly if the secret fuel actually worked.

"How does it work, this *NB* gas?" Dellschau asked Peter.

"I devolve the powder which I discovered in an equal amount of water. This liquid mixture is then, through a series of hoses and valves, dripped onto a drum made of a special material which turns the liquid into *NB* gas at just the right rate. The chemical action which takes place inside the drum, or fuel container, causes the container to turn, which supplies the power to turn the shaft which controls the direction the pilot wishes to travel in. The gas, in turn moves the air compressor and distributes itself both upward and downward to fill all of the compartments for use in lift."

"The gas would have to be under extreme pressure for it to move downward as well as upward throughout the ship," Dellschau remarked.

"It is," Peter answered. "The amount of lift is controlled by the amount of gas in the

Fig 13.2. Cut-away view of the "falleasy" on the Aero Goosey.

flexible gas bag." Peter pointed towards the main bag, which had a hollow ring around the base and was dome-shaped at the top. "When the ship is aloft and you want to come down the flexible part of the bag can be compressed by pulling those cables hooked to the dome on top. This action releases the gas through valves connected to the hollow ring and the Aero descends."

"How soon will *The Goose* be ready to fly?" Charlie asked Peter.

"It's almost ready now," Peter said. He pointed towards the air pressure motor. "That's just a box at the moment. We're still experimenting with the materials used to actually build the motor. But, it will work. Just a minor problem or two to be solved."

Charlie believed him.

In Columbia the population was returning to their claims. The gamblers whose animal had won the fight were counting their new holdings, while the losers were already looking towards the next scheduled fight knowing that next time their chosen animal would win.[1]

After Dellschau sent a glowing report back to NYMZA headquarters in Germany, secret money transfers started to arrive. The members of the Sonora Aero Club were now able to buy the supplies needed to complete the Aeros they were working on. The work went fast.

On a cold January day in 1857 a dozen members of the Aero Club gathered in the field adjacent to their hangar. The morning was freezing, and most of the miners who had decided to winter in the region were huddled around stoves in their tents. But the cold didn't deter the Club members. *The Goose* was finally ready for a test flight.

The Aero was brought out of its hangar on a wagon pulled by two mules. The handful of members who had gathered for the secret flight all helped in easing the flying machine from the back of the wagon to a spot in the middle of the snow-filled field.

Peter Mennis climbed into the tiny pilot's cockpit, made a few adjustments and carried on a conversation with George as he waited for the chemical action to take place to create *NB* gas. Dellschau couldn't make out what they were talking about from his spot 50 feet away. His gloved hands were holding on to a slack inch-and-a-half-thick hemp rope.

Suddenly The *Goose* started to rise and every man in the field gave out a forbidden cheer. Charlie was overcome with joy. If anyone had been paying attention to him they would not have believed their eyes. Sourpuss Dellschau with tears in his eyes. But none of the others noticed. All eyes were skyward. Peter could be seen turning valves and making adjustments as he began the next leg of the test, the maneuverability of the craft. A large smile could be seen wrapped around the pipe in his mouth.

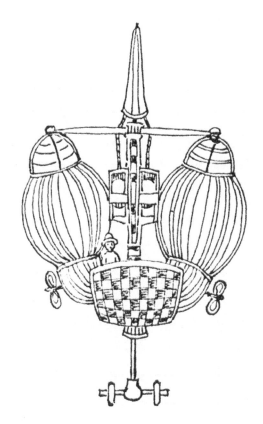

Fug. 13.3 Peter Mennis flying the Aero Goosey.

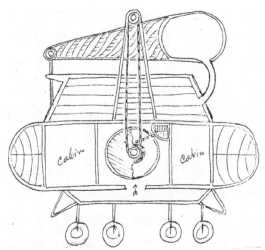

Fig. 13.4. Cut-away view of "hidden wings" and the rope-pulley mechanism used to lower or extend them.

For most of the morning Peter maneuvered his craft back and forth across the field. He flew up to 100 feet above the ground as the final test. In all he spent two hours and 20 minutes in the air.

For the first time a man was flying in a heavier-than-air vehicle. The Sonora Aero Club had finally achieved its first goal.

Over the next several months Charlie Dellschau began the tedious work of compiling the club's records and diagrams into an organized manner. He also began to use his drafting ability to make blueprints of the many ideas put forth by the members of the club. As draftsman for the group, Dellschau not only drew up the blueprints of the members' ideas, but also contributed to many of the Aero designs.

One of the first ideas Dellschau explored with the other members of the group was one put forth by Oscar Marthin. He brought the idea of using wings on airships before the members of the Aero Club. The Aero wings as proposed by Mr. Marthin were nothing that could be compared with any of the present-day design for aircraft wings.

The question that was

brought before the membership for discussion was what type of hangar could be used to house that sort of aircraft. One of the suggestions was that the wings be hidden or folded on the back of the airship when at rest and expanded when in flight. Other members of the club evidently scorned the idea, but George Newell — half in jest — went along with Oscar Marthin's idea. And Dellschau, in turn, went ahead and worked on the problem.

The idea that was finally worked out was to have wings that would be filled with the trusty *NB* gas. The gas could then be used to extend them when in flight and to retract them so they could be folded back when on the ground.

Even in 1910, when Dellschau made his drawings, the idea of folding wings on aircraft was far in the future for aircraft designers.

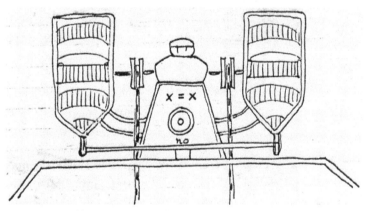

Fig. 13.5. "Hidden wings" as seen from above.

Dellschau compared this to bird's wings and remarked on the fact that *every bird hides his wings when at rest.*

This account, taken from plate 1607 reads:

> *Single Lifter fixet up … half for scorn. It fly you all ought to know has his wings hidden on its back at rest but expandet when a flying and every bird hides its wings when at rest. But the question here is how can you fly with hidden wings? Now I asure you Brother Marthin places them above, or on a Dooely between the two lifters - possible enough and hidden for good. But will - they do = wing duty?*

Dellschau added: *Now I shall work on the problem. Scorn or no scorn.*

Plates 1615 through #1621 contain additional drawings of the Aero with hidden or retractable wings. Dellschau states that he made the drawings from

material submitted by various members of the club, taking only those ideas that suited his purposes and intentions.

In his last drawing of the airship with retractable wings he uses the symbol that means Aero and puts *O.K.* next to the symbol. This indicates that the Sonora Aero Club board members finally approved the design for the Aero as shown in the final drawing.

Lamar Ollray, another member who joined the club in 1858, proposed the *Fallnott Airpress Wing* in 1856. This wing was designed to prevent a

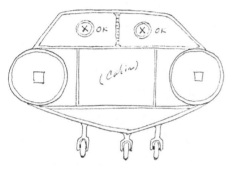

machine from plummeting to Earth upon its descent, and worked on the same principle as the wing action of birds. There existed one fault with the design: its weakness in stormy weather. When Dellschau read in a newspaper story in 1920 about "a new flying machine" that had "sea gull wings," he remarked that this idea was "not new" since Ollray had thought of a similar device over 60 years earlier.

Fig. 13.6. We believe the OK in this sketch indicates that the design was approved.

The idea of wings on the airships was eventually shelved, and there are very few of Dellschau's drawings which show wings.

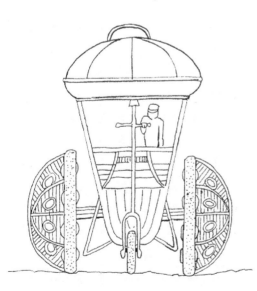

Probably the most unusual vehicle designed and built by members of the Club was the *Cripple Wagon*. The *Crippel Wagon* was originally a land vehicle equipped with "*hydro wheels.*" This auto was actually invented by F. W. Schultz in 1837. Dellschau had a lot of influence on getting it built. Charlie had been Schultz's young assistant for a few years and possessed detailed drawings of the strange car. He presented the plans to the members of the Aero Club. His plans were accepted and adapted into an Aero by the members of the Aero Club. The

Fig. 13.7. A view of F. W. Schultz's Crippel Wagon designed in 1837.

tricycle-looking vehicle ran on compressed air that worked in combination with the *hydro wheels* which contained water. Schultz also invented what he called *Flydrows* in 1837.

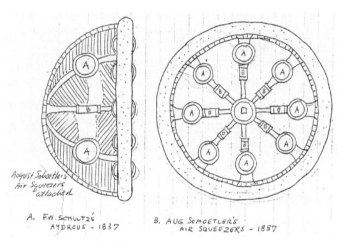

A. F.W. SCHULTZ'S
AYDROUS - 1837

B. AUG. SCHOETLER'S
AIR SQUEEZERS - 1857

Fig. 13.8. August Schoetler's air squeezers.

According to Dellschau's notebooks, in 1857 (20 years later) August Schoetler invented what he called *air squeezers* which he adapted for use on the *Crippel Wagon.* The *air squeezers* consisted of a tube through which air was compressed and ejected as in a jet engine.

Another innovative idea to come out of the Aero Club, now seen on all of our modern aircraft was spotlights. Joe Oliver invented a lighting system for the Aeros, or to be more correct, the spotlights that were used on the Aeros in 1858. It was a system that used reflectors and "flames." Carl Ansler also proposed a lighting system that used an incandescent type light. It is interesting to note that electric incandescent light bulbs, which are so commonplace today, hadn't been invented yet. Therefore it's safe to presume that although he had an idea for such an invention, the spotlights (called "flashlights") were not the type that we see now.

Plate 1905 contains a drawing of the *Aero Honey Moon.* In the drawing Dellschau shows a cross-section of the airship and its "flashlights."

In the beam of one light is the name *Joe Oliver* and *Turnhull Flashlight.* The other light contains what looks like a gas flame and has the date 1858 over it. Inside the reflector is what appears to be an incandescent light bulb with the notation *Today* on it. On the beam of this light are the name *Carl Amsler* and the words *Pull. Push.*

Aircraft with retractable landing gear and wings, jets and spotlights. These were all unique ideas in the early 1900s when Dellschau assembled his books.

And if invented in the mid-1800s, as Dellschau claims, these assemblies were truly amazing.

Endnotes

1. Years later, Wall Street would immortalize these famous fights, unique to the time and place, by naming the ups and downs for the stock markets the *Bull* and *Bear* markets in honor of these events.

Fig 13.9. The Aero Honey Moon. Note the two "flashlights" lighting up the ground on either side of the craft. From the P.G. Navarro Collection.

CHAPTER 14

Inventions and Intervention

If George Newell was living, would he not open his peepers?

— C. A. A. Dellschau

SONORA, CALIFORNIA, 1856 - 1860

Dellschau and Peter Mennis found out that they had many common interests other than the passion they shared most of all — a belief that man could fly. They became fast friends and were inseparable. To see them together, they made an odd-looking pair. Dellschau was short, skinny as a rail, and dressed in a black suit while Mennis, to the contrary, always wore rough, practical clothes and was a rugged-type individual with chin whiskers. His usual attire was the unofficial uniform of most of the '49ers; a red shirt open at the collar, and black trousers tucked into a pair of boots. He wore a black hat and constantly smoked a curved pipe. He also carried a gun in a holster. His constant companion was a little black terrier.

In his aeronautical notebooks Dellschau told many stories of his friend's exploits. One such story illustrates the extent the Aero Club members would go to for a practical joke.

The *Aero Goosey* had a tent-like apparatus used to cover the craft when it was on the ground. This apparatus also served as a shelter for use by the pilot when

Fig. 14.1. Mennis relaxing in the Aero Goosey under his "tent."

on extended trips in the field.

Mennis was fond of taking naps in his Aero-tent when he was away on trips to the outlying country, and would make camp wherever he happened to land. Dellschau mentions an incident in which one of the members once sneaked up on Peter as he was asleep in his vehicle:

... Inside the tent, and with a knife, cut away some of the tent flaps, exposing Peter Mennis to view as he slept soundly. Of this incident Dellschau wrote, *Cruel feat, cutting Goosey clean away ... and exposing Peter Mennis napping.*

Louis Caro Jr., another member of the club, once said of Mennis: *Did you ever hear of Mennis? Peter flew for years, in lull or blow in Goose. Like it was a good old buggy trapp. When at rest to take his nap ... in Goose ... fixed to a tent.*

At times Peter liked to go off by himself in his machine. One time Mennis was presumed lost on one of his jaunts in the *Goosey;* however, he reappeared several days later, all in good shape, happy as ever, much to the relief of the other members of the Sonora Aero Club.

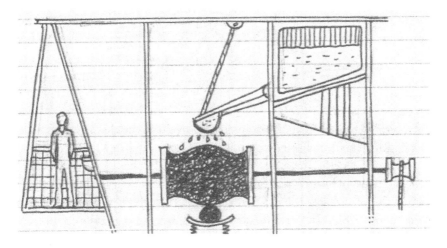

Fig. 14.2. The power plant for the Aero Newell.

Dellschau worked with George Newell on his idea for a flying machine, the *Aero Newell,* in 1858. After several discussions with George regarding its construction, Dellschau drew blueprints.

Years later he included several drawings of the *Aero Newell* in his notebooks. In the drawings Dellschau showed the motor and other bits of machinery in detail. Another innovative idea as pictured by Dellschau on this huge Aero was an on-board bathroom. The tremendous size of the airship made it necessary to use two large motors, or energy converters, located in the center of the Aero's

cabin to produce the motive power as well as the gas. The gas was used to fill two cigar-shaped balloons on either side of the aircraft. The airship had a deck (or walkway) with a railing all around the balloons.

In 1857 Newell presented some new ideas to the club that other members took lightly, calling them a "joke."

A joke ... Aero won't go, they said.

You Dutch smarties, Newell, an Englishman, retorted. *You don't know it all. I'll open your peepers.* Newell's retort to the other members was, no doubt, said in good humor, but it's also evident that he stood firmly behind his convictions regarding some of his ideas.

In 1910, 53 years after the above incident allegedly took place, Dellschau wrote, *"If George Newell was living, would he not open his peepers?"* This is obviously in reference to the events that had transpired during the first years of the 20th century, which saw the invention and development of the airplane. Something that would have definitely startled

Fig. 14.3. The huge restroom onboard the Aero Newell.

Newell, not to mention those *Dutch smarties* who had doubts about his radical ideas, whatever they might have been.

Over the next two years the Sonora Aero Club designed many craft and were able to fly several of them. Although they were able to keep their experiments secret from most of the people, somehow rumors did get out.

According to Dellschau, the military had heard of the club's efforts to design navigable aircraft. A high-ranking military officer approached them one day, and it is unknown whether he was representing United States or German interests. Dellschau refers to him as *"that Prussian Officer."* The military man suggested that they sell their Aeros for use as war machines. The offer was heatedly discussed by the membership. They eventually turned down the suggestion. Did they do this on moral principles, or did they turn down this opportunity of making money from their inventions for some other reason? Dellschau never says. It is very likely that they turned down this opportunity to sell their inventions to the government because of the red tape that would be involved in dealing with the military. Dellschau's remarks concerning this "military intervention" can be found in plate 1743:

And who are you to question our board? Now what makes practical military airship 10 or 100 miles an hour??? Hell.

Those acting officers act just like race track gamblers. No such questions asked as bulletproof, good gas reservoir, fall ease, anti-ballast! What did you say? Holy Red

Tape.

Yes, when the weather suits — gas can be got when reaching camp. What won't Peter Mennis say to you simply, 'nonsense.' Amen.

Fig 14.4 Rough sketch of cannon on War Wagon.

The military officer's main concern seemed to be that the airship must travel at speeds up to 100 miles per hour. The officer must have been upset at the board's refusal to deal with him and that is when Dellschau asks, who does he think he is "to question the board?"

Dellschau is of the opinion that the military official was not concerned about many of the more important features of the airship, like the failure to inquire as to the impregnability of the aircraft under fire or if it would hold enough fuel for a prolonged flight. Other requirements he felt they should be more concerned with were such things as the *fall-ease*, a device to soften the impact of landing, and the *anti-ballast*, a device to keep the airship on an even keel. All the officer was interested in was the speeds to be obtained by the aircraft. So, "those … officers act just like race track horse gamblers."

"Holy Red Tape." This remark was obviously made because of the red tape Dellschau and the club members knew would be involved in dealing with the military.

For whatever reason, the members felt that complying with the officer's request would probably put them under an obligation to conform to certain military rules and regulations, the very things they were trying to escape by setting up in the free-wheeling state of California to start with. They vetoed any assistance to the military man. Although members of the club generally were against the use of their aircraft for military purposes, nevertheless, they did work on at least one Aero, the *War Wagon,* that included features designed specifically for that purpose. The progress of the club was amazing. The innovations and ideas put forth by the members were at least 100 years ahead of their time.

Then sometime prior to 1860 an event took place which would mean the

end of the Sonora Aero Club's efforts. And it must have happened suddenly. Towards the last days the members only worked half-heartedly at trying to advance their experiments. It seemed as though they had become more of a debating society than a working group. The evidence pointed towards the fact that, although some of their Aeros had flown, subsequent designs now were never built. Although they continued to meet and exchange ideas, the truth of the matter was that it was over. The club fell apart. The members began to argue amongst themselves. Many dropped out of the club and moved on. Finally, heartbroken, Dellschau returned to Texas with nothing but his memories. What had happened to cause this turn of events? What could have been so devastating to have suddenly stopped these aeronautical pioneers in their tracks? Pete had yet to find the answer.

According to public records C. A. A. Dellschau returned to Texas sometime during the early part of 1860. The records show that he once again applied for citizenship in Richmond, Fort Bend County, Texas, on June 28, 1860. A marriage between Dellschau and Antonia Hill was recorded in February 1861. He obviously was back in Texas to stay.

Was his involvement with the Sonora Aero Club and airships over? We have no way of knowing. All that is known for sure is that Dellschau was living at 704 Clay Street, at the corner of Clay and Louisiana Streets in Houston, Texas, during the years 1896-97 — the years of The Great Airship Mystery.

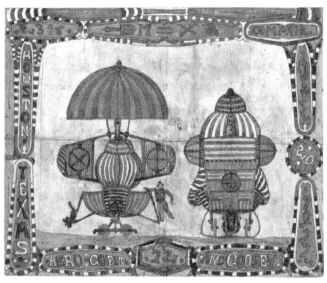

Fig. 14.5. Black and white photo of Dellschau's plate 2375 which compares the Aero Goosey with the Aero Goeit. The P.G. Navarro Collection.

Part 3

In Search of the Truth

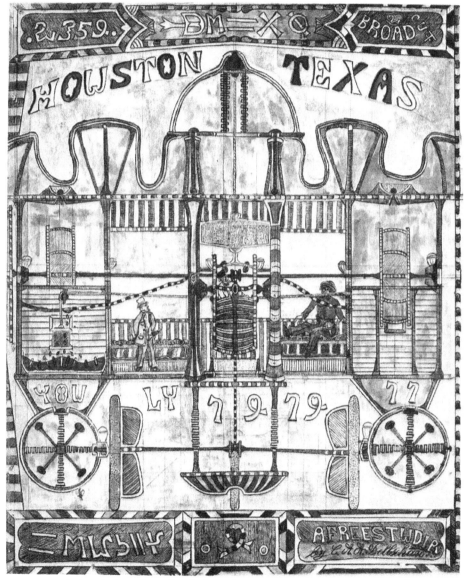

Fig. 15.1 Black and white photo of Dellschau's plate 2369. From the P.G. Navarro Collection.

CHAPTER 15

A Short Look at Aviation History

History is bunk.

— Henry Ford, 1919

On October 30, 1949, the *Waco Tribune Herald* published the following article:

McLennan Aeronaut
Built Plane Six Years
Before Wright Bros.

Six years before Orville and Wilbur Wright lifted their plane off the field at Kitty Hawk in 1903, a quiet Frenchman, a ticket agent from the Katy Railroad, W.D. Custead by name, flew a plane of his own design from Elm Mott [Texas] to Tokyo [Texas] and back, a distance of 5 miles. ...

Popular belief has it that Wilber and Orville Wright made the first powered and controlled flight by man near Kitty Hawk, North Carolina, on December 17, 1903. However, what we are taught as history is not always the whole truth. Many facts, for whatever reason, get distorted, hidden or lost in the shuffle. This is true of the Wright brothers claim.

Actually the honor of being the first to fly a controlled flight should rightfully go to Brazilian Santos-Dumont.[1] He flew a bright-yellow dirigible powered by a small gasoline engine and controlled by a rudder in France in 1898. It is also interesting to note that the Wright brothers flimsy craft stayed aloft for less than a minute and covered a distance of only 820 feet. It wouldn't have even been able to get off the ground were it not for a 25 mph tailwind. Santos-Dumont flew his craft from St. Cloud to the Eiffel Tower in Paris, circled the world famous landmark, and then flew back to his starting point (a distance of 7 miles). He remained in the air for a full 30 minutes.

The age of flight by man actually began 115 years before Santos-Dumont's historic aerial escapade. In 1783 two Frenchmen, Etienne and Joseph

Montgolfier, sent their brave friend Jean Pilatre de Rozier aloft in a hot air balloon.[2]

In 1842 two British entrepreneurs, inventor William S. Henson and machinery manufacturer John Stringfellow, started the first worldwide airline the Aerial Transit Company. Henson had invented, and been granted the patent, on an "aerial steam carriage" and the two men planned to manufacture and fly his machine. The airline never got off the ground, so to speak, because Henson's model craft, the *Ariel*, didn't fly. However Henson continued to experiment and actually flew a steam-powered model of his aircraft in 1848.

Americans were also trying their hand at flying during the 19th century, long before the Wright brothers entered the picture. Dr. Soloman Andrews of Perth, New Jersey, invented an airship he called the *Aereon*.[3] On June 1, 1883, he flew the *Aereon* over New York City and established the record of being the first man to fly against the wind. Yet, Dr. Andrews did not even have a motor on his airship. As he explained in his book, *The Art of Flying*, his source of power was "gravitation." According to Dr. Andrews, *the difference of specific gravity between the balloon and the atmosphere in which it floated could be applied as a power to propel the airship in any direction.* Until this day no one has ever been able to duplicate his flight or fly against the wind in a balloon without a motor.

Since Dr. Andrews was a contemporary of Dellschau's and had an interest in aeronautics, we wonder about the possibility that there may have been a connection between Dr. Andrews and the Sonora Aero Club.

In the year 1849 Dr. Andrews bought the army barracks at Perth Amboy, New Jersey, and converted them into The Inventors Institute where he and a cooperative organization of inventors constructed an airship. The airship never left the building, but they learned a lot about how to go about constructing an airship. That activity, of course, led to Dr. Andrews' success in 1883. One wonders if perhaps some of Dellschau's colleagues might not have been members of the Inventors Institute. As can be seen from the above examples, men were flying around in machines throughout the 1800s.

Then there is the "Great Airship Mystery of 1896-97."

On November 17, 1896, a large object was seen by many people as it flew over Sacramento, the capital city of California.[4] [It should be noted that Sacramento lies a very short distance to the west of the Aero Club's alleged home base of Sonora.] The witnesses, as reported in local newspapers of the day ,had seen what they believed to be an "airship."

Over the next 13 months, tens of thousands of people across the United States reported sightings of strange "flying machines" in the skies over a large

The Call

SAN FRANCISCO, SUNDAY MORNING, NOVEMBER 22, 1896—TWENTY-EIGHT PAGES.

SAW THE MYSTIC FLYING LIGHT

Oaklanders Who Believe an Airship Hovered Over Them.

Say That They Saw a Dark Body Above the Gleam.

It Was Headed for San Francisco and Seemed About to Come to Earth.

OAKLAND OFFICE SAN FRANCISCO CALL, 905 Broadway, Nov. 21.

Fig. 15.2. The Nov. 18, 1896, issue of the San Francisco Call front page report of the airship sighting over the San Francisco area.

portion of the country. Some even reported meeting and talking to the 19th century aeronauts who flew these futuristic craft. A few lucky souls even claimed to have been invited aboard for a spin through the heavens.

Over the years, most mainstream scientists and engineers have refused to look into the possible implications of the many newspaper reports of these airship sightings. "It was a hoax" has been the most common reaction. And admittedly many of them probably were just that. After all this was the day of "yellow journalism" and many a tall tale was told in the local and very independent newspapers of the time. But on the other hand many of these airship reports came from respected, solid, down-to-earth witnesses. In fact, many times the entire population of various towns and cities reported sighting an airship. And these sightings occurred over too wide of an area of the country for the whole episode to be explained away as a simple hoax.

For instance, the airship seen sailing through the skies over Sacramento that night in November 1896 was reportedly "viewed by thousands." Included in the list of witnesses to the event were such respected citizens as Deputy Sheriff Mallory, District Attorney Frank D. Ryan, and Assistant to the Secretary of the State of California, George Scott. [5]

By the end of November 1896 sightings of these strange flying machines had occurred all over California and the Pacific Southwest. As reported in an unpublished manuscript compiled by researcher T. E. Ballard, the sightings can actually be separated into two different and distinct waves.[6] The first occurred between November 17 and the middle of December 1897, and was confined to California and the Pacific Southwest. The second wave of airship sightings started to surface in the middle of January 1897 and lasted until May of that year. This time the unknown pilots were reportedly flying their huge craft, or fleet of airships, into the very heartland of America.

Airship reports continued to appear in local papers all across the mid-section of the country until December 1897. Then, suddenly, reports of the strange

craft stopped. Why did the reports stop? Where did these craft disappear to? And the most important question of all: If the strange flying machines that thousands of people swore they had seen really existed, why didn't someone come forward to claim the fortune and fame that would rightfully have been theirs for the asking?

Today, over 100 years later, the mystery remains: Who were the secret inventors and pilots of the huge craft that dotted the uncluttered skies over a large portion of the United States in 1896 and 1897? And of course, *our* underlying question remains: Were these airships in any way connected to Dellschau and the Sonora Aero Club?

Endnotes

[1] *Ships in the Sky* © 1957 by John Toland. Henry Holt & Co., NY
[2] *Ships in the Sky*
[3] Ibid.
[4] *The Great Airship Mystery: A UFO of the 1890's* © by Daniel Cohen. Dodd, Mead & Co. NY
[5] *The Great Airship Mystery.*
[6] *The Airship File.* (1982) T.E. Ballard. Unpublished manuscript.

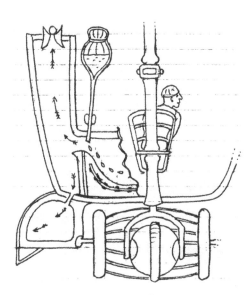

Fig. 15.3. A cut-a-way view of some of the working parts of the Aero Goosey.

A Man Named Wilson

*It is not known exactly who Tosh Wilson was, nor whether
he was a member of The Sonora Aero Club ... Tosh Wilson
might have been the pilot of the airship ... that landed at
several points in Texas and Arkansas in the year 1897.*

— Pete Navarro

HOUSTON, TEXAS, 1971

Pete Navarro sat in front of the microfiche machine in the Galveston
Public Library. He had been searching the microfilm of the *Galveston Daily
News* all morning looking for reports of airships sighted in the area in 1897.
He was hoping to find connections between the airships of that period and
Dellschau's Aeros. What he was currently reading was actually a letter that had
been reprinted in the newspaper. A person who had come in contact with the
pilot and his crew near Lake Charles, Louisiana had written the letter. The
recipient, a Mr. D. H. Tucker of Harlem, Texas, described the letter writer
(whose identity is not given) as a young man "of scientific turn of mind."
Mr. Tucker also said the young man had studied physics and had worked as
a draftsman during construction of the Panama Canal. Unfortunately, he
had drowned during a flood near Grenada, Mississippi, about a week after
mailing the letter. The re-printed letter turned out to be an exciting read.
According to the article the pilot's name was Wilson.

Pete got out his notebook. He was sure the name Wilson was on the
Dellschau list. He found the right page and ran his finger down the list of
names. "Tosh Willson." Wrong spelling, but knowing the way Dellschau
spelled things, the actual spelling of the name probably was Wilson. The
other thing that excited him was the description of the machinery used to fly
the mysterious airship. In his mind's eye he could almost see a description of
Dellschau's detailed drawings.

*... All the machinery seemed very simple and did not occupy
a greater space than five feet in length by four feet in width. To
elevate or depress the ship while flying through the air a small*

wheel at the stern of the boat is operated. This wheel was something like that in a ship pilothouse, but instead of having spokes there was an arrangement of magnets connected to storage batteries. By passing the current over the tire of this wheel the operator was able to overcome gravity, thus elevating the ship. By passing the current in the opposite direction and under the tire the weight of the ship was increased and could sink like a shot to the earth. By passing the current in opposite directions at the same time the vessel could remain horizontal to the earth.

Fig. 16.1. An unidentified piece of machinery from plate 2620.

Pete rested his eyes before tackling the fine print of the old newspaper again. He was hoping he'd find some details regarding the construction of Wilson's airship in the long, descriptive letter. Maybe he'd even see some clue as to its methods of propulsion and lift. Pete returned to the fascinating newspaper article of a century before.

Mr. Wilson told me that the current of wind had little effect upon them, as by pressing a button at the wheel he could rise above or below [high] winds or storm … He showed me the mechanical means by which the ship was propelled. At one end was a propeller (working on a shaft connected with the sprocket wheels) … the blades … of the propeller were enormous being ten feet in length. What I thought were canvas sails were actually wings used in steering. The length of the ship was 75 feet by 25 feet.

It doesn't sound exactly like Dellschau's drawings but it's close, Pete thought. He wondered if the Sonora Aero Club's 1850s Aeros might have been prototypes for this 1897 airship? Pete paused and pondered this for a moment, shrugged, and returned to the newspaper.

Mr. Wilson said that his pantry was easily supplied with

provisions ... he had only to drop down near a town ... they had built 3 of the ships as experiments ... each was essentially different in some of the details and comparisons were being made ... they refused to state what point they started from or give any information concerning their business.

Pete stopped reading the article. A secretive group. Could the 1897 Airship flap have been caused by competition between different lodges of the Sonora Aero Club in 1896 and 1897? Pete didn't know. *It's only speculation,* he thought, *but who knows what I'll find. The further and further into the secrets of Dellschau I get, the more and more questions there are to be answered. Could Dellschau and Wilson have come to Texas to form a new branch of the Sonora Aero Club?* The possibility was there, but Pete knew he was stretching the facts a bit. Once again he focused on the article.

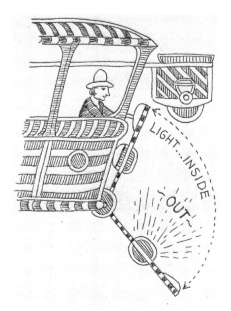

Fig. 16.2. Dellschau's flashlights from plate 2620.

At night a small but powerful searchlight was used to flash ahead or below. It was mounted on the forward deck ... they were capitalists and planned to construct a line of airships to be operated between New York and San Francisco ...

Pete stopped reading once again. *Could these possibly be the "flashlights" Dellschau describes?* he wondered. *Or were the lights being described actually advanced models of Dellschau's floodlights?* He could only speculate.

In the letter, the writer stated that after he had been invited aboard the aircraft he had noticed a number of incandescent lamps about the walls and hanging from the ceiling.

The young visitor immediately concluded that the motive power of the airship was electricity. Upon expressing his conclusion to Mr. Wilson he was told this was not the case.

Mr. Wilson explained that the airship was propelled and sustained by a gas that had the property of great compressibility under a light pressure and a corresponding great power of expansion.

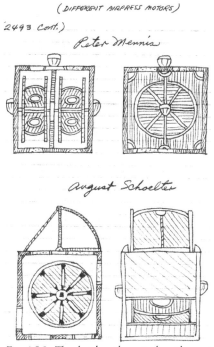

Fig. 16.3. *The sketches above and on the next page illustrate several of Dellschau's "airpress motors."*

This line started Pete's blood pumping. Could Wilson's airship's power have been supplied by using Peter Mennis' elusive *NB* gas?

The news article went on to explain that Wilson had invented an engine that, once started, worked automatically; then all that was required was for the helmsman to pay attention to the governor that regulated the speed. Further reading revealed there was a receiver made of aluminum. Pipes were attached to what appeared to be a square box, at each end of which was a cylinder with an exhaust chamber. Inside the cylinders were pistons that attached to a very singularly constructed driving wheel.

To Pete it seemed that the apparatus for generating gas and the engine for utilizing it were very descriptive of the engines seen in Dellschau's Aeros. He wondered if the young eyewitness were to have seen Dellschau's drawings, would he have identified them as being the machinery he had observed on Wilson's airship.

Mr. Wilson next explained to his young guest that the highest rate of speed attainable was over 1,000 miles per hour, and that he had never been higher than 2,000 feet because it affected the crew disagreeably. He also stated that since he had only been experimenting with the craft for about two weeks, he did not know what would be the most desirable or comfortable height at which to travel. The letter writer stated that he had told several people in Lake Charles of his experience, but since they treated it as a "Munchausenism" he had not made any particular effort to convince them of the truth.

The fact that Wilson and his crew were in the vicinity of Beaumont, Texas, at that time is substantiated by another eyewitness account from the local paper, *The Liberty Vindicator*. According to the report, Mr. J. R. Ligon,

a local agent for the Magnolia Brewing Company of Houston, and his son Charley had driven home near Beaumont. It was 11 p.m. on Monday, April 19, 1897. That night, as they began to unhitch the horse, they saw a light in the adjacent pasture a few hundred yards distant. They went over to investigate and discovered four men moving around a large, dark object. When Ligon called to them they answered and asked if they could get some water. He talked with one of the men who told him his name was Wilson, and that he and his companions were traveling in a flying machine. They were returning from a trip out on the Gulf and were now heading for Iowa, where they told him the ship had been built. Mr. Ligon described the airship as having four large propellers attached to the bow and stern, much like some of the navigational equipment seen in Dellschau's drawings. The witness was told that, just as in Dellschau's Aeros, *the hull of the ship ... contained compartments into which compressed air was pumped when the ship was in action.*

Fig. 16.4. An airpress motor designed by Jourdan.

Pete conjectured that it was very possible that the "Tosh Willson and Co." Dellschau wrote about could very well be the Wilson and Crew of the 1897 reports; a ship's crew is often referred to as a ship's company. Pete realized that Dellschau might have been acquainted with the 1897 Wilson.

As an experienced researcher, Pete knew that in order to prove facts you have to have many additional connecting facts. The more connecting facts you find, the more likely that it is the truth. Usually, if the information isn't true you can't find any confirming facts. With Wilson and Dellschau Pete had

found several connecting facts.

If the name "Wilson" were the only connection between the mid-1850s Sonora Aeros and the airships of 1897, that would be stretching it. After all, Wilson is a fairly common name. But in this case there are several good connections. The facts put both Dellschau and Wilson in East Texas at the same time. Dellschau lived in Houston, just a short distance from Galveston, a town with a large German population. There were plenty of wide, empty beaches along the Texas Gulf Coast in 1897, from which to launch an airship without anyone witnessing the operation. If it were true that the club had expanded, Pete speculated, then it stands to reason that sooner or later they would have a competition between the different branches. Wilson mentioned that there were three different ships made from three different designs and that they were competing. Were these three different branches of the Sonora Aero Club having a go at it?

Of prime importance in finding a connection between Dellschau's group and Wilson was the matter concerning the buoyant properties of both the Aeros and the mystery airships. Did Wilson posses the formula for producing the lighter-than-air substance known as *NB* gas? Pete thought it possible.

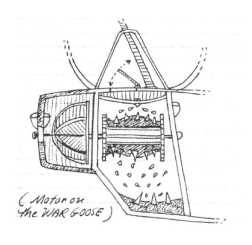

Fig. 16.5. A cross-section of the NB gas conversion chamber and some of the machinery around it. From P. G. Navarro's Journal.

(*Motor on the WAR GOOSE*)

CHAPTER 17

More Possible Connections

During the 1850s there was an enormous wave of airship sightings in Germany.

— Jerome Clark

HOUSTON TEXAS, 1972

In January 1972, Pete received a phone call from Jerome Clark, a well-known writer/researcher associated with *Fate Magazine*. *Fate* is a very popular magazine which carries a wide variety of articles and stories about UFOs, ghosts, the paranormal and many other unexplainable mysteries.

After introducing himself, Clark explained, "Lucius Farish and I collaborated on a series of stories on the Air Ship Mystery sightings which was published in *The Flying Saucer Review*. During my research I came across some interesting information that may have a Dellschau connection."

Clark went on to explain that during the 1850s there had been an enormous wave of airship sightings in Germany.

"I was just wondering if there might be a connection. Are you sure Dellschau immigrated from Germany?"

"Pretty sure," Pete answered. "I was given that information by Helena Stelzig, Dellschau's step-daughter. He lived with her for many years, until he died. I believe she is the person who went to town and got his art supplies for him."

They continued talking about the overall airship subject for a while. Clark mentioned the similarities between Dellschau and John O. Preast, who claimed he had built and test-flown an airship in 1877. Preast was also a German immigrant who had moved to Omaha, Nebraska, around 1877. He was living the life of a recluse, and spending a good portion of his time drawing and constructing models of airships. After his death drawings strikingly similar to Dellschau's were found in his home in Nebraska. Both Dellschau and Preast were compulsive students of aviation who consumed years of their time making drawings of strange looking aircraft. Just on the basis of his drawings of airships Mr. Preast is believed to have designed a navigable aircraft which has earned him the title of "Airship Inventor."

"Another thing," Clark remarked, "there was a man by the name of Charles Downbar who built an airship in Illinois around the same time as Dellschau's group was building theirs. I was wondering, could the literal translation into English of Dellschau be Downbar?"

Pete laughed. "Actually, it translates into 'Showman'."

Clark chuckled. "That's appropriate, I guess."

They talked for a while longer and promised to keep in touch.

A few months later Jerry Clark wrote Pete an interesting letter. He said that he was writing an article called *Secrets of the Airships*. In the article he was trying to map out the conflicting claims made by and about alleged inventors of the aircraft. Jerry said that after all his research on the subject, he was finally getting a grasp on what was going on during that incredible period. There had been airship sighting flaps in both Germany and France during the 1850s and 1860s.

In late 1848, about the time of the gold strike in California, an "R. Porter and Company" printed up a circular, announcing that an "Aerial Locomotive" that would be in operation by April 1, 1849. It was supposed to fly passengers to California and return to New York within seven days.

He also stated that he wished there were some way to connect Dellschau with the Airship mystery without stretching things. In the first place he thought that Dellschau's diagrams resembled absolutely nothing

Fig.17.1. 1849 poster advertising an alterative mode of travel to the California gold fields.

that was seen by anyone during the celebrated flaps of the 19th century. Clark was basing this opinion on the fact that none of Dellschau's diagrams he had seen resembled any of the airships that were seen during the late 1800s.

However, the drawings Pete had sent him represented only one type of aircraft designed by the Sonora Aero Club. There were other drawings, in Pete's opinion, which pictured aircraft that resembled the descriptions of the celebrated "Mystery Airships" in many ways. It could be that Dellschau's airship designs were but prototypes for later airship models that gradually took other forms and shapes which, by 1897 (some 40 years later), were more in line with the recognized contours of the 1986-97 airship.

Jerry Clark's mystery airship article eventually appeared in *Fate* magazine. Later he collaborated with Loren Coleman to write a book titled *The Unidentified* in which he mentioned Dellschau and the Aeros.

Chapter 18

A California Trip

To the best of our knowledge there was never such an organization known as NYMZA or a Sonora Aero Club in our area.

— John J. Muzio, Secretary, The Toulumne
County Chamber of Commerce

HOUSTON, TEXAS, AND SONORA, CALIFORNIA, 1973

Other than the infamous aeronaut Mr. Wilson, Pete had been unable to locate another single name from Dellschau's list in accounts of the 1897 flap of airship sightings. He felt it was now time to try to find out if there was any information available on any of the other names Dellschau claimed to be members of the Sonora Aero Club. Pete wrote to the Sonora Chamber of Commerce requesting any information they might have pertaining to any group that may have existed in the late 1800s that was made up of aeronautically minded individuals. He asked them to pay particular attention to any mention of The Sonora Aero Club or NYMZA. He included the list of 62 members he had been able to find in Dellschau's works. Ten days later he received an answer from the Toulumne County Chamber of Commerce.

> *To the best of our knowledge there was never such an organization known as NYMZA or a Sonora Aero Club in our area. Nor do any of the names of the various individuals you mentioned have any connections that are known in any of our records or history papers. It would seem apparent, that if there were such imaginative undertaking here in the year 1858 or thereabouts, it would not have been missed, as the area around Sonora and Columbia were packed with gold miners. We do believe these must be the writings of someone or several individuals with a great imagination ... in other words, pure fiction.*
>
> *John J. Muzio*
> *Secretary*

The reply to Pete's query was to the point and almost final in its assumptions, but he still felt that if there had been any activity by the Dellschau group in that area it did not necessarily mean that it would be obvious to those working the gold claims. If what Dellschau said was true it stands to reason their experiments were carried out in isolated sites, distant from the populated areas. Even if they were observed, they would be taken for miners themselves.

Interestingly enough, there were actual reports of groups of men building airships in secluded areas of Northern California, a short distance from the twin towns of Sonora and Columbia only 40 years after Dellschau's claimed Aero Club days.

In November of 1896, a reporter from the *San Francisco Call* met an old hunter by the name of Brown on Bolinas Ridge just to the west of Mt. Tamalpais. Mr. Brown lived on the mountain and had a strange tale to relate. He claimed that he had seen a large, dark shape in the sky that had come down near him suddenly. He was almost stunned by the sight. By the time he had collected his senses the object had flown off and was out of sight. "I have been kind of dazed ever since," he said. "And to have you tell me that I don't look crazy is a relief. But I know what I saw was an airship."

Several days later, William Jordan, another hunter, reported the following to the *San Francisco Call*.

The mysterious light mentioned in your valuable paper this morning as seen by several citizens in different parts of the state, and which seems to mystify yourself as well as your readers, is nothing more than an airship, and of this fact I am perfectly convinced. I think now that I am released of my obligation of secrecy, that I have kept for nearly three months, as the experiment in aerial travel is a fixed fact and public, a few of the public at least, have seen its workings in the air.

In the latter part of last August I was hunting in the Tamalpais range of mountains, between the high peak and Bolinas Bay. I wounded a deer, and in chasing it I ran into a circular bush pile about 10 feet in height in a part of the mountains seldom visited by anyone.

I was somewhat astonished, and my curiosity prompted me to approach it, when I encountered a man who sang out, "What are you doing here and what do you want?" I replied that I had wounded a deer and was chasing it. He said that they had been camping there for a month or so and had not seen a deer, "but

if you think your deer is in the neighborhood I will assist you in finding it as we need meat in the camp"
This man went with me and in less than 500 yards found the deer. We carried it into the bush corral. And what a sight, a perfect machine shop and an almost completed airship. I was sworn to secrecy and have kept it till this moment. Six men were at work on the "aerial ship." It is this ship that a few people have seen at night on its trial trip. It returns to its home before dark and will continue to do so until perfected."

In another Mystery Airship report in the *San Francisco Chronicle,* a Mr. Collins who was acting as attorney for the airship's inventor, claimed that it was perfectly true that there was at last a successful airship in existence.[1]

He had known about it for some time, and the inventor (who was a very wealthy man) had come to California from the state of Maine in order to be able to work on his airship away from the eyes of other inventors.

He said it was his client's airship that had been seen flying in the area of Sacramento, California. The flight had started from Oroville, in Butte County California, on November 17, 1896. It had then flown in a straight line directly over Sacramento.

Asked how it was possible to house a 150-foot long vessel in a barn in the vicinity of a town without its existence being known, Collins said, "That is easily accounted for, the barn is not very long, and it is tacked onto an old dismantled two-story dwelling. The partitions have been knocked out, making the place practically one long room."

He said that none of the larger parts of the airship had been made in California, but had been manufactured in various parts of the East and shipped to Oroville and Stockton, where they had been gradually put together.

Other reports asserted that it had been observed that certain parties, living about three miles east of Oroville in a thickly wooded section not traversed by roads, had been experimenting with different gases for some time. One man had been overheard to say that the parties had been experimenting with a new, very light gas for use in aerial balloons. It was rumored that an airship had been constructed by a group of people from the East who desired to escape prying eyes and sought seclusion in that isolated area.

Pete was pleased to learn there were actually accounts of men building and flying airships in California in 1896. However, as interesting as this was to know, he couldn't seem to find a direct connection between Dellschau's claims about the Sonora group and the reported actions of the Oroville group in 1896. It seemed that no matter which way Pete turned, he was coming up

empty-handed.

Pete studied as many historical accounts of the Sonora-Columbia California area as he could get his hands on. Nowhere did he find any mention of any Aero Club or of any aerial devices being tested anywhere near there. Even though there was a strong element of doubt as to whether such events actually took place there, the possibility still existed. Pete realized, taking into account that the Aero Club operated in total secrecy, the matter could be debated pro and con but it would lead nowhere. Pete decided that he would have to go to Sonora himself and see if he could dig up any facts.

Navarro visited Sonora and Columbia, California, in the summer of 1973. The twin towns are located in the heart of California, nestled in the foothills of the Sierra Mountains about midway between Stockton, California, and Reno, Nevada.

Gold was first discovered on nearby Kennebeck Hill by a group of Mexicans in March 1850.[2] Working the area, they recovered between seven and eight ounces a day. Naturally, such a find couldn't be kept secret for long. Dr. Thaddeus Hildreth and a large group of unscrupulous men, all related, ran the Mexican miners off and renamed the gold field the "Hildreth Diggings." They discovered an unprecedented mile-wide band of surface gold. During the peak of the find they were removing an unbelievable 15 pounds of gold a day. News of the strike spread like wildfire throughout Northern California and the area quickly reached a population of 8,000. However, the easy pickings were soon gone, and within a few months most had left the area, chasing rumored and actual strikes in other areas. By late summer there were only 10 people left, but not before the town was formally named Columbia in April 1850.[3] Columbia became incorporated in 1854 and George Sullivan was elected the town's first mayor. During the peak of the excitement, Columbia developed a reputation for being the fastest growing, noisiest and wickedest gold camp in the mother lode.[4]

Finding that gold was no easier to dig up in other, less inviting areas, many of the miners returned to the famous mining camp. In the next several years Columbia's population mushroomed to 15,000, making it the third-largest town in California. There was even an unsuccessful movement to make Columbia the capitol of California.[5]

Back in the mid-1800s Columbia was known as the "Gem of the Southern Mines."[6] To visit Columbia, California, today is to take a trip back in time. Designated a California State Park in 1945, Columbia is the best-preserved gold mining town in California's Gold Rush district, and is now a popular tourist attraction for those wanting to visit a real "forty-niner" town. Over the

years Columbia has also been used as the backdrop for many western movies including *High Noon* (1952), *Texas Lady* (1955) and the 1982 CBS TV movie *The Shadow Riders* starring Tom Selleck. The town was also used for many exterior shots of *The Lone Ranger* television series in the 1950s. [7]

Every building has been restored with trendy restaurants, old-fashion soda fountains and souvenir shops occupying the old buildings where saloons, gambling establishments and brothels once vied for the miners' hard-gotten diggings. There is even a working blacksmith shop and newspaper office.

Pete found no evidence of the Sonora Aero Club in the area during the period covered by Dellschau's work. He did, however, find many items of historical importance concerning the two towns which correlated with some of the events and random notations contained in the Dellschau books. Mention is made in some of the books of an Aero built by one of the members that had burned in a fire in Columbia in 1858.

Pete found during his research that the town of Columbia was destroyed by fire at least three times. The first occurred in July 1854. All the buildings burned to the ground except one. The only brick building in town remained standing. Because of this, when the town was rebuilt many of the buildings were constructed of brick (although a large number were rebuilt of wood, the same as before).[8]

On August 24, 1857, the town was again consumed by fire when a Chinese resident, cooking supper, put some pork fat in a hot frying pan and the grease flared up. The shack where he lived caught fire, and in no time the whole town was in flames. Once again, the town was promptly rebuilt.[9]

The last big fire was in 1858.[10] It started in a building that housed the Woman's Christian Temperance Union reading room. It quickly spread to a shed where some oil was stored. From there it jumped to the next block. This time the fire was put out before it spread throughout the town. Supposedly during this conflagration August Schoetler's airship was incinerated.

Another circumstance that lends credence to Dellschau's statements is the fact that there were a lot of Germans in the town. In fact, after the first gold excitement had passed, Columbia developed into a regular German town with brass bands, breweries and beer gardens.

As for the town of Sonora, there is evidence that persons of intellect inhabited the town during the time of the gold rush. As early as the 1850s, Sonora was known to have had several bookstores and they were reported to have been doing a good business. There may be some significance in this, as it is definitely a contradiction to the popular conception that the inhabitants of mining towns in those days were a rough-shod group with absolutely no manners, much less schooling.

While in Sonora Pete went to the newspaper office of the *Sonora Daily Union Democrat*. He gave them a list of all the names mentioned in Dellschau's writings. They in turn sought the aid of the County Historian of Sonora, Mr. Carlo DeFerrara. They told Pete Mr. DeFerrara would be in touch with him by mail.

One thing of interest that Pete found out while in Sonora was that during the Gold Rush days some of the townspeople were members of a society of fun-loving jokesters known as "Clampers." They belonged to the Ancient and Honorable Order of E. Clampus Vitus. The basic principle of the organization was based on the premise that life was just a big joke and that it was against nature and a fraud on the public for any man to take himself too seriously. The top member of this organization was known as the "Noble Grand Humbug." Taking into account that Dellschau had made the notation "Humbug" in several of his drawings, Pete wondered if he might himself have been a member of this lodge during his time in Sonora. Were his intentions when preparing his books to perpetrate a huge joke on someone, at some future time, by creating and putting together a fantastic story of events and activities which he claimed to actually have happened?

While in Northern California, Pete was unable to find any of the names from Dellschau's list anywhere except for one. G.W. Gore started publishing Columbia's first newspaper, the *Columbia Star,* in 1852. The newspaper suspended publication after five issues. One source stated Gore founded the *Star* on October 28, 1851. Could this have been *Mike* Gore? The lead dies with this one bit of information.

A few days after Pete returned home to Houston, Mr. De Ferrara's reply arrived. Pete opened the letter hopefully.

> *I have been looking over information you left concerning the Sonora "Aero Club," allegedly active in this area in the late 1850s.*
> *I have run the list of 62 names through my indices, but I have been unable to identify a single individual. Unless the names are aliases or in code, they seem to have no local connections.*
> *The area you identify as being where the experiments were conducted (now the Columbia Airport) was known as the Lawndale Gulch and French Gulch areas at the time and was adjacent to the town of Springfield. It was quite heavily mined and thickly populated. Certainly, if any aerial activities were taking place there, someone would have noticed.*

Although Pete had been expecting just such a reply he was nonetheless

disappointed.

Mr. DeFerrara closed his letter by stating, however *"This does not necessarily mean that such activity did not take place, as it could have been carried out in a highly secretive manner."*

Pete put the letter aside. Once again the truth of Dellschau's story remained elusive. Mr. DeFarrara's statement that the work of the Sonora Aero Club could have been carried out in a highly secretive manner was indeed true. In fact, Pete thought, he would have been surprised if it hadn't been. And the fact that all the names of the club members were probably aliases or in code had already crossed his mind. The very fact that much of the information contained in Dellschau's books was written in code and symbols tells a tale. It was as though Dellschau, growing old and finding himself all alone, realizing that past events were slowly fading away in his memory, was compelled to put everything down on paper. Not only would he leave a recorded history of past events, but he would also leave a legacy and preserve the memory of his friends with whom he had worked in those days. But he would honor his pledge of secrecy by

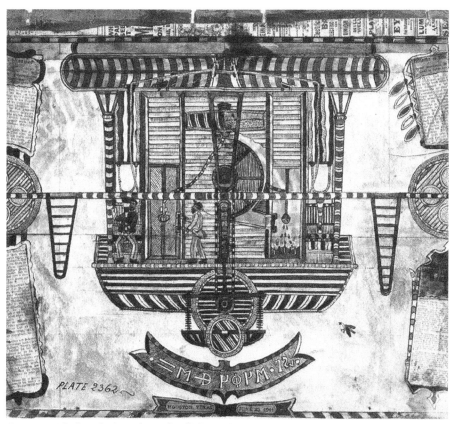

Fig. 18.1. Black and white photo of Dellschau's plate 2362. The P.G. Navarro Collection.

rendering his books in such a way as to discourage the casual investigator yet still have meaning to those who would spend the time and effort to try to interpret same. He realized that eventually the secrets hidden in his books would be realized and the world would know what the members of the Sonora Aero Club had accomplished. Dellschau was also aware, Pete presumed, of his personal danger were it known by certain people that he was revealing the club's secrets. After all, while the Sonora Aero Club's membership was mostly intellectuals whose only concern was building and flying machines in the sky, this might not have been true of the members of the parent organization, the elusive NYMZA.

Endnotes

1. *The Great Airship Mystery* by Daniel Cohen © 1981 by Daniel Cohen. Dodd, Mead & Co. N.Y.
2. *Gold, Booze and Boot Hill* by Doris Cerveri. Feb. 1971 issue of *Great West* magazine.
3. *Three Years in California: William Perkins' Journal of Life at Sonora.* William Perkins. © 1964 by the Regents of the University of California.
4. *Gold, Booze and Boot Hill.*
5. Ibid.
6. *When 49ers Terrorized the Mother Lode* by Leo Rosenhouse. July 1973 issue of *Great West* magazine.
7. Exterior Movie Locations, Columbia California. http://employees.oxy.edu/jerry/columbia.htm
8. *Gold Spring Diary. The Journal of John Jolly.* Edited and Annotated by Carlo M. DeFerrari. © 1966 by the Tuolumne County Historical Society, Sonoma California
9. Columbia History. Http://www.sierra.parks.state.ca.us/history.htm.
10. *History of Tuolumne County.* Herbert Lang. © 1882. B.F.Alley Co. San Francisco, CA.

Chapter 19

Water, Water Everywhere

Wouldn't it be something if the secret of their power was really water? The Earth is three quarters water, we could have virtually free energy.

— Jimmy Ward

HOUSTON, TEXAS, 1979

Fig. 19.1. Research/writer Jimmy Ward. Photo by P. G. Navarro.

Ten years after he first started unraveling the Dellschau story, Pete began to work with an associate, researcher/writer Jimmy Ward. Jimmy had worked as a cryptographer while serving in the 51st Airborne in the early 1950s. After his discharge from the army he put his cryptographer training to good use as a researcher into strange phenomena.

He had called Pete on the phone one day, explaining to him that he had read of his research into the intriguing Dellschau mystery in Jerome Clark's book *The Unidentified.* Since he also lived in Houston, Jimmy wanted to join forces with Pete in the research.

"What do you plan on getting out of it, Jimmy?" Pete asked soon after Ward approached him.

"Well, I just like to research such stuff. I'd also like to get the information into as many hands as we can. Who knows, someone might come up with all the answers." Pete liked Jimmy's attitude and they became close associates and fast friends.

"What would you like to tackle first?" Pete had asked Jimmy during that first telephone conversation.

"I'd like to have a go at the *NB* gas," Jimmy answered, "solve that and you've solved the puzzle."

"You got any ideas?" Pete asked.

"Well," Jimmy paused for a second, "didn't Dellschau say that the *soupe* was composed of an unknown element added to water?"

"Yes, that's true." Pete was pretty sure he knew where Jimmy was headed.

"Well, I've noticed in my study of the UFOs that many modern sightings seem to happen near bodies of water. Witnesses are constantly reporting seeing UFOs take on water as they hovered over lakes and such. I'm thinking this might be the connection we need to start with."

Pete smiled into the phone. "I think we're going to work good together. Can you come by tonight, say around seven? I'd like to show you what I've been working on."

Jimmy replied in the affirmative and after getting directions from Pete hung up.

Promptly at seven that evening Pete answered his doorbell and let Jimmy Ward in. He was a medium-sized young man in his late 40s. He had dark hair and bone-rimmed glasses, and was the type of person who was immediately likeable. After a few minutes of pleasantries they went upstairs to Pete's study. Pete spread several photocopies of old newspaper reports on his desktop.

"I was looking for the name Wilson and I began to realize how many of the meetings between townspeople and the 1897 aeronauts referred to water." He pointed at the photocopies. "Read the sections I've highlighted."

Jimmy sat down and read the yellow highlighted areas of the old newspaper copies.

Conroe, Texas, April 22: *A social game of dominoes at the Conroe Hotel was interrupted by two men who said they were from the airship and needed water. The domino players were Prof. G. L. Witherspoon, proprietor of the hotel; Major Dan D. Donahue, auditor of the Texas, Louisiana, and Eastern Railroad; Colonel A. H. Traylor, tax collector; and John Wahrengerger, local merchant. The four men were somewhat skeptical until they actually saw the 'wonderful aerial traveling machine' … rise majestically from the earth, illuminated by brilliant electric lights, and plow its way through space.*

The same night near Josserand, Texas, Frank Nicols, *a prominent farmer … looked out the window and was amazed to see the airship. He was accosted … by two men from the ship, carrying buckets, who asked his permission to draw water from his well.*

April 24, Eagle Pass, Texas: *Some frightened Mexicans ran to the house of the local Sheriff, R. W. Dowe, to report that a strange 'something' had descended from*

the sky and come to rest on the banks of the Rio Grande just below Fort Duncan. The sheriff grabbed his trusty shootin' iron and took off toward town to investigate. He found the crew of three and learned they had stopped to fill their canteens The crew invited Sheriff Dowe to join them, but he had to decline because district court was in session.

"Can you believe this?" Jimmy stopped reading and glanced up at Pete. "Talk about dedication, this sheriff didn't join the mysterious flyers because court was in session." He shook his head in disbelief and went back to the other clippings.

According to another clipping from *The Galveston Daily News* dated April 20, a crew of three men from an airship and the mysterious Mr. Wilson were entertaining Sheriff H. W. Baylor while taking on water. A bright light and the sound of strange voices in back of his residence in Uvalde first attracted Sheriff Baylor's attention. Upon investigating he found the men and their airship. They told the Sheriff that they were on a trial run and did not wish their presence known to the people of the town. One of the men gave his name as Wilson and said he was from Goshen, New York. He inquired about Captain C. C. Akers, former sheriff of Zavala County, whom he understood lived near there. He said he had met Captain Akers in Fort Worth in 1877 and had liked him very much and would be pleased to meet him again. When told that Captain Akers was now at Eagle Pass in the Customs Service, but that he often visited Uvalde, Wilson asked to be remembered to the Captain on the occasion of his next visit. After procuring water at the hydrant in Baylor's yard, Wilson and his three companions boarded the airship and flew away.

The newspaper made a further investigation of the Baylor report and contacted Captain Akers requesting him to let the public know what he knew about Mr. Wilson. The Captain's reply was published in the paper:

Noting that on that airship said to have been seen by Sheriff Baylor in Uvalde was a man who gave his name as Wilson, who claimed to have known me in Fort Worth. I can say that while living in Fort Worth in '76 and '77 I was well acquainted with a man by the name of Wilson from New York State and was on very friendly terms with him. He was of a mechanical turn of mind and was then working on aerial navigation and something that would astonish the world. He was a finely educated man, then about 24 years of age, and seemed to have money with which to prosecute his investigations, devoting his whole time to them. From conversations we had while in Fort Worth I think that Mr. Wilson, having succeeded in constructing a practical airship, would probably hunt me up to show me that he was not as wild in his claims as I had supposed. I will say further that I

have known Sheriff Baylor many years and know that any statement he may make can be relied on as exactly correct.

"Wow!" Jimmy looked up from the clippings with excitement. "That's a pretty heavy endorsement of the claim that a Mr. Wilson was flying around Texas in an airship in 1897." Jimmy turned to the next article.

On the night of April 21, 1897, a Mr. John M. Barclay living near the town of Rockland, Texas, observed an airship that landed in a pasture next to his house. He took his Winchester and went out to investigate. About 30 yards from the strange machine he was met by a man who requested him to lay his rifle aside as no harm was intended.

When Mr. Barclay inquired who he was and what he wanted, the man answered, "Never mind about my name, call it Smith." He would not permit Mr. Barclay to approach nearer the airship. After obtaining some things they needed for the repair of their ship, they again boarded the aircraft and flew away.

About two hours after the Barclay contact, an aerial visitor settled to earth in Harrisburg, Arkansas. It was reported that there were three men and a woman aboard. They were taking on a supply of fresh water. One of the men talked with a witness — an ex-Senator named Harris — and told him a story containing some information regarding the possible method by which the airship was made airborne.

It referred to a scientific invention made about the year 1871 by which the laws of gravitation were entirely and completely suspended.

The inventor, who was the aeronaut's uncle, had died and left the invention locked in a vault. After a lapse of about 19 years (about the year 1890) the nephew had been able to secure the invention, and having plenty of money at his disposal, had devoted his time and talent to experimenting. Finally, after having experimented for seven years he had eventually succeeded in developing and constructing an airship, which he was then testing.

He further stated that he flew his airship only at night to keep from being detected, as he was not quite through experimenting with it. According to his account, he was able to suspend all gravitation by placing a small wire around an object.

Jimmy put aside the pile of photocopies of the old newspapers.

"Have you noticed the diversified accounts given in the different reports of airship sightings regarding their possible motivational power, Pete? There is no mention ever of an anti-gravity substance or of an anti-gravity gas in any of them."

Pete shook his head in agreement. "I think that it is possible that each witness was given a different explanation of the means of propulsion on

purpose. I'm not calling the airship occupants liars, nor do I believe they had a habit of bending the truth. I think they felt they had to make these devious claims to hide the truth. But, one thing is for sure. The need for water is apparent in many of the reports."

"Wouldn't it be something if the secret of their power was really water?' Jimmy injected. "The Earth is three-quarters water; we could have virtually free energy."

Pete smiled, "Dellschau aside, Jimmy, that possibility does exist. Have you ever heard of Viktor Schauberger?"

Fig. 19.2. Air chamber from plate 3631. Its use is unknown.

Fig. 19.3. From plate 3619. What is in the chamber is unknown, as is its use.

Chapter 20

Forbidden Science

Water and Air, they contain all the power we need.

— Viktor Schauberger during
a presentation to Adolf Hitler

Germany, 1885 - 1946

Viktor Schauberger is known to many as *"the father of water."* Born in Austria on June 30, 1885, he became interested in nature at an early age. As a young boy he spent most of his life roaming the forested areas of Germany, studying and observing the movement and workings of the mountain streams and rivers. Viktor's father wanted him to follow in his brother's footsteps and go on to collage. He refused. Later in life he wrote,

> *The only possible outcome of the purely categorizing compact-mentality thrust upon us at school, is the loss of our creativity. People are losing their individuality, their ability to see things as they really are and thereby their connection to nature.*

Instead of going off to school he became a junior forest ranger, spending the next several years in Austria's remote forested areas. In that day and time many of the forests were still untouched by human hands. He was able to study nature in an environment unavailable to students today. It was during this period that he became aware of the levitational energies of water. One day he noticed the actions of the trout in a mountain stream and he wrote of the incident:

> *How did the trout actually manage to get to this spot? — and later I saw dozens of them in the stream — which was cut off by a 60-metre-high waterfall about a kilometer downstream.*
>
> *How was it able to flee upstream like a streak of greased lightning in mockery of all the laws of nature? How was it possible for this fish to stand so motionless, only steering itself with slight movements of its tail fins, in this wildly torrential flow? What forces*

enabled the trout to overcome its own body-weight so effortlessly and quickly and at the same time overcome the specific weight of the heavy water flowing against it?

Viktor studied the water like it was an obsession. He noticed that rocks accumulated in many places under waterfalls. The ones caught directly under the spot where the water hits the pool were in constant motion, sometimes even bouncing upwards. How did they rise against the force of the water? He studied temperature differences between water as it flowed through sunny and shady spots. He discovered that water was drawn to shade, and that the twists and turns of streams and rivers were due to water's natural tendency to want to be as cool as possible. In other words, his theory was that water could feel the temperature. Not only that, but Viktor believed that water *"thinks"* in a natural way. Water seeks to be cooler. He also discovered that the cooler water is, the heavier it becomes. He also found that water left to find its natural course would build up an energy force that flowed in the opposite direction. It was this force that caused the rocks to rise at the foot of a waterfall. This was also the same force that trout and salmon used to leap over waterfalls and travel effortlessly upstream against a swift current.

As a young man Viktor invented and patented a machine that would make any water into high-quality drinking water. However, he must have stepped on some official toes, because the Austrian Army reportedly confiscated and destroyed the machine.

His ideas about water management were too advanced for both the scientific community and the government. When he tackled the problem of saving the dying Rhine River his ideas were ignored. Today many in the scientific community agree with his ideas.

In 1931 he teamed up with a Dr. Winter, an engineer from Vienna. Their aim was to construct a machine that would produce energy using nothing but water and air. He called the machine the *trout turbine.* Air and water were directed into the machine through *spiral-shaped pipes of a particular material* with a *specially cross-shaped cross section.* As the water and air mixture spun through the machine and reached a *certain count of revolutions* it was *directed into a corkscrew motion,* at which point the energy was released. The point being to *screw* together the water and air without resistance just as he had observed it happening in Nature. Viktor built two machines. One of them allegedly tore itself off the foundation and went crashing against the ceiling. He had proven to himself that water and air could be combined to produce power; however, he couldn't control the amount of energy released.

Using the same principle, Schauberger also developed an engine to be used

in airplanes using air as the only fuel source. *It would suck in the air and convert it to fuel while flying, and at the same time create a vacuum in front of itself in which it could move continuously without resistance.* During World War II a model of this engine was reportedly tested successfully.

In 1943, under orders from Himmler, Schauberger was taken to the concentration camp at Mauthausen and offered a choice. He could work on their supposedly ultra-secret "flying saucer" project or be hung. Viktor took the first choice. Using the principles of his trout turbine he developed a small saucer. According to Schauberger, *if water is rotated into a twisting form of oscillation known as 'colloidal,' a build up of energy results, which, with immense power, can cause levitation.*

Shortly after that Americans occupied Leonstein, where Viktor was conducting his experiments. They took him into "*protective custody*" and kept him for six months. Then the Russians came in. They blew up his apartment and took most of his research papers away. Allegedly, none of the latter has since been seen.

In a letter to the West German defense minister on February 28, 1956, Viktor was reported to have written of the experiment with the "flying saucer" that "*the apparatus functioned on first attempt … and rose upwards, trailing a blue-green, and then a silver colored glow.*"

A few weeks later Jimmy went over to Pete's house to compare notes. Jimmy was visibly excited as he walked into Pete's study.

"Didn't you say that *NB* gas had been shown by Dellschau to be a mixture of water and a green substance?"

Fig. 20.1. From plate 4308. According to Dellschau these two ingredients mixed in equal parts produce an anti-gravity gas.

Pete nodded. "Dellschau called the green stuff *supe*."

"Then read this, Pete," Jimmy said as offered him a file folder. "I think you'll find it interesting." Pete opened the cover and began to read.

> *On July 13, 1979, the story of Guido Franch and his "Mota-Fuel" made newspaper headlines nationwide. He claimed he could turn ordinary tap water into 105-octane gasoline by merely adding some green crystals to it. He demonstrated his remarkable fuel to executives and experts of the Ford Motor Company, Standard Oil and Earl Eisenhower, the famous General and past President's brother. With a fuel shortage in full swing, his announcement was met with a great deal of interest.*

Pete sat up straighter. "Green crystals ... hmm. You might have something here, Jimmy." He returned to the report and read the whole thing without pause.

> *Franch, 69, of Villa Park, Illinois, had been subpoenaed to appear in Federal Court with records "relating to the purchase of any fuel, fuel powder, or fuel formula in [his] possession or under [his] control since 1968."*
>
> *Franch did not claim credit for discovering the mysterious fuel, only for converting the formula. He claimed the real inventor was Alexander Craft, a German scientist who died in 1941. Kraft was a rocket fuel expert involved in "doing research way ahead of his time."*
>
> *According to Franch Mr. Craft had approached him in 1925 and given him the formula. Franch claimed he could make one pound of granules out of 25 pounds of coal and that it cost him about $100 to make a pound of granules. Mass production would drive the cost down to about $4.00 a pound, or about 8 cents a gallon. However, Franch refused to reveal to anyone the formula for making his fuel. Anyone interested in investing in his fuel was given a greenish liquid that smelled like cleaning fluid. After being mixed it would not mix with additional water. However, it did burn and even powered automobile engines without causing any damage. No comment ever came from those corporation people who saw the demonstrations.*
>
> *He was later charged, tried and convicted of bilking large sums of money from his investors.*

Pete stopped reading. "What do you think, Jimmy, was Franch really a con man? Do you think he really could convert water to fuel?"

"I don't know, Pete, but, I find it strange that during the trial, the matter of whether he actually could or couldn't convert water into fuel was hardly mentioned. More curiously, the allegation that his 'Mota-Fuel' was a hoax was never mentioned. In fact, there was no mention of a hoax at all. Only that he had 'stolen' money from his investors."

Pete said aloud, "Interesting that he should be using green granules and water."

According to Franch the reason he wouldn't reveal the formula of his fuel was because of what happened to Mr. John Andrews. He claimed that the mysterious "Mr. Kraft" had taught Mr. Andrews. In 1917, Andrews used a green powder to convert seawater to gasoline before the astonished eyes of several US Navy big wigs. Even though it was tested in the tank of a motorboat and proved more than satisfactory, the Navy was "not interested." In fact, he seems to have been unable to find anyone who was interested. Then he disappeared before the secret process was divulged.

However, he reappeared briefly in 1935 and it was reported that he converted tap water into fuel before members of the Bureau of Standards and gave a demonstration of its power, but they too declined to take action. Shortly after this exhibition he was found murdered in the basement of his home in Liberty, Pennsylvania. No powder or formula was found anywhere in his house. It was rumored that he had given everything to his sister who lived in England. She was also found murdered in her home less than a year later. Again no powder or formula was found. Franch said he feared for his life if he divulged any more information.

There are stories of other inventors who appear to have been able to transform water into something resembling gasoline. All of them have the same basic elements; green granules or powder made from coal added to water. Typically the alleged inventor never takes full credit for his discovery and declines to divulge the secret process for creating the mysterious green granules.

"Jimmy, do you believe that some of these reports of fuel made from green granules and water are true?" Pete asked, "Could one, or all of these formulas be one and the same? Maybe even the half of Peter Mennis' formula called "*supe*" which made his *NB* gas?"

Jimmy shrugged and smiled, "I don't know ... but I do find the coincidence intriguing."

Pete also found it interesting.

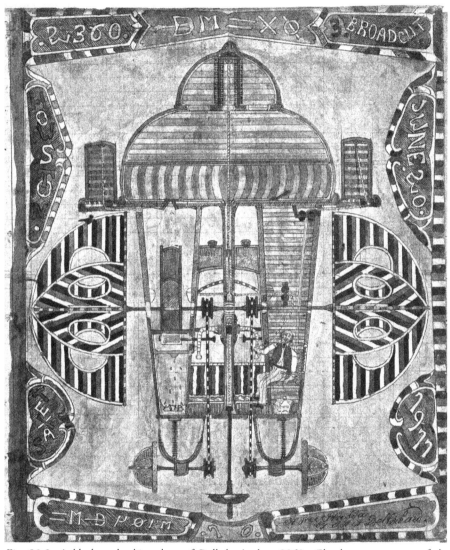

Fig. 20.2. A black and white photo of Dellschau's plate 2360. Clearly seen are some of the mechanisms that make the Aero fly. From the P.G. Navarro Collection.

CHAPTER 21

An Analysis of One of Dellschau's Aeros

I can ride the highest wave of any ocean,
And I move myself on land.

— Dellschau, plate 2024

As Pete spent more and more time studying Dellschau's books he wasn't exactly sure which Aero was the original prototype that had been used for later models. All indications pointed towards the *Goosey* as being the first Aero. Pete had discovered that the *Goosey* was actually named the *Aero Gander* until someone, maybe even Dellschau himself, began to call it the *Goosey*. This nickname took hold in the same manner that a Chevrolet became a "Chevy." Soon everyone in the Club was calling it the *Goosey*. Dellschau claimed that this Aero was designed, built and flown by Peter Mennis. The *Goosey* was one of the smaller of the airships and was designed to carry two people. While Aeros were designed in all sizes, from a one-man Aero to airships of monstrous proportions, they all had one thing in common: All of the designs followed the general aerodynamic principles and elements embodied in the *Goosey's* basic construction. If Dellschau was making these drawings up in his mind as he went along it's hard to believe that he would continue to use the same components used in his early Aeros to make up the working machinery in his later machines. Consider the fact that by the time of Dellschau's later drawings ,actual airplanes were flying in the skies. It seems that he would have changed his designs by incorporating known airplane features. The fact that he only showed evolutionary improvements (not abrupt changes) in his machinery and their way of operating the Aeros lends credence to the suggestion that the story he was telling was not fictional.

Without a doubt some of the Aero designs may be said to be veritable monstrosities, and it is doubtful that some of them could possibly have gotten off the ground, much less maneuver up in the air with all the gadgetry and cumbersome equipment Dellschau portrays being on-board.

But, Pete thought, *isn't that exactly what was once said about the modern airplane?* Of course, there were early airplane designs that never got off the ground either, and would probably look funny and unflyable to us today, but

eventually there was a workable model of an airplane that did fly. New ideas were incorporated into the early designs that grew progressively better until today we have actual flying monsters that, at an earlier time, no one would have believed would ever get off the ground either.

Pete turned his journal to a drawing he'd duplicated from plate 2522. The sketch was of the *Aero Babymyn.* The plate had the year 1858 predominantly featured. It also included the words "Sonora, California," "Gastav Kolbe - proposer" and "Drawn by C. A. A. Dellschau." The commanding object of the plate was a cut-a-way side view of the *Aero Babymyn.*

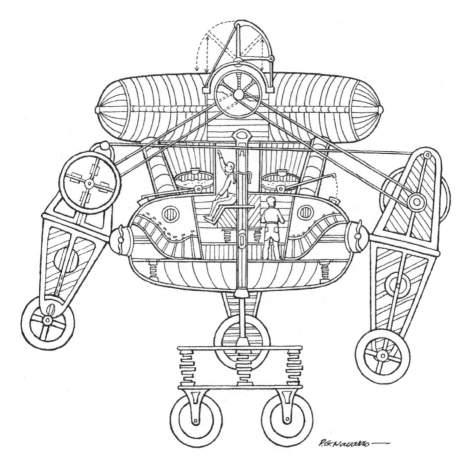

Fig. 21.1. Cut-a-way drawing of the Aero Babymyn.

In this drawing much of the working parts of the Aero were quite visible and Pete had been able to sketch the components in pretty good detail. He noted that there are certain things about it which seem ludicrous, to say the least. For instance, for a balloon-type airship of this sort the gas compartment

atop the machine does not seem large enough to contain the large volume of gas necessary to lift it. Not as we understand gas balloons today anyway. Of course, they still didn't know anything about the properties of Dellschau's claimed *NB* gas.

Pete turned to his latest journal and wrote across the top of the page:

Analysis of an Aero, the *Babymyn*

1. It will be seen that the main body of the airship, as shown in the drawings, is high on the center pole, which would indicate that the machine is Airborne.

2. The center pole is like a hydraulic lift, or jack, on which the body or carriage slides up or down.

3. When the machine (airship) comes down to the ground, the carriage settles down onto the platform that is over the wheels. (This will make it less apt to topple over when it is on the ground.)

4. The two pipes, or ducts on either side, which connect the body, or carriage with the balloon at the top are like extension bellows — which shorten or lengthen as the carriage moves up or down.

5. Whatever it is being injected into the left-side compartment (which is contained in a tank above the main body) is the substance that generates the power. This agent goes up the duct through the "portholes" which can be seen on either side of the body. It moves the machinery in the center-top of the airship and is ejected through the compartment on the opposite end.

Now here is where the "scientific invention" … the anti-gravity device comes in, which, according to the "aeronaut" whose description appeared in a newspaper article of 1897, consisted of a wire that was placed "around an object."

6. It will be noted that above the machinery of this Aero, or flywheel atop the airship is a device that can be moved so that it covers the machinery. This particular device may consist of a wire or wire grid that goes "around an object" and may very well be the device that is used to counter the force of gravity, and enables the airship

to rise. The movement up or down being controlled by the position of the "wire" over the machinery.

7. The thing attached to either end of the body are the rudders and propellers for moving and maneuvering the airship in horizontal, angular and side motion, as on a helicopter.

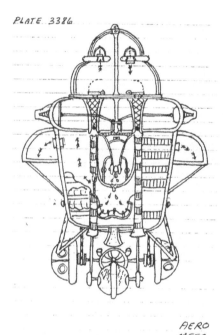

PLATE 3386

AERO
MEEO

Fig. 21.2. Drawing of the Aero Meeo from plate 3386. Note detail of machinery and equipment used to fly the Aero and the actions of the supe and NB gas.

Pete reread what he'd written. *Plain and clear, but how does it all work?*

Pete felt almost without a doubt that Dellschau was diagramming a working machine. The detail was too precise, the same pieces of machinery placed time after time on his Aeros. Pete shook his head. Nothing made sense.

If we are to accept reports of airships that supposedly cruised through the skies in the late 1890s and early 1900s as fact, then we must consider that there must have been "inventors" or aeronautically minded people at that time who were experimenting with new principles of flight; new means of "lift" for airships and new methods of navigation. But if that's true, where is the proof?

As has already been noted elsewhere in this book, it was the inclination of the scientists and inventors of the era to keep their experiments and inventions secret. And then there's the mysterious, powerful and obviously feared secret society known only as NYMZA.

PLATE 3204 ∘Ⓐ∘Ⓢ∘ ⒶⒺⓇⓞ ∘>

Fig. 21.3. Drawing from plate 2304. Another type of NB gas converter.

CHAPTER 22

Secret Connections

The only way to keep a secret is to keep it to yourself.

— Unknown

Everyone likes secrets. Everyone likes to belong and feel that they are "special." These two facts are what secret societies thrive on. From the cults of primitive tribes through the pagan/Christian Mystery Schools of the Middle Ages to the think tanks of today, secret societies have been an important part of the human experience. Many times since the beginning of recorded history these groups have used secret knowledge and a web of connecting societies to change the course of history or science.

In the mid-1800s every man worth his salt belonged to some kind of organization or Fraternal Order, secret or otherwise.[1] There was no television, shopping malls or NFL. For the entertainment value alone the monthly meeting of the local Order of Odd Fellows, the Modern Woodmen of America, the Knights of Columbus, the Benevolent and Protective Order of Elks, The Ancient Order of Druids, The Loyal Order of Moose, the Ancient Order of Foresters and many smaller groups was the highlight of many Americans' hard lives. The camaraderie, the feeling of belonging and the monthly break from everyday problems and chores was looked forward to with expectation. Most of these organizations were nothing more than they seemed.

People of common interests formed many of these Fraternal Orders with the idea of socializing and aiding each other in time of need. For a small fee most offered their members benefits in the form of help in the case of illness, old age or death. Actually most were no more than social clubs; however, there was one common thread throughout. They were patterned after the European secret societies. In particular most adopted the lodge system of the Freemasons. From the Freemasons came the idea of following certain rituals and conducting business in confidential meetings.[2]

A major attraction to these organizations is sharing secrets and hardships with like-minded people. The Sonora Aero Club – if it indeed existed outside Dellschau's imagination — was such an organization. Its common goal was to build an airship and members shared in secret their ideas and inventions. But the club was only the visible link. As with some of today's different groups and

lodges, lingering in the background are more sinister forces. From the "front" societies they recruit new initiates into the more secret brotherhood. These are the real "Keepers of the Secrets." The Brotherhood of the Rosy Cross (more commonly called the Rosicrucians) and the most secretive of all, the Illuminati (or simply, the Order[3]) are two examples of this type of secret society. Their main reason for existence is to keep the secrets of history, science, etc., so that the ancient knowledge will not be lost. At the same time they want to keep us ordinary people from knowing that which they decide we do not need to know.

None of these should be confused with another type of ultra- secret society. These are only spoken of in whispers while glancing over one's shoulder. They have names like the Assassins, the Tongs, and the Thugs of India.[4] These are actually private armies more than secret societies, but many of the rituals of the three types of secretive groups are the same.

What about NYMZA? Was it an ultra-secret society? We have no idea. But a good guess is that they were one of the "Keepers of the Secrets" types. The only information we have regarding NYMZA's alleged existence is Dellschau's vague hints that this was the Aero Club's parent organization and major financier. He also underscored the importance of the NYMZA organization by displaying the society's coded name prominently on almost every plate.

However, in many of the later plates of Dellschau's books the coded NYMZA was just as obviously missing. Why? Did the members of NYMZA disband? Or were they still around 40 years later? Were they responsible for the 1897 airship mystery? It's impossible to tell.

But one thing is known. There are many matching factors between the Dellschau Aeros of the mid-1800s and the ships seen flying in the skies of the late 1800s that make one wonder. For instance, some of the engine designs as depicted in Dellschau's books look remarkably close to what was described by witnesses to airship sightings in 1897. Then there is the aeronaut Wilson.

Wilson is quite a common name so the fact that both Dellschau's books and the 1887-airship saga contain the name is probably nothing more than a coincidence. However, the odds of two men named Wilson being involved in airship design and flight in the 1800s would be an even greater coincidence.

Pete had started this quest to find out if Dellschau had anything to do with the 1897 Airship mystery and ultimately anything to do with our own modern day mystery airships ... the elusive UFOs. Pete would be the first to admit that he could find no direct connection to either.

However, there are several tidbits of information that shouldn't be ignored. Pete and Jimmy Ward had studied the water connection between all three phenomena quite thoroughly. Peter Mennis' *supe* needed water to produce it, the 1897 airships were constantly taking on water, and many modern UFOs

have been observed taking on water, or at least being near a body of water.

Then there is the human factor. The members of the Aero Club were certainly human, and the reported pilots of the 1897 airships were human. When most people think of UFOs they think of aliens from outer space. (In particular, many think of the little round-headed alien that became the Smiley Face of the 1990s.) But during the height of the modern UFO contact reports beginning in the late 1940s and up through the early 1960s the contactees always described the occupants of the UFOs as human.[5]

So it stands to reason that at least some of the modern airships known as UFOs could possibly be from Earth, designed and flown by Earthlings. There is no direct proof to back up this statement; however, there is plenty of circumstantial evidence although the "experts" never mention most.

An examination of the early days of UFO studies finds all kinds of inconsistencies in what is popularly believed about these elusive modern airships. Probably the most common false belief about UFOs is that there is no physical evidence supporting the fact they exist.

According to Stanton Freidman, a well-known and respected nuclear physicist who has made a lifetime study of UFOs, "*There are 35 pieces of physical evidence that I know of.*"

Of course, many believe that UFOs are not solid flying craft at all. Probably the best piece of evidence supporting the belief that UFOs are real flying machines made out of a solid substance is the report by a young American Indian boy of his experience while hunting deer in the Uintah Basin of Utah.[6] According to his account, he and his father came upon a UFO and were "*so close that [the] father had shot at it.*" He added that "*they had heard the ricochet from the [bullet hitting the] UFO after which it rapidly took off.*" Surely these two experienced outdoorsmen would know the sound of a high-powered bullet ricocheting off of a solid object. They fired at and hit a physical flying machine.

Not only is there physical evidence pointing towards the fact that UFOs are in fact nuts-and-bolts flying machines, but there is also proof that many are probably of Earthly origin. For some reason, no one ever talks about the metal findings. And metal has been found; many times.

What is interesting is that the best-documented UFO stories — most of which contain good hard evidence — are the very ones the "experts" are quickest to cry hoax the loudest about. The three cases we'll look at here, out of the dozens of possibilities, have several things in common.

1) They were purposely chosen because of the many years separating these cases. Even with the spread of years between them these cases present a pattern of similarities that cannot be denied.

2) All three have been viciously attacked as "phonies" by those organizations

and certain media approved "UFO experts" whom we have grown to expect to debunk all sightings across the board. However, on closer scrutiny we find that in none of these cases can a solid case of fraud be proven. When pinned down and faced with this truth the skeptics' weak position is "the evidence is *too good* not to be faked."

3) In all three of the cases pieces of metal have been found and analyzed.

The famous 1897 Aurora, Texas, Airship Crash is often called a hoax. Yet there were metal fragments found. The gentleman who collected the fragments of metal from the bottom of a well, located by extensive research, paid a high price. Pictures of his hands look as though he had a bad radiation exposure; they were red, raw, and swollen almost to bursting. The pieces of metal were turned over to the staff of the television show *Encounters: The Hidden Truth*. The results as reported on their Sunday, December 8, 1994 show were that "The metal was 90% pure aluminum." According to the report, "It is hard for us to refine 90% pure aluminum today and would have been impossible with the technology available to people in 1897."

And most telling of all, no *foreign* elements in the samples. All the metal samples contained earthly elements.

Most experts and researchers regard the famous Kenneth Arnold sighting of nine unidentified flying objects over Mt. Rainier in Washington State on June 24, 1947, as the beginning of the modern age of flying saucers. However, three days before Arnold's report there was a potentially much more important sighting.

On June 21, 1947, two harbor patrolmen — Harold A. Dahl and Fred L. Crisman[7] — were on patrol in their boat near Maury Island, one of Washington State's coastal islands. With them were Mr. Dahl's son and a pet dog. Suddenly their attention was drawn to a group of strange objects in the sky above the island. As they watched, one of the objects began to discharge "what seemed like thousands of newspapers from somewhere on the inside of its center." At the same time, "black or darker type metal which looked similar to lava rock began to fall from the vessel." All of these fragments of metal "seemed hot, almost molten. When they hit the bay steam rose from the water." Pieces of this strange metal hit the wheelhouse of the patrol boat and caused extensive damage. Mr. Dahl also reported that his "son's arm was injured by one of the falling fragments and our dog was hit and killed." The fragments of metal, which were too hot to handle, eventually cooled enough for the two men to gather. "What had looked like falling newspaper also turned out to be a strange metal."[8]

Ray Palmer, editor of a small magazine who was writing a story on the

"saucers," hired Kenneth Arnold to fly to Washington State to interview the two men and look into their claims and collect some of the material they were reported to have retrieved. What happened next is typical of such finds.

> *A military intelligence officer called on Mr. Arnold and took away from him every piece of metal he had from Maury Island ... The military man took Mr. Arnold to a smelter's works and pointed out tons of material that he said "was exactly like the fragments. It is only smelter's slag that you found in Maury Island," said the officer, smiling.*
>
> *He did not explain how that could be when there is no smelter's works in this very sparsely populated island, nor is it used as a dumping ground.[9]*

A question never answered: If Arnold's samples were nothing but slag why did the ATIC officer insist that Arnold turn them over to him?

Fortunately, Mr. Dahl had sent a cigar-box full of the metal to Ray Palmer before the intelligence officer arrived on the scene. Mr. Palmer had the metal fragments analyzed. The analysis of the fragments reported high constituents of calcium, iron, zinc and titanium. According to the report the metal also contained aluminum, copper, magnesium, silicon, nickel, lead, strontium and chromium. There were also traces of tin and cadmium.[10]

As reported by Palmer,

> *Nothing of an unusual nature exists in [the makeup of the metal] except the unusual high quality of calcium and titanium. It is interesting to note that titanium; one of the constituent metals, is now believed to be the key metal in constructing missiles or ships capable of space travel. Also calcium has an affinity for particles of radium, and the ability to capture them and prevent contamination of surrounding areas.[11]*

The final conclusions were that the metal fragments sent to Palmer were not composed of slag nor were they natural rock. The most telling findings in regards to our study are that the metal fragments were composed of earthly elements. There were no strange outer space elements in the makeup of the samples. This of course points toward an earthly source for the metal.

This is not the only case of metal being dropped from UFOs. According to John Keel, another well-known and highly respected early UFO investigator,

The flying saucers have been spewing all kinds of trash all over the landscape ... We can start with the slag dumped from the sky [over] Maury Island ... Heaps of this stuff have turned up since in New Hampshire, Michigan, Indiana, Pennsylvania, and many other places following UFO sightings. It has often been found on hilltops and deep in trackless forests, places where it had to be dumped from the air.[12]

Another well-documented case of a UFO dropping metal happened near Campinas, Brazil. Several witnesses saw a group of UFOs in the sky on December 23, 1954. They observed one of them suddenly drop a "silvery liquid material that fell to the ground as hot molten metal." Upon being analyzed, chief chemist Dr. V. Maffei of Young Laboratories, reported that "the sample was 88.1 percent tin and 11.9 percent oxygen. The latter was simply the result of oxidization as the metal cooled and absolutely no other element was found; this was, in fact, 100 percent tin." Once again, a pure metal that would be hard for our labs to produce even today. And again, all earthly elements.[13] Bits of metal falling from UFOs are not the only pieces of solid evidence that have been found. One of the most exciting finds of all time happened near Silpho in Yorkshire, England. In 1958 a very small *"space toy"* landed in a field just outside of town. The copper-colored saucer-shaped object was glowing hot when it landed. Inside the "circular opening at the top ... was some copper piping and a copper scroll with writing on it."

The British Non-Ferrous Metals Research Association reported that the copper shell was of exceptional purity. This immediately put it out of the normal run of coppers that a hoaxer could have obtained. Commercially available coppers have different impurity atoms added to make them tougher, or easier to cut, more suitable for the electronics industry etc ...

"The copper scroll material was analyzed by the Department of Metallurgy at Manchester University and they came up with a similar degree of purity. However the scroll was not a single sheet, but consisted of three very thin sheets laminated together ... the research chemist of our group, George Elliot, was unable to show any signs of crystalline structure or of normal means of fabrication. It was as if the copper were formed as one giant single crystal – something unknown in the world of metallurgy ... On examination the shell [of the small saucer] proved to be formed like a sandwich of copper sheets with a material looking rather like the

adhesive Araldite as the filling. But even that was not simple, for it was found to be a form of polystyrene of such high molecular weight that Elliot was sure no one had managed to produce anything like it commercially and was doubtful if it had been fabricated in the laboratory.[14]

Again, earthly elements and advanced technology.

Probably the best studied and analyzed pieces of metal allegedly coming from a UFO was presented to researchers by Billy Meier, a Swiss farmer who claims to have had many contacts with a group of UFO occupants. One of his contacts, a female humanoid, gave him five pieces of metal and explained that they represented the five steps used in creating the outside skin of their airships. These were turned over to respected chemist Marcel Vogel.

Vogel had worked for IBM for 22 years. He holds 32 patents and was the inventor of the magnetic disc coating memory system still used in IBM systems today. After running many tests on the fragments Dr. Vogel reported that one microscopic area revealed "an enormous mélange of almost all of the elements in the periodic table" and each was exceedingly pure. What intrigued him more than the number of elements and their purity was:

> *their discreteness; each pure element was bounded to each of the others, yet somehow retained it's own identity.*
>
> *But even more surprising was that the major element present in [one of the samples] was the rare-earth metal Thulium. Thulium was only purified during World War II as a by-product of atomic energy work, and only in minute quantities. It is exceedingly expensive, far beyond platinum, and hard to come by. Someone would have to have an extensive metallurgical knowledge even to be aware of a compound of this type.*

In conclusion Dr. Vogel stated that "I could not put [the metal] together myself. As a scientist, I think it is important that those of us who are in the scientific world sit down and do some serious study of these things instead of putting it off as people's imaginations". [15]

As we might expect, the Billy Meier case is the most highly disputed case of all time. However, no one has ever been able to explain or recreate any of the astonishing amount of evidence he has provided to back up his story.

As the picture of analysis of metal findings from UFOs emerge two things become clear. The metal samples coming from reported UFOs have all been

composed of elements that exist on earth. There have been no alien elements found. Yet the ability to produce these artifacts is reportedly beyond our modern technology.

What does all this have to do with Dellschau and the members of the Sonora Aero Club? Nothing directly. However, it does give strong support to the possibility that somewhere on this planet a secret group could be making strides into scientific areas we can only dream of. And pretty much keeping it a closely guarded secret.

At least one whistle blower claims just that. In his hard-hitting, well-documented book, *The Cosmic Conspiracy* (1992) Stan Deyo claims that as a young US Air Force Academy cadet he was issued secret orders to proceed to Australia to work secretly with scientists on anti-gravity projects. As reported in the *Eclectic Viewpoint* newsletter for January of 1997:

> *Deyo the ex-cadet, as a protégé of [Dr. Edward] Teller and Dallas-based radiation researcher Dr. James R. Maxwell, began learning of an extensive, international network of ati-gravity projects being conducted in secrecy while at the same time being recruited to participate in them.*

Fig. 22.1. A Max Heiss proposal from plate 1997. But a proposal for what?

If what Mr. Deyo reports is true — and he presents plenty of documentation in his book to back up his claims — then there is a slim possibility that part of that international network working on secret anti-gravity projects could be the modern inheritors of the Sonora Aero Club under the direction of the ultra-secret NYMZA.

Endnotes

1. *Modern Secret Societies*. Charles A. Blanchard, D.D. © 1903 by the National Christian Association.
2. Ibid.
3. *Final Warning: The History of the New World Order*. © 1984, 1994 by David Allen Rivera. Published by American Quick Press. Harrisburg, PA.
4. *A History of Secret Societies*
5. *The Walton Experience* © 1978 by Travis Walton. The human crew member was a fact "overlooked" in the movie of Mr. Walton's experience, "Fire in The Sky." *The Interrupted Journey* © 1966 by John G. Fuller. This story of Barney and Betty Hill's abduction is one of the most studied abduction cases ever. The crewmembers of the UFO they described under hypnosis were human looking.
6. *The Utah UFO Display: A Biologist Report.* © 1974 by Frank B. Salisbury .
7. In a case of "it may or may not" have anything to do with Mr. Crisman's involvement with this important sighting it should still be noted that this Fred L. Crisman is the same man identified as being one of the three "tramps" arrested in Dallas Texas on November 22, 1963 in connection with the assassination of President John F. Kennedy. Their involvement in that crime has never been satisfactorily or fully explained.
8. *The Coming of the Saucers.* (1952). Ray Palmer and Kenneth Arnold. Amhurst Press
9. *Flying Saucers on the Attack*. (1954). Harold T. Wilkins
10. *The Coming of The Saucers.*
11. *The Coming of the Saucers.*
12. *UFOs: Operation Trojan Horse*. (1970.) John Keel
13. *UFO Quest.* (1994.) Alan Watts
14. *UFO Quest.*
15. *Beamship: The Meier Chronicles.* VHS. ©1885 INTERCEP

CHAPTER 23

Peter Mennis: Making it All Work ... With Alien Technology?

Nothing new on Earth says Brother Caro — Flying today, with gas, with or without either. Did you ever hear of Mennis? Peter flew for years, in lull or blow in Goose.

— C. A. A. Dellschau, plate 1878

HOUSTON, TEXAS, 1980s

After careful study Pete realized that if the dates accompanying the drawings of the aircraft indicate the year they were built, the *Goosey* was designed and built in 1857. The motors for the Aero were made or invented a year before, sometime in 1856. It is probable that work on the motors or even the Aero itself were started prior to the charter date of the Aero Club. Possibly even before the group settled in Sonora.

Pete knew from studying Dellschau's writings that the artist's mastery of the English language left something to be desired. However, in most instances the meaning of his words are quite clear and there is little doubt about what he is trying to convey.

In plate 2099 Pete found a notation that reads *"Peter Mennis' Goose, the mother of all!"*

To Pete this was perfectly clear. Finally, Pete was certain of what he'd thought all along. *The Goosey* was the first Aero.

Pete was also positive that it was Peter Mennis who either discovered or was given the formula for the *soupe*, the green ingredient that was the basis for the Aero's fuel and was used for both lifting and providing the motive power. And that he was the only one who knew how to make it.

In one unnumbered plate two other members wanted to make improvements to the *Aero Goosey* and then test-fly their ideas. Dellschau tells us *but P. Mennis would sell no soupe —— and they could not make it themselves. They had to stay on earth.*

Further evidence of the reluctance of Mennis to disclose his secret of the fuel formula and manufacture, or to cooperate in other matters in which his advice or assistance was needed, can also be found on plate 1892 in which Peter

is quoted as saying *Let me give Mike Gore my little finger — and — he got me — soul and body!* Meaning he wasn't giving Make Gore anything. The question is: Why was Peter Mennis so reluctant to cooperate or confide in other members of the organization? Was he just a selfish sort? Could it be that this secretive attitude of Mennis was the cause of the eventual failure of the organization to accomplish their objective?

There were other examples of non-cooperation or a lack of willingness to help each other. They were not working together as they should have in order to advance their efforts in a practical workable form. In fact, in some cases they were actually working against each other

But Pete didn't want to think too harshly of Peter Mennis yet. Mennis seemed to have been well-liked by the other members of the club as they relied a lot on him because of his ingeniousness. It may have been that Mennis sometimes felt he was being taken advantage of and of being used.

An example of the reason for this possible feeling on the part of Peter Mennis may be gotten from a remark by Gasper Gordon. In explaining the construction of his proposed airship design, Gordon stated that his idea for the *Aero Lowdown* was a good one. That "his airship would work day or night, in storm or in lull, rain or shine. All that he needed was to have Peter Mennis *join him.* That is, assist him, and they'd find out the truth of his statements. But apparently Peter Mennis was aware of Gasper Gordon's well-known habit of boastfulness and may even have had doubts about the validity of his statements. In any event, it seems that Mennis knew Gasper well enough not to go along with him on his ideas and, as he said in plate 1824, *the trap didn't catch,* which Pete took to mean that Mennis did not fall for Gordon's plans to coax him into working on his *Aero Lowdown.*

Pete realized that if he was correct in presuming that the *Goosey* was actually the first Aero built by the Sonora Aero Club, and that it was designed and constructed by Peter Mennis, then it is very likely that Mennis was the first man to fly a navigable airship, the *Aero Goosey.* That was quite a claim.

It seems that although members of the club generally were against the use of aircraft for military purposes, they nevertheless sometimes contrived to make Aero designs with features that were designed for the use of war. It may have been that through the suggestion of a certain unnamed military official, who once approached them with the idea of using their Aeros for military use, that they were induced to convert some of them and to adapt their ideas to possible war use.

They presumably worked on an idea for the conversion of the *Goosey* to a war machine and called it the *War Goosey.* But since this idea was proposed by

the probably non-existent Professor Des Jehtnich it is possible that this whole *War Goosey* idea was done as just a joke. It may be that their efforts at creating a war Aero were nothing more than a big inside joke, or perhaps it was just an exercise in creativeness, because *desjeghnich* means *it won't go*. When they worked on an Aero that had uses for war, they would attribute the proposals for such aircraft to a fictional character which they had invented and whom they called Professor Max Des Jehtnich.

Dellschau once took the design of Mike Gore's *Aero Dora* and converted it into a warship calling it the *War Dora*. He did this conversion, he said, *to keep up with the times*.

Another of their military Aero designs was the *War Aero*. Although originally designed by Jourdon, it was actually a product of the combined efforts of several members, including Michael Gore, Dr. Saxe and Peter Mennis. Why did they work on these designs for war Aeros when they obviously did not care to use them for war purposes?

Pete had discovered in Dellschau's coded writings that the military had heard of the club's efforts to design navigable aircraft, approached its members and offered to buy converted Aeros for use as weapons of war. Even though the members had rejected the involvement with the government perhaps some of the members, including Dellschau, were interested in finding out for themselves whether the Aeros could be converted into war machines. However, Dellschau knew that a war wagon wasn't in the future for the club.

Since Peter Mennis had the say so in matters concerning the *NB* gas supply to be carried aboard the airship, Dellschau was of the opinion that Peter Mennis' attitude would be to call it *nonsense* to try and fly at high speeds and not carry enough fuel.

It was about this time that Jimmy Ward injected a possible angle to Peter Mennis' involvement in the Sonora Aero Club that opened a whole different way of looking at the mystery.

"Pete, I think I've about come to a conclusion regarding Peter Mennis," Jimmy began shortly after he arrived at Pete's house to exchange information and review their thoughts. Pete sat back in his chair and nodded for Jimmy to continue.

"Well, it seems to me that his comings and goings in California during the mid-1850s fits a pattern that has been frequently encountered since early times in 'contact cases.' Cases where some Alien being contacted a scientist, or group of scientists, and gave them some new ideas on how to develop or work on an entirely new, far advanced project for the good of mankind. In this case that would be the *soupe* and *NB* gas. The formula for an energy source for

flying machines was given to Mennis during the first contact. Then the Alien demonstrates the possible powers of the unknown chemical substance, usually described as 'almost magical.' In subsequent visits the contactee, Peter Mennis, was instructed and helped to design a simple Aero to prove to him that the *soupe* actually worked. He later took these designs to the members of the Aero Club, and out of their work came the *Aero Goosey.*"

Jimmy stopped for a minute and looked across the desk at Pete. Pete was mulling over what Jimmy had just said. Not wanting to break Jimmy's train of thought Pete just nodded at him to continue.

"Well, if it followed the pattern of other such meetings between Aliens and the special people they choose to contact, after Mennis had been given the formula, or more probably only a small supply of the ingredients, not the knowledge of making the *soupe* … and helped to understand the workings and design of the *Goosey,* the Alien life-form told him to go and find a group to help him build the craft. That he, the Alien, had to leave for a bit but that he would return shortly. The problem is, he never returns, and Peter Mennis must protect and ration out his diminishing supply of the *soupe* still anxiously awaiting the return of its supplier."

Pete removed his glasses and rubbed his eyes, "You know, you just might have something there, Jimmy. That would explain several of the questions we've been asking ourselves. It explains his stinginess when it came to giving out the fuel and his guarding of the secret formula. You can't share what you haven't got. And when it was gone, it was gone. That could have been the end of the Sonora Aero Club."

Pete also remembered that back when they'd been studying the German translations of Mr. Walzem, Rudolph had commented that sometimes it seemed as though Dellschau writings were the writings of a man from another world, looking down upon the Earth. Pete hadn't really though about it at the time, but it could fit. After all, Mr. Walzem had said that Dellschau's German was stilted, like he was not a German at all. Dellschau looked German and could have merely assumed that nationality. Hadn't Mr. Walzem also given his opinion that German may have been Dellschau's second language?

Pete rubbed his chin for a second. "But, one question still bothers me. If this is true, why do you believe the Alien would have done such a thing? To give Mennis a small amount of an advanced power source and the plans to build a flying machine and then to just vanish. It doesn't make sense."

"I've though about that myself," Jimmy began to explain. "You have to put yourself in the Alien's shoes. Look at their agenda as a long-range plan. What have they accomplished?"

Jimmy stopped and looked at Pete. Pete just waited for Jimmy to continue.

He seems to have thought it all out, Pete realized, and he had no concrete objections so far. Jimmy nodded his head slightly, reading from Pete's body language that he wasn't ready to comment just yet.

"Remember, Pete, I'm using a pattern that has already been established in such cases. What has been accomplished is a group of intelligent people have been pointed in a direction of experimentation and study which they may have never taken had the Alien not intervened. The object being to 'jump start' an area of human achievement in technology that seemed to be feebly heading in the wrong direction. It seems that these Alien 'helpers,' for lack of a better word, always give the chosen contacts a nudge in the right direction by giving them hints, but never the whole solution."

Ward glanced at his watch and announced that he had to go.

"You just might have something there, Jimmy. But, here's another thought," Pete said as he got up from the desk to escort Jimmy to the door. "You know, as Dellschau mentions more than several times, Peter Mennis also used to disappear. Could Peter Mennis have been the Alien himself?"

Jimmy laughed as he followed Pete out of the study, "Thanks, buddy! As usual I bring you a possible answer and you give me more questions to ponder."

The next time Pete was with Rudolph he asked for his thoughts on the possibility of there being an Alien connection.

"There does appear to be an Alien purpose behind it all," Rudolph replied quite seriously. Then started laughing. "Seriously, though, it is an option. I mean nothing is really known about Dellschau until he shows up in Houston at the turn of the century. Sure, we've built him a timeline back to Germany. But that too is based on guesswork and 100-year-old documents. Actually it all boils down to a few facts. We know he existed. We know he made these drawings. But, other than a few fading documents and the thousands of drawings by Dellschau we have no proof of anything. It could very well be that Aliens from another world might just have picked someone from Earth to do their work. Dellschau might have been just a henchman of theirs. Perhaps they didn't tell him everything … only that he tell no one what he knew. Maybe that's why he was so secretive."

Secret Societies and now Aliens, Pete thought. *Actually, as usual when it comes to the secrets of Dellschau, further study is needed.* Pete shook his head in bewilderment as he said goodnight to Rudolph at the front door.

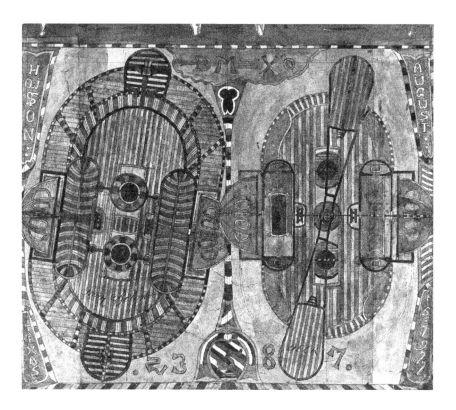

Fig. 23.1 Black and white negative of plate 2387 showing two views of an Aero. One "from below" and the other a "deck" view. Note how details stand out when switched to a negative view. From the P.G. Navarro Collection.

Chapter 24

Aero Fuel and Power Plants

*Flying today, whit gas … whit machine only but too
fit in fine weather … and out here on a long, long trip
her in the enemy's grip, what becomes of heat of gas?*

— Louis Caro, Jr.

Houston, Texas, the 1980s

At their next meeting Jimmy Ward brought out the matter of the paddle-wheels which are on most of the airships.

He said their function as propellers was absolutely nil since they wouldn't accomplish anything the way they were designed. He said they were probably gyroscopes for stabilizing the aircraft in flight, and for steady inertia. He felt that the "bells" on the Aeros — on the rudder like devices — may actually be exhausts. *I'll have to study this one out,* Pete thought, *I was thinking they were landing lights.*

Jimmy also felt the openings on the airship flange area around the gasbags might be nozzles for navigation purposes; e.g., for thrust.

He said the "balancers" also didn't work as is supposed (like the tail of a kite to keep it balanced). He noticed that the barrels (or balancers) slide or

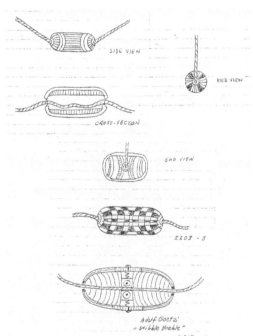

Fig. 24.1. A page from a journal showing rough sketches of "balancers" and "wibble-wobbles."

tilt on the rope or cable holding them, like they were not used so much for balance as for *landing*. "They were useful for landing and for movement on the ground," Jimmy said.

That's why its called a wibble-wobble, I suppose. It keeps the airship from wobbling while on the ground, Pete thought. *Jimmy might have something here.*

Since Jimmy was so interested in the *NB* gas, Pete decided to ask Roy and others in the growing *wonder weavers* group to concentrate on the possible energy source and how it worked in conjunction with the Aeros' machinery. They spent many hours individually and together studying and trying to figure out the function of certain features of the Aero engines and their components.

Without a doubt it was Mennis who designed and built the first motor to use the *NB* gas. In plate 4578 is a notation which reads, *P. Mennis — 1856 — Airpress Motor — Laughed at — soon needed.*

Pete interpreted the above to mean that Peter Mennis invented the Airpress Motor in the year 1856 and that the other members of the organization laughed at his contraption. But that soon they were to find that there was an actual use for it as it was practical, and needed by the Aeros for propulsion and navigational purposes.

Actually, there seemed to be two types of power units in the Aeros. One had a drum (or rotating, hollow, barrel-like unit) which was covered with a black substance upon which the liquid was dropped, and evidently penetrated the black substance into the central hollow area where a type of grill (or tooth-like) protrusions lined the inside.

The other type of power unit did not have the barrel-like contrivance. Instead, it had a chamber into which the liquid fuel was injected directly onto the black substance which lined the inside of the chamber. However, some of

Left: Fig 24.2. Two different configurations of one type of Aero power unit. The top is from the Aero Newell (plate 1926). The second from a second version of the Aero Newell. (plate 1941).

Right: Fig. 24.3. This second type Aero power plant comes from plate 4730 and is a "centralized unit" according to Dellschau. Note the lack of a drum in this machine.

these chambers also are drawn with the spike-like protrusions sticking out of the black substance.

Fig. 24.4. Side view of the air press motor from plate 4570.

Fig. 24.5. Front view of the air press motor.

Dellschau's *Pressure Motors* referred to the unit that acted as a sort of compressor. This unit was activated by the action of the *motor roller* or power unit. But Pete still hadn't figured out what made this power unit turn.

Roy was the first to suggest that the drums might not turn. It was his opinion that although the drums seemed to be on an axle, they were actually fixed chambers and were not designed to turn.

Jimmy Ward agreed with him. "It doesn't turn. And while Dellschau referred to this gas chamber as a motor, it's actually a converter, as it converts the *soupe* into gas."

Pete went back and re-examined the drawings of the drums that Roy and Jimmy believed did not turn. After studying many of the devices from different Dellschau plates Pete came to the conclusion that Roy and Jimmy were wrong. The device did turn.

A drawing showing a cross-section view of an Aero called the *Immer* clearly indicates that the gas generated in the power chamber was used to turn a large wheel in the center of the airship, which in turn (by means of a chain or belt) turned the side-wheels or paddles. But what made it turn?

This type of combustion, or gas producing unit, which they thought of as a converter — for it converts the liquid Dellschau calls *soupe* into the *NB* gas — was shown in almost all of the Aero constructions with only slight variations

PLATE 4557

Fig. 24. 6. Sketch of a cross-section of the Aero Immer from plate 4557.

in design. It was obviously a major piece of the puzzle.

It was plain to see that the *soupe* that produced the *NB* gas was a liquid. The *soupe* is dropped directly over the drum or roller by gravity injection. The drum is covered with a black substance or material that evidently absorbed the liquid that dropped into it. What was this black substance? The inside of the roller was hollow with teeth, or prongs that stuck out from the interior walls of the casing. At the bottom, on the inside of the drum, or cylinder, were chunks of material resembling lumps of coal. Somehow the action that took place within the cylinder, or in the chamber containing the cylinder caused it to turn, sending power (or movement) to the wheel by the means of a shaft or axle. The gas in turn would also move the air compressors and would move into the bag atop the airship as well as travel down into the lower compartments. Pete arrived at the following two conclusions. That the amount of lift was controlled by the amount of gas that was in the bag or *lifters* and that the movement of the airship up or down could be controlled by the amount of gas in the flexible gas bag between a hollow ring around the base of the bag and the dome on top. If the airship was aloft and it was desired to come down, then the flexible part of the bag was compressed by pulling down on the dome on top and releasing gas through valves on the hollow ring.

Actually, the only thing that seemed to be required in order to fly one of Dellschau's machines was the gas which was shown in use in every one of the Aero drawings. Unfortunately, the method or means of manufacturing it continued to elude Pete and his group.. So did the exact purpose of the different pieces of machinery used in conjunction with the gas.

At least Pete knew one thing for certain. What Dellschau is telling us is that the Sonora Aero Club had access to a sort of anti-gravity substance that eliminated the weight of the machines and was the energy source not only for lifting, but also to propel the airship. But the main questions remain. What is *soupe?* What is *NB* gas? And how does it all work?

Pete and his group decided to skip over the *NB* gas for a moment and look at the machinery as though it were a forgone conclusion that the gas actually worked in the machinery diagramed by Dellschau.

Assuming for this exercise — although they had no clue as to how it worked — that the power source was Mennis' *NB* gas, they tried to figure out what each piece of machinery's job was and how they fit together to make a complete power system.

All of the Aeros had one thing in common: All of them had fuel tanks on board.

"Those fuel tanks might contain mercury," was Rudolph's thought. Pete told him he doubted that was the answer. "Seriously, Pete," Rudolph continued, "I read an article in a magazine[1] which mentioned the discovery of a curious artifact in Columbia, South America, which resembled an airplane. This ancient 'airplane' was presumed to have contained a 'power plant' which used mercury as the energy source. The article, written by Ivan Sanderson, stated that this idea would be purely speculation were it not for the explicit, technical descriptions of just such engines contained in some ancient Indian texts which spoke about flying machines or *vimanas* which supposedly existed in those ancient times."

The article went on to say that one of these Indian devices was said to have been powered by heated mercury.

A scientific dissertation upon the results of putting an open flame under a container of mercury appeared in the January 3, 1922, issue of *Science* magazine. It was absolutely possible that this liquid metal could be the motive force for Dellschau's airships. But Pete still had his doubts.

One thing that was very obvious to him was the fact that the fuel tanks seemed to contain a liquid that was light green in color and was not heated by open flame, but was gravity-injected into a chamber wherein the motive power was created. But how? That was the question that gnawed at their minds.

The following sketches, taken from Pete's Field Journals, illustrate the various power plants as depicted in Dellschau's drawings of the different cut-a-way or cross section views of the Aeros.

Since so many of Dellschau's plates contain cut-a-way views of the airships, you can plainly see the various motors and engines. They appear to be a very unusual type of power-generating plant. What was fascinating to the group was that, although similar in their general form of construction or appearance, each contains certain features that are quite different from each other. From plate to plate, or I should say from Aero to Aero, the power plants are

shown in a slightly different form although with apparently similar functions. I presume that this difference in engine design was probably dependent, or due, to its position on the airship and its particular application as a power source — for generating power for compressors or turbines, or for producing the gas for lifting the machines. Or it could illustrate the advances being made in the design of the Aeros by the Club members over time.

Fig. 24.7. Power plant from the Aero Honeymoon.

Fig. 24.8. Cross sections of two of the conversion chambers where NB gas was produced.

I assume that the earliest drawings, the missing drawings, might have contained information and details upon the construction and operation of the engines, and also the type of fuel used, for nowhere have I found any information regarding this matter, as though this particular problem had already been solved, and all that was necessary to do the later drawings was to show where the power units were to be located in the proposed airships and merely allow the proper space in them for their installation.

The question of whether those engines used mercury as the energy source still persisted. Even more so after Pete had found two separate places in different books where Dellschau had made a notation reading, *If I had the M.* What did he mean by *the M?* Did he mean mercury ... or money? Or did he mean something altogether different?

Whatever the meaning Pete still had his doubts about mercury being the energy source. It was fairly obvious that the power units must generate or produce some kind of lighter-than-air substance or some kind of force or pressure that could lift as well as propel the airships.

It is to be noted that in all of Dellschau's drawings, the fuel (or substance)

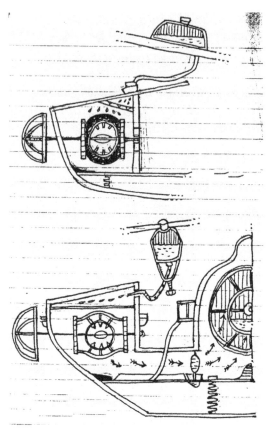

that is injected into the power unit (or chamber) is always a light green color, while the surrounding area (inside the unit and in the gas bags) is always a reddish or pink color. Did this mean that the light green substance injected into the power chamber was vaporized and converted into heat? Or was it turned into a hot gas? What was the green substance? It obviously wasn't gasoline, for it stated in plate 2573 that gasoline was not yet known in 1857. Since most of Dellschau's aircraft designs contained this type of power unit, including the earlier models, it seemed reasonable to assume that gasoline was definitely not the energy source that was used. This

Fig. 24 .9. Two more types of power units. The top one is from the long distance Aero Emmer (plate 2093). The bottom one is from a later version, Distance Aero.

was obviously the case, for the gasoline engine as we know it today had not been invented yet. Neither could it be used as a gas to lift the machines because of its extremely volatile nature.

In plate 2576 Dellschau made the notation, *If I could solve the Supp Riddle and somebody find it out yet.*

This notation brought up another area of discussion between Rudolph and Pete.

This was the question of the *supp* or *supe*, which must have been Dellschau's word for fuel. It appeared that despite the many airships that were designed, with motors and engines included, the Sonora Aero Club members still lacked the fuel, probably the *NB* gas, or the knowledge of how to produce it. On the other hand, why would they design or include a motor or engine which required a certain type of fuel that would give them the motive and lift power that was required, but not be able to produce it in quantity? Unless, of course,

they had already seen such a motor work.

This left them with the alternative that either they had a motor which actually worked, with a fuel they knew about, but were not able to obtain the quantities required, or that Dellschau's motors were just some more fanciful creations. Pete personally was inclined to believe that they did have a motor. And that it was a motor that worked, and that the fuel was *NB* gas, which wasn't that easy to come by. Could it have been a problem in refining? After all, gasoline hadn't been invented yet, and methods of refining fuel as used in today's motors were still relatively unknown. Then there were the air pressure motors of Juan Maria. What was their purpose? And how did they operate?

"I tell you what Pete," Rudolph stated, "this really is a case of 'the more you know the more questions you have.'"

Dellschau wrote that the *NB* gas which was used to *negate weight* was a liquid fuel or *soupe* as he called it, which when dropped into a *lift hold* or chamber, onto a rotating drum containing some unnamed black material, the liquid fuel turned to gas. This gas not only provided the lift necessary to get the cumbersome aircraft off the ground, but it also turned a wheel, or turbine, which is designated in Dellschau's drawings as a motor.

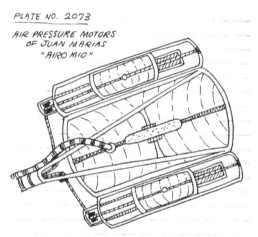

Fig. 24.10. Juan Maria's air pressure motors.

NB gas was obviously no ordinary gas, since it contained properties that would neutralize the effect of gravity to a certain extent.

Now, if we look into the liquid fuel produced by Mr. Guido Franch, as covered in an earlier chapter, we find that this liquid is also a pale green color. Could it be that Peter Mennis and Guildo Franch's formulas for making this fuel is one and the same? With the possible exception that Mr. Franch was not given the information on how to convert the liquid into a gas? If it is the same, then Mr. Franch must hold the solution to the development of an anti-gravity gas. There are statements in Dellschau's writings that may give a hint as to the process used to make this gas. It is certain that no fire was used in converting the liquid into a gas, for there is a statement by Peter Mennis to the effect that no fire was to be used or carried on the *Goosey* because *Fire and gas are like two*

lovers. They will meet. This passage also tells us that the *NB* gas was probably flammable or explosive.

In another plate, Peter Mennis' statement above is repeated in a slightly different way. Evidently Dellschau was never able to learn the secret of making this fuel, although he had a desire to know. In plate 2576 he says, *If I could solve the soupe riddle - and someone will find it out yet.* Obviously he meant someone besides Peter Mennis.

One thing was certain. Fire was *not* used in any way or manner in the Aeros for inflating the balloons and lifting the ponderous contraptions. Which was probably what was meant by Dellschau's cryptic message that *When material is used other than Peteris fuel even the Army using fire to ascend, cannot stay up long, because nothing travels* [in the air] *like the 'Goosey.'*

The above evidently refers to the use of hot-air balloons by the Army for observation purposes during the War Between the States, which of course used fire to produce the hot air as a lifting agent. This statement also tells us that the Aero Club members were obviously trying other fuel combinations, but they didn't work.

Pete told Jimmy about another of Dellschau's cryptic lines, one that he'd had trouble deciphering, for it seemed to have a double meaning. But after coming to the conclusion that fire was not an essential part of the lifting or moving of the Aeros, the meaning of the phrase reading "No Fire With us — NYMZA" seemed to make more sense and no doubt alluded to the fact that the NYMZA group did not use fire for lift or for the maneuvering of their aircraft. This is written in cipher thusly:

Let's suppose that the drums themselves are made of carbon, or coated with carbon. It may be that the liquid that was dropped into the carbon drums produced the gas … but no fire.

Fig. 24.11. This bit of code reads: NO FIRE FOR US — NYMZA.

Another thing to think about is that the gas is probably very light, which means it must dissipate fairly rapidly through the bag containing it. This would require replenishment on a regular basis to keep the Aeros afloat.

Pete believes that was exactly the reason that in most of the drawings the liquid fuel was constantly being dropped onto the carbon drums in order to keep the Aero as buoyant as necessary. There is no doubt that the gas may have dissipated since they only had fine cloth (silk was documented in one instance)

for use in making the balloons.

Jimmy had his own ideas. "There's something I've noticed about the construction of the air-press motors. On several of the diagrams of the air-press motors I got the impression that they were a crude form of ram jet device. As for the *NB* gas, I would say it's more likely to be nitrate of boride rather than mercury. Dellschau's Aeros used no fire. Nitrate of boride is a chemical that is used to produce heat without the use of fire."

Pete was of the opinion that *NB* gas, or the *supe,* was an as yet unknown chemical element. *We need the missing Dellschau books,* Pete thought.

Endnotes

1. *Argosy*, November, 1969

> *Dennis,*
>
> *Upon reviewing the MS you sent by priority mail I have particularly noted one item in Chapter 24, "Aero Fuel and Power Plants". This item is in reference to the various power plants as depicted in several of the cut-away (or cross-section) views of Dellschau's drawings. It brought to mind some notes I had made in regards to the SOUP and WATER combination, which I thought might have been used for duel purposes, according to the amount of water that was used in with the SOUP ingredients (or granules) that were used to produce NB gas. I dug up these old notes, which I am sending you, for whatever use they might be. Here is what I found as jotted down at the time:*

> *1. Look at page 85 in Journal number XIV] - there is a sketch of a central motor - called a "Starter" which produced "Heat of Gas".*

PLATE 4612
- CENTRAL MOTOR STARTER - M Goré

2. *Note that there are two liquid containers. One is dropping liquid onto a device (probably to make the NB gas, for lift) - while the other (on the right) seems to be producing a force that turns the wheel in the center.*

Now look at this drawing. Liquid is being dropped onto a sort of plate - and underneath is something that appears to be heat. (Not flames).

Heat not flame heating the liquid.

CHAPTER 25

Outside Interest

Let's see where it ends ... this tale of Dellschau's

— Warren Fontaine[1]

HOUSTON, TEXAS, 1981

"Well, he's here," is the short message Pete heard from an obviously excited Jimmy Ward on the answering machine. That was the entire message Peter needed. Several weeks before a popular researcher and author of paranormal books had contacted Jimmy. His last book had been a huge bestseller and was currently being made into a first-run movie. He had shown a lot of interest in their investigation into Dellschau's work and had asked to meet Pete and Jimmy on a trip through Houston. We'll call him "Warren Fontaine"[2] for lack of a better name. Pete called Jimmy on the phone and agreed to meet with him, Warren and his assistant (whom we'll call "George Nelson"[3]), the next morning at a popular restaurant near the writer's hotel for breakfast and to map out their plans for the day. Jimmy informed him that they also wanted to try to get an interview with either Helena Stelzig or Miss Helen Britton.

Pete was up bright and early the next morning and arrived at the restaurant about 15 minutes early. He chose a circular back booth, which gave some semblance of privacy. The other three men arrived a few minutes later, Warren and George having picked up Jimmy at his house. While enjoying a good breakfast and getting to know one another the four men talked of their mutual interests. They kept this first meeting light by making small talk and insiders banter. After a friendly young lady removed the dishes and served fresh coffee around, they got down to the business they were here to discuss.

"You guys have quite an interesting story here, " Warren smiled at each in turn. "I think it might even be marketable." He then began asking questions of Pete and Jimmy, all the while weaving it together into a story he felt would appeal to readers who might choose a book about Dellschau and his airships. Warren's assistant George took precise shorthand notes of the conversation.

"First, take me to Dellschau's grave," Warren requested. "Let's see where it ends, this tale of Dellschau's".

Little does he know, Pete smiled a small smile. *It never ends.*

The first thing they saw as they got out of the car in front of the Stelzig cemetery plot was a dead blackbird lying by one of the tombstones. Warren Fontaine made the remark, "Wonder what kind of omen that is?"

"You think that's something, look over there." Jimmy pointed to the family plot that was almost adjoining the Stelzig plot. Live blackbirds were gathered around on it, as if they had gathered there to mourn their departed feathered friend. It was the "Fontaine" family plot. All eyes shifted to Warren. He looked stunned. There was a moment of eerie silence, and then everything was normal again.

After reading the inscriptions on the grave markers, taking notes of the information and looking around the area, Pete suggested they go and see the old house where the records were once kept and where the old lady who used to clean the plots lived before she was brutally murdered just a few months prior.[4] The house was kept locked up, and apparently no one had ever gone back to it again.

From there they went next door to Glenwood Cemetery and the grave of another famous man who, like Dellschau, had lived out the end of his life as a strange recluse, Howard Hughes. It looked like souvenir hunters had removed part of the grave ornaments on top of the grave.

"Under our feet is the body of a man who was worth millions," Pete remarked.

"He was worth billions," Warren said, correcting Pete's understatement.

Next stop was Stratford Street to look at the house where Dellschau used to live. They parked in the alley behind the house. There was a man working on his car, which was parked in the middle of the alley.

"Howdy," Pete said as he walked over to the man.

"Howdy," the man returned as he slowly whipped his greasy hands on an equally dirty shop rag. "Can I help you?"

"We were just wondering who was living in that house over there," Pete said indicating the old Stelzig house.

"Don't know em," the man said, "but there is an older lady and a younger thin woman and another lady … " He didn't finish the sentence, but used his finger to make a circle around his ear. Warren wanted to try and get an interview, but Pete didn't believe he needed to go back up to the house, so Warren decided he'd do that later.

Their next stop was Mrs. De Menil's, where her assistant greeted them. They didn't get to look at any of Dellschau's books as they had all been placed in cold storage to preserve them. They did get to look at some photographs of the drawings, which Warren found fascinating, although they were only black and white 8x10 prints.

After leaving Mrs. De Menil's house the group of researchers drove over to Fred Washington's warehouse and workshop. Or I should say, the foundation where his warehouse and workshop used to be. That's all that was left of the warehouse — the foundation. Not only had the building been torn down and removed, but also the entire lot around the warehouse seemed to have been cleaned. Pete remembered a lot of junk lying around all over the place, but all that had been cleaned up. This part of the Dellschau story was gone forever.

Warren next wanted to go back to the Stelzig home on Stratford Street to see if he could arrange for an interview with Helena, or her niece Helen Britton. Pete and Jimmy begged out of that trip and had Warren drop them at Jimmy's place of business, a Washateria on Houston Avenue. It wasn't long before Warren and George returned. They both wore long faces as they walked in the door of the Washateria.

Warren explained that after introducing himself as a reporter, and showing her his press card, Helen Britton appeared to be willing to talk with him, but that a stout woman, whom he took to be the nurse or housekeeper, had come to the door as he and Helen were talking. She stood there for a second then suddenly pulled Helen away, telling her they "had nothing to tell them." Then slammed the door in their faces.

But Warren was determined to talk to someone who had been in that house. So, they all piled in his rental car and went over to northeastern Houston looking for the residence of Salina Harris.[5] Warren had gotten her name and address from the department of motor vehicles after writing the license numbers of the cars at the Stelzig home. Salina Harris was the only one whose car was not registered at that address.

However, once the address was found, not one of the three cars parked there was Ms. Harris'. After several passes, Warren decided to call it a night and returned Pete and Jimmy to the Washateria.

"We've got to go to California," Warren told Pete, "flying out early in the morning. I've planned a stop at Sonora and Columbia and I'll let you know if we find anything interesting there. In the meantime I'll study the information you gave me and we'll come up with a book deal. I'll be in touch soon."

After goodbyes and handshakes all around and Warren and George had driven off, Pete and Jimmy talked a few more minutes then Pete walked over and climbed into his car for the drive home.

It was an interesting day, Pete thought. *Very interesting indeed.*

Several days later Warren called Pete from Sonora, California.

"Just called to give you a progress report, Pete. I've been here two days. Quite a piece of history this area. I've been visiting some of the graveyards in

the area and using the list you gave me I've found a few that are on Dellschau's list. One was Ernest Krause, who had died in 1875. He was thrown from a horse on the Fourth of July, and died five days later. I also found J.W. Oliver, which could very well be Dellschau's Joe Oliver. Another was Jack Maria. Jack, of course, is "Juan" in Spanish. I also found some interesting tombstones in Columbia's boot hill. I found an old tombstone with the name Newell, but no first name. Found another with William H. Newell on the headstone. I found out he'd owned a brewery in Columbia and had been born in New York in 1822. There were several Gores, but no Michael Gore. I also spent time researching the Census and other local records. That's all I came up with. Not much help, but its something." After Pete thanked him and they knocked a few more ideas around they said their goodnights.

After hanging up the phone Pete started thinking about something that had started to nag him. It had occurred to him while talking to Warren that when he had given the very same list of names to the historian of the Sonora and Columbia area. After a search of the public records nothing was found documenting any of those names being in the area during the time in question. Yet, Warren found some of these same names in the graveyard. It makes a person wonder. Even if the people buried in the graveyards aren't Dellschau's friends, the names of these people should have shown up somewhere in public records. After all, they were buried right there in the cemetery. A different kind of person might start to imagine a conspiracy somewhere along the line to eliminate all traces, and names, from the public record of all those involved with NYMZA or the Sonora Aero Club. But as with most conspiracies the perpetrators botched it. They forgot to destroy the names on the tombstones. Or maybe they did destroy some but missed others. So many maybes. *I've got to get another hobby,* Pete thought as he went up to bed.

Several days later Pete received a phone call from Warren Fontaine. He was back in Houston. He'd left Northern California and flown to Washington, D.C., and then back to Houston. They talked about how any proceeds from a book to be written by Warren would be handled. Warren assured Pete that any photos, drawings or sketch he used in the book would be copyrighted to Pete. Warren explained that they wouldn't be in Houston long, but that he'd like to see some of Pete's journals he'd been keeping on his research of Dellschau.

Pete agreed to pick Jimmy Ward up, and then meet at Warren's motel, the Ramada Inn on the Katy Freeway.

After picking Jimmy up Pete drove across town to the motel. The silent George was with Warren with the ever-present notebook and pen.

Pete brought along three of his journals and three of his sketch books.[6] As

Warren studied the journals Pete was impressed with how observant Warren was of minor details that were in several of the drawings.

"Pete, you've got to let me borrow these books. I don't really have time now to study them like I'd like to. I'll take care of them and get them right back to you."

Pete reluctantly agreed. Pete also let him borrow the three sketchbooks. That was the last Pete saw of his property. Never mind any "book deal" on their research into Dellschau.

Of course about this time our Mr. Fontaine was running into his own troubles. Shortly after Pete's dealings with him, Warren Fontaine admitted to researchers that he had been spreading misinformation concerning government dealings in regards to UFOs. He said he had agreed to pass the phony information around to the UFO crowd in exchange for real information. He felt this was a fair trade.

Pete wondered if Warren's trip to Houston to look into Dellschau was really all about a book. Or did Warren Fontaine, top-drawer researcher/writer and admitted government mouthpiece, have another agenda?

Pete tried several times over the years to get his journals and sketchbooks back, but was always put off. He finally received a letter from Warren telling Pete that his home in California had been destroyed in an earthquake and his books had been lost at that time. Pete tried to contact him again, as usual, to no avail. Finally, on April 17, 1997, Pete received the following letter from Mr. Fontaine:

> Dear Pete,
> Regarding Dellschau, I managed to rummage a bit while in Hollywood this past weekend, and came up with a box marked "Dellschau/Aztec." Therein I found a thoroughly shuffled mess, which appears to have been dumped in there after the quake and never looked at again. Since my time was limited, I set the monster aside for another day when I will have more time to spend with it. Just how much Dellschau is in there, I know not — but on the positive side, I did spot one of your black notebooks right on top of the heap, and it appears to be only a little water-damaged. When I have more to tell you, I'll write again.

Pete is still waiting.

Endnotes

1. Fictitious Name.

2. Fictitious Name.

3. Fictitious Name.

4. The story was published in the *Houston Post* newspaper on 7/9/1977, "Violent Death Concludes Woman's Cemetery Vigil." According to the front-page article, Leona Tonn was found dead in the caretaker's house on an "all but forgotten downtown Houston Cemetery." The article continues, "Detectives say they have no suspects in the death of the 72-year-old woman, caretaker for the past 32 years of the otherwise neglected Washington Cemetery at 2911 Washington. "Her death was ruled a homicide after an autopsy showed she had died of suffocation … her home had been ransacked." This had nothing to do with Dellschau I'm sure, but at the time it gave Pete a thought or two. He had just visited Ms. Tonn a short time before her horrible death and had actually planned a return visit the very day she was murdered. He wondered what became of the cemetery's record books; the ones that contained Dellschau's information in particular.

5. Fictitious name.

6. The journals Pete gave the well-known researcher/writer were Volumes XVI, XVII and XVIII. These three journals had miscellaneous information Pete had gleaned from Dellschau's books along with some of the most detailed sketches he'd made of interesting drawings and diagrams from Dellschau's plates. The sad part is that Pete never actually had a chance to study

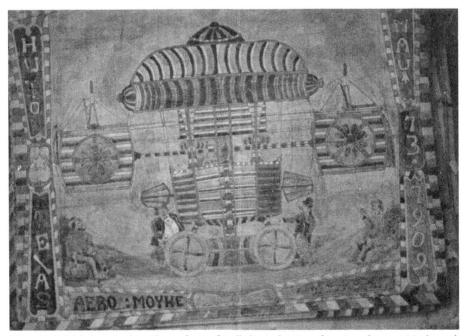

Fig. 25.1 A black and white photo of one of Dellschau's drawings featuring the Aero Moyke and several of the Sonora Aero Clubs most prominent members. The P. G. Navarro Collection.

those particular journals that closely. Important information could be contained within these missing research journals that could tie together known facts.

CHAPTER 26

The Death of Peter Mennis

"Why did Dellschau keep on about not having the soupe? It's so simple that there could be only one logical answer. Their supply of fuel was cut off. And this was evidently because of the loss of one of the members. The member who had the secret. Peter Mennis was dead."

— Jimmy Ward

HOUSTON, TEXAS, 1985

The next time Pete saw Jimmy Ward he asked him if he had been able to use any of the info left with him the last time they'd gotten together.

"You can say that again, Pete!" Jimmy said with a big smile. "The material was great, and I think I've figured out one of the most important questions we've been asking ourselves. As you know I've said from the start that my primary interest was to find information about the *NB* gas."

Pete nodded his head in agreement, wondering what Jimmy had found. However he held back any questions. He knew he'd have to let Jimmy tell of his discoveries in his own way.

"Well, evidently I made time to concentrate on that single aspect of the mystery and arrived at a very important conclusion." Jimmy stopped speaking for emphasis.

"I'd been concentrating on the question of why Dellschau was always moaning about 'not having the soupe' and not being able to 'accomplish his aims.' As I began to study the material you gave me I started to realize something. Peter Mennis was very active in Dellschau's earlier plates, the ones with the lower numbers. Yet we don't see or hear of him as much in the later, or higher numbered drawings.

"Then it struck me." Jimmy continued. "It's so simple that there could be only one logical answer. Their supply of fuel was cut off. And this was evidently because of the loss of one of the members. The member who held the most important secret of the Sonora Aero Club. Peter

Fig. 26.1 Peter Mennis' grave. From a P.G. Navarro drawing.

176

Mennis was dead. "He must have died unexpectedly and that had left the Aero Club members without the key figure upon whom they depended, not only for obtaining the *soupe,* but because he was also instrumental in creating and designing some of the earliest and most successful Aero models. And his personality was what held the group together."

Pete instantly saw the possibility. "You might have something there, Jimmy. I'll look through my notes and see if I can find anything pertaining to Mennis' death."

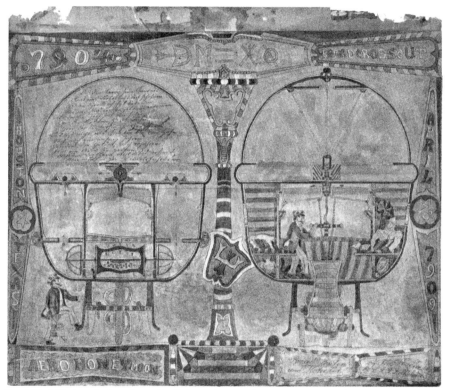

Fig. 26.2 A black and white photo of Dellschau's plate 1904. A "Broadcrosscut" of the Aero Honeymoon.

Jimmy's idea of Mennis being dead before the break-up of the Aero Club immediately set Pete to re-studying some of the cryptic phrases in Dellschau's books. He returned to, and studied closely, some of the coded information he had copied down into his field journals but never decoded. The first break was a passage that stated that Peter Mennis had been burned. The decoded paragraph did not state that he had actually died, but nevertheless, it made clear the fact the he had been in some kind of accident. The passage reads:

Alas Make Hay, But Not a Straw Roof
— Which is Unthinkable, Besides It Was
Tar That Burned Peter Mennis.

However, this wasn't enough to say for sure that Jimmy had the answer. Pete now knew Dellschau well enough to know that if Peter Mennis had died an untimely death it was almost inconceivable that he would have failed to make note of the fact somewhere in his artwork or writings. He was 100 percent positive that somewhere in Dellschau's books was a notation of Mennis' death.

Then Pete remembered something. A drawing he'd made from one of Dellschau's drawings. He'd thought it was a mountain or hill. As Pete remembered it had appeared in the background and had several letters on it. Pete turned the pages of his journals one after the other. Suddenly it leaped out of the page at him. He saw now, with this new knowledge, that it wasn't a hill or mountain at all. It was a tombstone. And there plain as day the initials, "P.M.," Peter Mennis. Above the initials were the coded ciphers for NYMZA. Above that, as a heading, was a line reading "THINGS CHANGE."

There is no doubt that their plans had been drastically changed, Pete thought.

With Mennis gone the club members gave only half-hearted efforts toward advancing their experiments into building a viable flying machine. What was the use, they didn't know where to get the anti-gravity fuel. And without that their wonderful heavier-than-air craft could not fly.

Although the members of the club continued to meet and exchange ideas for a short period of time after Mennis' death, the truth of the matter was that it was over. The members begin to argue amongst themselves. Many dropped out of the club and moved on. Finally, heartbroken, Dellschau also quit the club and returned to Texas with nothing but his memories. Had Dellschau died without leaving his wonderful books, the knowledge of the Sonora Aero Club and the Aeros would have been lost forever.

Dellschau: The Enigmatic Man (1981)
By Jimmy Ward and P.G. Navarro

Shall the machine be lost to the world? Who shall inherit my writings? I hope that our work will produce the results that will bring forth the right man.

— C. A. A. Dellschau

Fig. 27.1. Dellschau's neglected grave as it was found by Pete Navarro. Dellschau ... a forgotten man. Even his tombstone has his name misspelled. Photo by P. G. Navarro.

The tombstone reads, "C. A. A. Dellschaw — June 4, 1833 — April 20, 1923" with a Christian Cross prominently chiseled in the center. On first inspection the headstone is not unlike millions of others in cemeteries big and small everywhere. Yet for those who look further there are several things that seem strange. First, all markers in this family plot have the relationship of the person in the grave to the families who own that plot, including in-laws, inscribed on them — except Charles Dellschau's. It's also odd that his name is misspelled. He never ended his name with a 'W.' It is very seldom that

stone carvers make a mistake on a headstone. In Dellschau's case, was this a mistake? Another weird fact is that all those buried in the family plot are listed in public records. Except for Dellschau. Equally odd is the listed birth date. In interviewing members of the Stelzig family no one seemed to know where he was born, much less when. Up until about 1889, when he moved to Houston, Texas, nothing much is known about him.

While having nothing to do with Dellschau, some other oddities concerning the Washington Cemetery may be of interest to some. In another cemetery next to this one and a few hundred yards away is buried another man of mystery — Howard Hughes. Over the years, several "phantom cats" (lions and black panthers) were reported to have emerged from the cemetery and run across the busy avenue, only to disappear without a trace. And adding another touch of the bizarre to this area is a photograph, taken by one of the authors, of Howard Hughes' grave. The camera was aimed toward Dellschau's grave in the next cemetery. When the film was developed you could see the Houston skyline in the foreground. The problem is that the skyline cannot be seen from that angle and the photo was not a double exposure.

On another visit to the Washington Cemetery, the authors found a flock of blackbirds surrounding a dead blackbird lying next to Dellschau's tombstone. There were no blackbirds anywhere else in the cemetery.

And finally consider the following news item from the Saturday, July 9, 1977, issue of the *Houston Post*:

Violent Death Ends Woman's Vigil

Leona Tonn's long, lonely vigil as the caretaker for an all but forgotten downtown Houston cemetery ended Friday. She had been killed. Detectives said they had no suspects in the death of the 71-year old woman, caretaker for the past 32 years of the otherwise neglected cemetery.

An unknown assailant who broke into the house on the grounds of the cemetery where she lived (and where she kept the cemetery records) had murdered Leona Tonn. She died of suffocation when her killer wrapped a slip, a blouse and a pillowcase around her head, secured by an elastic bandage. No motive has ever been discovered nor has the murderer ever been caught. Just another case of robbery and random murder? Probably.

This crime would not even have a place in this book except for one odd fact.

The *Houston Post* story was read over the breakfast table that morning by

one of the authors. He almost spilled his coffee. He was scheduled to visit Mrs. Tonn at her small house on the cemetery grounds that very morning. He had made plans to talk to Mrs. Tonn concerning what she knew about Dellschau. The expectations for this interview had been running high, as Mrs. Tonn was also acquainted with one of the family members. Now there would be no information coming from this source. Coincidence? Why not, this investigation has been nothing but. But then again ….

Much of what we know about Dellschau comes from his drawings, writings and coded messages. From his use of printing terms in his books, and from the methods used to create his "plates" it can be presumed that Dellschau had worked in the printing field at one time in his life. In one of his drawings Dellschau had an insert showing a teenage boy flying a kite. The name *Muehlberg* and the date 1845 also appeared in this drawing. It is assumed that this young man is Dellschau himself, and that at the age of 15 or so, he had lived in Germany. Muehlberg is a small town just on the edge of Germany's publishing district and he may have served an apprenticeship as a "devil" in the printing field there. There is another possibility that will be covered later. No immigration record has been found that would shed light on when he may have arrived in the U.S. The only information we have is from Dellschau himself. He wrote that he was living in California in the mid-1850s and was a member of the Aeroy Club of Sonora. He related hundreds of events that allegedly took place in and around the towns of Sonora and Columbia. Many of the newsworthy events that Dellschau claimed to have happened while he was there have been verified. But those events dealing with the activities of the Aeroy Club (later changed to the Sonora Aero Club) have not, except in a periphrastically (or round about) manner. The Toulumne County Historical Society has no record of any Charles Dellschau, nor does the Columbia State Historical Park at Sonora. Furthermore, a personal search of records and cemeteries in the area has turned up nothing that would prove the members of the Aero Club ever existed. Several similar names were located and the dates fit the time frame, but no connection with each or to the club has ever been found.

It is obvious from Dellschau's intimate knowledge of the area during the 1850s and the events that transpired there, that he must have lived in the area, or had frequent contact with someone who did, whether the remainder of his tale is true or not. The lack of records would seem to indicate that the entire story of the Sonora Aero Club is a figment of his imagination. However, in secret societies (such as NYMZA) the members often adopt "club names" and refer to each other by those names when discussing club matters. If such were the case here, there would be no public record of any of the names mentioned

by Dellschau in his notations. Only if private papers turned up containing part or all of these same names can anyone say there is positive proof that the story is real. So far, no such papers have been found.

Assuming the story is true and the names mentioned by Dellschau to be "club names" or names Dellschau made up using variations of the true names or characteristics one must look elsewhere for verification. Is there anyone known to have been in the area during this time period that could have been Dellschau using another name? There are two likely candidates for this dubious honor — both brothers by the name of Duchow, John Charles and William A.

John Charles Duchow was born October 14, 1830, the same year as Dellschau, in Salem, Massachusetts. From Duchow's diary we learn he went to work at the *Salem Gazette* on June 4, 1845, as an apprentice. He worked there until March 27, 1853, and shortly after that set sail for California on the ship *Staffordshire*. He tells of the trials and tribulations suffered on the trip. The last entry is July 4, 1852. They had "rounded the Horn" (Cape Horn) the day before and were 62 days out of Boston.

According to records John Duchow began his newspaper work in northern California at San Francisco's newspaper *Alta California* on August 1, 1852. In October 1852 he arrived in Columbia, where he took editorial charge of the *Columbia Gazette*, which had been established by Colonel Falconer. In the fall of 1853, he purchased the *Gazette*.

However, further research disclosed the following contradictions in the records: The *Staffordshire* arrived in San Francisco on August 13, 1852, so he could not have worked on the *Alta California* as early as August 1st, 1852. Another discrepancy: Colonel Thomas Falconer established the *Gazette* on October 23, 1852. His account book states that he hired Wm. A. Carder as a printer on October 18, 1852; "Mr. Willis" from May 20, 1853, to August 29; and John Ducuw [sic] on June 26, 1853, seven months after the previous record reported. There is no evidence in his accounts or in the papers available to indicate that Duchow worked on the *Columbia Gazette* before this date.

There is no record of what Duchow did at the *Gazette* until September 27, 1853, when he began keeping the accounts of the paper. This is probably the date on which he took over the business although no record of the sale has ever been found. In 1857 he sold the plant and turned his attention to his extensive mining interests. In the fall of that year he returned to the newspaper business by establishing the *Tuolumne Courier*. In 1872 he moved the *Courier* plant from Columbia to Sonora, and with his brother established the *Tuolumne Independent*. In 1884 he purchased his brother's interest. Heart trouble forced him to retire. (Some sources say 1896-1897 while others report "shortly after the turn of the century.") This seems to preclude the possibility

that he was Dellschau, since the latter moved to Texas around 1886. However, some additional doubt has been raised as to the date of his retirement and the possibility looms that it may have been earlier than 1896.

William Arthur Duchow, a more probable candidate, arrived in California slightly after his brother. The exact date of his arrival is unknown but apparently it was in the fall of 1852. He settled at Columbia and engaged in newspaper work, typesetting and editing. His first job was at his brother's newspaper, the *Columbia Gazette*. During the years in which the brothers Duchow conducted the *Gazette*, and afterwards the *Tuolumne Courier*, the flush times of Columbia were past.

Leaving Columbia in 1859, William became the foreman of the *Daily Argus* and *Weekly Democrat*, papers published in Stockton California. Later he lived for a while in San Francisco, working as a printer, and them taking a contract to issue a paper with Aleck Montgomery in Napa, California. He became one of the owners of the *San Francisco Times*. Later, he went to Santa Cruz and worked for the *Sentinel*. Later still, the *Pajaro Times*, a paper published at Watsonville, California, engrossed his interests.

After five years William returned to Tuolumne County engaging in the publication of the *Independent* with his brother, John. The actual date of his death is in question and some doubts have been recently expressed as to his grave even containing a body. It seems a fake funeral may have been held while he fled that part of the country to escape some "trouble." No proof of this has yet been found but some evidence (albeit rumors and expressed doubts) has been uncovered. Neither has the exact nature of the "trouble" been uncovered. But, if this fake burial is true, it might explain the name change and sudden appearance of Charles Arthur Dellschau in Texas.

As to the character of the Duchow brothers, no better example can be found than the following story related to Arthur D. Duchow, the son of John Charles, about his father:

> *Throughout these exciting times when the six-shooter was king, my father was never armed stating as the reason that on account of his quick temper he might kill someone and forever regret it. He witnessed several lynchings and disgusted by the horror of them took a firm stand against mob rule. He always maintained mobs were cowardly and proved it by personal experience.*
>
> *On one occasion, Bill, the chief printer of the Gazette, was accused of cheating at cards. This was a major crime in those days. He was pursued by a mob bent on hanging him. Bill headed for the Gazette office with the mob in hot pursuit. He ran through a*

narrow alley to the rear of the Gazette building, through which only one person could pass at a time. My father knew that if they executed Bill the publication of the Gazette would have to be postponed until a new printer could be found, meaning a long delay. He grabbed the first weapon at hand - an axe, and standing behind a corner in the alley where only one man could face him at a time, and he was concealed from the street. When the leader of the mob rounded the corner, saw the uplifted axe and the determined look in my fathers eyes, he beat a fast retreat. The mob without their leader concluded that Bill was not a bad fellow at all and dispersed. The day was saved, the Gazette came out on time, while Bill, though badly shaken, managed to do his part.

The two Duchow brothers were "peaceniks" but would use violence when necessary. They both had hot tempers. They both were adventurous with William being more so than his brother. They were active in public affairs and members of a number of societies. Other than the "active in public affairs" (which would be nullified if William Duchow was on the run) this description would fit Dellschau exactly. Physically, Dellschau could fit either brother's, height, weight, color of hair and skin, etc. No connection has been found between the Duchow brothers and Dellschau, however, the similarities between them cannot be ignored and should be entered into the record until such time as evidence to the contrary can be found.

In checking over century-old records three other names have appeared that may identify three people included in Dellschau's coded writings. He wrote about an "F. W. Schultze" (or Schultz) and his wife who designed and built a contraption called the *Crippel* (cripple?) *Wagon*. There was a Henrietta Schultz who ran a saloon in the latter part of the 1850s and a J. Schultz who ran the Lager Beer Saloon. Only brief references were made to these two Schultzes and it is not known if they married or even if they both worked in the same saloon. However, it is interesting that the only two Schultzes were a man and a woman and both were connected with saloons.

Another name quite prominent in Dellschau's story is Mike Gore. Records regarding a G. W. Gore were found. In 1852 he published Columbia's first newspaper, the *Columbia Star*. One source stated that Gore founded *The Star* on October 28, 1851. It was printed on the historic Ramage Press on which several of California's earliest newspapers were printed in other cities ,including Monterey, San Francisco, Sacramento and Stockton and the first editions of the *Sonora Herald* in Sonora. Again the connection is only tentative, but

Why suspect a connection between Dellschau and newspapers? In his notes

Dellschau often used printing terms and always called newspaper clippings "press blooms." Even so, it must be admitted that there is no other evidence that he even knew the first thing about printing or publishing of any kind. His only known type of work was as a sales clerk and later as a janitor. Up until his "retirement," when he began making his books, there was no hint that he could even draw, much less do all the elaborate and detailed work which distinguishes his drawings.

Another reason for believing in a connection is that a newspaper office would be the best place to be if you wanted to keep abreast of the latest news of inventions and discoveries worldwide.

Contrary to what most people believe, the question of whether the testing of flying machines were being conducted in the mid-1850s need not be addressed when looking at the Dellschau mystery. History is wrong when it states that the Wright brothers were the first to fly in a heavier-than-air craft. The heralded brothers were not even the first to accomplish a powered flight.

In 1843, William Samuel Henson patented and published a design for what he called an "Aerial Steam Carriage." It was a monoplane with a wingspan of 150 feet, fixed wings cambered for lift and braced with ribs and spars. The tail unit combined control functions of elevator and rudder. Two six-bladed pusher airscrews — or rear propellers — were driven by a 25- and 30-horsepower steam engine set in the fuselage which was equipped with a tricycle undercarriage.

On September 24, 1852, Henrie Gifford flew a 144-foot-long craft propelled by a three-horsepower engine.

In 1853, George Cayley flew in a fixed-wing glider.

1857 was the year Filex Du Temple and his brother, Louis, built a monoplane drawn by a propeller that was first powered by a clockwork mechanism. It took off and flew for a short distance and then glided down for a safe landing. The clockwork mechanism was replaced by a small steam engine and it flew even further.

1866 saw the founding of the Aeronautical Society of Great Britain.

In 1876, Alphonse Panaud patented an amphibious monoplane with a glass-domed, two-seated cockpit with a single control column to operate the rear elevators and rudder and a retractable undercarriage with shock absorbers.

Other patents include:

• 1887, Henry John Haddon — an aircraft constructed of steel plates with propulsion by jets of air.

• 1892, Wm. N. Riddle of Crowley, Texas — a navigable balloon with a propelling wheel on each side of a cylinder slung underneath.

• 1895, Estanislao Caballero de Los Olinos of New York City — a vertical take-off and landing craft.

Then on May 6, 1896, Alexander Graham Bell took the first photo of an engine-powered, heavier-than-air craft in flight. It was Samuel Pierpoint Langley's steam-driven scale model which weighed 26 pounds and was powered by a one-horsepower engine. The model flew for one-and-a-half minutes and a distance of 3,300 feet.

The above merely highlights the efforts of hundreds of inventors trying to build a cost-effective, safe flying machine during the 19th century and should prove that a group such as Dellschau's Sonora Aero Club could exist and probably did. The same may be said of the "Great Airships of 1896-97." The fact that there is no solid proof existing to give credence to their existence does not prove that they did *not* exist.

One question must be answered before any solution to the mystery of the "great airships" and Dellschau's drawings can be found: Why were Dellschau's Aeros and the mysterious airships all equipped with gas bags when fixed wings were already known to be better? One answer can be found in Dellschau's notes — speed!

Fixed wings were good for speed but could not hover. The craft must be tilted in order to turn, and the craft had small, open and uncomfortable accommodations for passengers and crew. But they had the *speed*.

The "airships" and Aeros were roomier, enclosed and much more sophisticated. They were designed for leisurely travel, not speed, and for comfort, and would not tilt when changing direction. Most could also be used as pleasure boats when one got tired of flying merely by landing on a body of water and using their side-paddle wheels. In other words, the airships and Aeros were more "civilized." Inside, they were more homey even than today's modern jet airliners. The larger versions contained bedrooms with full-sized beds, a kitchen, formal dining room, leisure room and observation decks, etc. All the comforts of home and then some, not unlike the great passenger liners of the early 20th Century.

Dellschau often asked why was speed so important when it was comfort and safety that really mattered. Flying was for enjoyment, not to see how fast one could get from one place to another. Perhaps this is why these airships disappeared. People lost their leisure time and became obsessed with saving time. These craft were never designed for the rabble — they would not appreciate them and misuse them as they did everything else. So, when the elite lost much of their leisure time, the great ships were eliminated. Was there a group of men secretly flying large airships around the country in the 1800s? Could this be the answer? Only time will tell.

Dellschau himself was afraid the secret of the Aeros would be lost as well as the memory of them and those men who had invented and worked on them.

For this reason he felt compelled to do his drawings and make his notations. Still, he did not want to give everything away to just anybody. He wanted only those who would take the time to study his drawings in detail to know his secrets. For he knew that only they would care enough to see that the world was informed. In his ciphers, as well as in "clear" English and German, he often ran words together, misspelled or transposed letters or words, and generally required considerable effort on the part of the reader to make sense of his books.

> *We are all in our graves, O Brothers. Come very soon. I take my friends in my house. We eat and drink and are joyful. We do mental work but we are forlorn, as we feel that we are fighting a losing battle. Shall the machine be lost to the world? Who shall inherit my writings? I hope that our work will produce the results that will bring forth the right man.*

Fig. 27.2. Pete Navarro believes this drawing from plate 4301 is a self-portrait of Dellschau as he looked in his later years. From the P. G. Navarro Collection.

The above translation from the German indicates his hope that some day after his death someone will come along with enough patience and inclination to try and figure out his writings. His own family considered him an eccentric old man who wasted his time creating "fantasies akin to Buck Rogers" cartoon drawings. What no one in his family had ever done was try to decode his secret messages and read what he was actually saying about these fantastic flying machines and the Sonora Aero Club. He had succeeded in his aim to discourage the merely curious, at least while he was alive.

Then in death, his books would have been lost forever except for a series of strange events — the childhood curiosity of a young man who took some of the books home with him and forgot to return them; the inability of an old woman to throw *anything* away; a fire and a fire marshal's order to clean up a house; the chance discovery and a hunch by a junk collector; a visit by some

collage kids who saw them in the junk collector's warehouse; an exhibition on the history of flight; an item in a newspaper; and the curiosity of P.G. Navarro; all of which eventually combined to bring Dellschau's works and story out in the open and assure their preservation. If nothing else, this story of coincidence is a story within itself.

After several years of delving into these books, Navarro gave up on trying to interest others. Jerome Clark and Lucius Farish briefly covered the Dellschau story in an article in *Fate* magazine. Later Jerome Clark teamed up with Loren Coleman to cover Dellschau and his Aeros in their book, *The Unidentified*, but nothing else came of his efforts.

Much later, in doing research into "The Great Airships of 1896-97," Jimmy Ward ran across the article in *Fate*. The article mentioned P.G. Navarro and a university. There was no P.G. Navarro listed in the phone book and a call to the university produced a blank. But just as he was about to hang up, someone happened to walk in the university office who knew about the books. Another number was given that almost produced the same blank results, but again someone just *happened* to walk in who knew a little about it and where P.G. Navarro could be contacted. At long last Navarro's office was reached only to find out he had sold the business some months before. Just as he was about to hang up again, Navarro's former secretary said, "Wait. Perhaps I shouldn't do this, but I feel it would be okay for some reason." She then gave Jimmy Ward Navarro's phone number.

Since the two had gotten together, interest has in Dellschau and the story he tells began to grow. It was almost as if Dellschau, the man of many enigmas, had been directing people and events to produce the results he wanted; almost as if his desire was so great that he was reaching out from the grave, keeping the story from being lost forever.

Chapter 28

Jimmy Ward, Psychic Findings and — Murder?

*As soon as the compass was in my hand I felt something like
a stab in my side.*

— Jimmy Ward

Houston, Texas, 1905

Jimmy Ward hooking up with Pete Navarro is another coincidence in this story of coincidences. The direct line of people who brought Dellschau's works from an obscure Houston, Texas, dump into Pete Navarro's hands is all a matter of coincidence. That is … if you believe in coincidence.

Is it a coincidence that Pete Navarro was probably the only man in Houston who could fulfill Dellschau's dream of his friend's names and their accomplishments not be forgotten?

Pete has just the combination of gifts and abilities that were needed to bring Dellschau's story to light. His inquisitive interests, in just the right combinations, of art, aircraft, mysteries, codes, UFOs and the 1890s Airship Mystery made the study of Dellschau's drawings an unavoidable obsession with him. Then, his ability to draw an almost mirror image of any object combined with his years as a graphic artist gave him the right tools to study the drawings with a meticulous attention to detail. He made drawings and kept minute records of everything. All with documentation that few would have taken the time to include. And most importantly, Pete's dogged determination to find out the answers to questions left unanswered, no matter the obstacle, kept him going. All of these characteristics were needed to fulfill Dellschau's wishes. Coincidence?

Had Dellschau's books not become available to this one individual, Pete Navarro, in their entirety — or at least the 12 books that have been found — Dellschau's story probably would have been lost forever.

Then there's Jimmy Ward. His special abilities, contacts and fresh ideas brought new insights into other possibilities. His writings on the subject published copyright free on the fledgling computerized information highway at the KeelyNet web page brought a larger, more open debate into the arena

Fig 28.1. Black and white photo of an oil painting by P.G. Navarro.

concerning Dellschau's secrets.

Jimmy Ward died in 1995. Not much is known about his ancestry. What is known was gotten from correspondence with many people Jimmy corresponded with and in interviews Pete had with Jimmy's mom, Nell Ward. "At an early age you could see that Jimmy was special," she told Pete. "He was well liked, by children and grown-ups alike. At age nine he was a police mascot and wore a uniform that was given to him by police officers."

Nell proudly offered Pete an old and yellowed newspaper article from the *Houston Press* to read. At the top of the public-interest article was a picture of 9-year-old Jimmy in his police mascot uniform with his arm around a white dog with black ears.

The article reads:

Boy's Plea Wins Dog

Love won out over material grandeur today and Pal [the] Spitz which gained fame last week for his long, lonely vigil over the body

of his dog friend, killed in traffic, was romping in a new home with a new master, 9 year old Jimmy Ward, shown above.

Offers of homes for Pal poured into Mrs. Frank Adams, S.P.C.A. director after the Press carried Pal's story and picture. Best of all, was that a well-to-do Houston man who is just moving into a big, fenced country estate. Mrs. Adams told him he could have Pal.

In the meantime Jimmy, who had seen Pal's picture too, had become a regular visitor to the S.P.C.A. He and Pal had become fast friends. "I've just got to have Pal," he told Mrs. Adams. So the man took another dog and Pal went home with Jimmy. Jimmy, who is in the third grade at St. Joseph's school, lives at 1511 Summer Street. He intends to turn Pal into a police dog, to help him in his junior policeman's "work."

"Yes, Jimmy was a good kid," Mrs. Ward remembered, "He was born right here in Houston. Right here in the Heights. He was born in a house because I didn't want to go to no hospital to have my baby. I was afraid to have my baby in the hospital because about that time two women had gone to the hospital to have their babies delivered, and one was a boy and the other a girl. But when they sent them home they gave them the wrong babies. One of the women didn't know it until they were changing the baby's diaper. The woman who was doing the changing said, 'I thought you told me you had a girl.' The baby's mother said, 'Yes, I did.' And the woman told her, 'You'd better look again. This is a boy.'"

Nell laughed. "It's sort of funny now, but back then … me being pregnant and all. No siree, no hospital for me! It later came out that the woman who had the boy had paid a nurse at the hospital to switch the babies' bracelets because she wanted a girl. It was four months before they finally got it all straightened out."

Pete turned the conversation back to Jimmy.

"Jimmy once showed me a picture of a man he carried in his wallet and told me he was his dad."

Pete asked, what happened to him. Nell smiled. "That picture wasn't Jimmy's father," she said. "He had no pictures of him. That was a picture of a family friend who was a movie actor. He use to show Jimmy a lot of tricks such as making like he was stretching his arms to be longer by rubbing on them. Jimmy adored him. He would take Jimmy out riding, and one time they went all the way to Las Vegas, Nevada. But, I can't remember his name … so many years ago. Then one day he left and we never heard from him again. But he

treated Jimmy like a son."

Nell looked sad for a moment, and then brightened up.

"Jimmy's old man walked out on us when he was four months old. One day, without a word he went to the bank and took out 15 dollars from a trust fund we'd started for the baby, closed out the household account, then came home, took all the money out of the piggy bank and left. We've never heard from him since. At least I didn't name Jimmy after him. He was named after an old boyfriend from my school days. We made it without him so it was probably for the best."

Nell noticed that Pete was busy taking notes so she continued. "Jimmy liked school. He liked to learn and was very inquisitive. He had many friends in both his elementary school, the St. Joseph's Catholic school and St. Thomas High."

"Where were you raised, Nell?" Pete asked.

"Oh me, I'm just an old farm gal. My family had a spread about 15 miles from San Antonio, Texas. Born October 19, 1908. Too much work out there. I remember helping to clear brush and cut down mesquite trees. I also had to gather the 'prickly pears' off the cactus. If you weren't careful you'd get the cactus nettles in your hands. Boy, did they hurt. After we'd gathered them, they'd build a big fire and burn them pears first to get all those 'prickles' off them then feed them to the cows. Nope. I don't miss farm work."

Pete let Nell sit quietly and think for a few minutes.

"Jimmy looked so nice in his Army uniform," Nell said, changing the subject. "He was in government service during the Korean War, you know?"

Pete nodded a yes.

"He didn't have to go over there, thank God. I'm not sure what his job was, but he was stationed in Washington, D.C. Something to do with Communications and Intelligence. I figured it was all probably hush-hush stuff, you know. So I never asked what he did. I do know that part of his job was manning a switchboard. That's what he was doing when he almost got killed."

"He almost got killed?" Pete stopped writing in his notebook. "How'd that happen?"

"It was during a severe storm. He had been given orders by the Commanding Officer to stay at his post, as it had to be operated 24 hours a day. He was instructed to stay with it and not to move from there. It had begun to thunder and lightning really bad while Jimmy had the earphones on his head. The Captain in charge of the office told him to take the earphones off, but Jimmy told him he had orders to stay with the line at all times and not to remove them for any reason. The Captain insisted that he get off the switchboard and that it

was an order. So Jimmy said OK and started to remove the earphones. Just as he began to pull them off his head lightning struck the switchboard lines and a flash of light came out of the set and singed the hair in back of his head. He was knocked down onto the floor and the Captain, who had come close up to him, was also knocked down. The lightning fused all the switchboard wires together. Jimmy was not knocked out but the Captain came over to him and got down on his knees. He grabbed Jimmy's head and was holding it close to him to see if he was still alive. At that moment Jimmy opened his eyes and said to the Captain, "Sir, I didn't know you cared." Pete and Nell both laughed. Nell laughed louder when Pete told her, "That was probably the best order he'd ever obeyed."

She told Pete that after that Jimmy started to have trouble with blood clots in his brain and that he'd been in an Army hospital in Washington, D.C., until they released him as well. But something had changed. He'd always had extra powerful awareness of the senses, but since the accident he seemed extra sensitive to his surroundings. Many of his friends believe that he had very powerful psychic abilities, Nell explained. Pete was already aware of Jimmy's psychic abilities.

Seven years before meeting Jimmy Ward, the Navarro brothers were discussing all sorts of methods they might use in trying to understand more of Dellschau and his drawings. The discussion came up about how archeologists determined the location of archeological sites for excavation, and their discovery of ancient ruins and artifacts by the use of psychic methods. Even the police used these methods to locate murder victims and to solve crimes. They decided to see what pyschometry could tell them.

Pete selected two people who had been tested to have high ESP abilities. The sessions were separate so nether one overheard the other. Pete begin the experiment by handing the first participant various objects that had earlier been sealed in brown paper envelopes. The first set of objects had no connection to Dellschau. The results were surprisingly accurate. Pete then handed him identical envelopes containing Dellschau material.

The psychic visualized several quick images. A man with long side-burns. Cross-bones. Someone standing, with his ribs sticking out of his body. He was a tall man, wearing black or dark clothes. The man started to tell him a story; that he came from a very high place. He saw clouds and mountains. A black mountain peak with three points on it. He saw that this man had been killed and that he was the man he had seen with the bones sticking out of his body. He had been killed from behind, with such force that it made the bones stick out in front. Someone took papers, or books from him. He saw pictures that

this man had drawn on rocks and carved on walls. The pictures were of things like circles with spokes, and the spokes were many colors … and they flew. He felt that the man was killed accidentally.

The second psychic visualized a room, like a basement, with old-fashioned trunks and clothes in the room, which were kept in neat order. She saw five men, talking. They were reading books, or diaries. The books looked like they were homemade, not very well put together. They read by candlelight. Two of the men made strange signs with their hands at each other. Then she saw nothing but darkness. She felt like her head was being banged against something. Felt sharp pains.

In another session participant number two saw the same room, or cellar.

She saw seven men in the room, sitting around a table. They appeared to be drawing pictures. They were talking but she couldn't tell what they were saying. Other sessions produced similar impressions and not much else of significant difference. The results of the experiment did not seem too illuminating or encouraging so they dropped further experiments with pyschometry.

Seven years later, upon learning that Jimmy possessed the ability of pyschometry, Pete approached him to try it out on some of Dellschau's material. He didn't,

Fig. 28.2. A cut-a-way view of part of the NB gas conversion chamber aboard the Aero Mina. From plate 3227.

194

however, tell Jimmy of the other times he'd used pyschometry in his search for Dellschau's secrets. At first Jimmy had been reluctant. His major interest was the *NB* gas, which he'd read about in Jerome Clark and Loren Coleman's book *The Unidentified*. But eventually he became caught up in the whole Dellschau mystery, just as everyone else who had spent any time looking over the material, and he agreed to an experiment. Wedged into one of Dellschau's books Pete had found a brass-drafting compass and a small glue brush. The obvious conclusion drawn by Pete was that Dellschau had used these very tools in the making of the drawings. He decided to let Jimmy use the compass.

Jimmy Ward commented upon Dellschau's frequent use, or reference to murder (or use of the word murder throughout his books).

He said that in psychoanalyzing the compass, which Dellschau used in making his drawings, he felt that Dellschau had "ran into one." He wasn't sure if it involved someone getting killed, or just stabbed.

"Has anyone else psychoanalyzed the instrument handed me?" Jimmy asked.

"Not as far as I know, Jimmy." Pete answered Since he'd found it in one of Dellschau's books it had only been handled by him and his son Chris and maybe two or three other people he'd shown them to.

Pete recorded the outcome in his journal:

Jimmy felt from the beginning (when he first came into contact with the object and had felt a cold chill), that something didn't fit. (Or he felt that he'd gotten something that didn't fit ... in his words.)

Upon holding the compass in his hand, as if holding a knife, he had suddenly felt something like a stab in the back. He had envisioned, or picked up a death scene, which quickly got him out of the mood for further psyching. "It brought me out of the mood," he said.

He had gotten flashes of insight though, in which he'd seen drawings ... but these flashed rapidly ... too fast, in fact. Then all of a sudden he seemed to be standing, stripped to the waist, with a big gash and blood below the ribs. Cloth had been wrapped around to stop the flow of blood.

The scene changed suddenly, just for a second, and he found himself about 300 feet up in the air. He could see a grassy meadow below. He could see the tops of some trees ... there appeared to be several trees in a clump. He could see a road running at an angle (to his line of vision). The terrain just behind seemed to be hilly ...

he could see something like mountains [mounds] which looked like "goose pimples." That was what he had seen ... and then suddenly he was back in a room, holding a cloth in his hand and looking on top of a desk for something ... it was all very confusing. (Or, was it actually that he was confused?)

Someone knew that he was dying and he was searching for something ... he wanted people to know, Pete had written in his notebook.

Jimmy had actually seen two different scenes. One was out of doors (when he was looking down from up in the air) and the other was in a room.

In the room was a desk; there were things on the desk. One was a large book looking much like a scrapbook.

There was a window (or windows) that was about even with a chair in the room. One window was close to the desk and another window was away from it, facing west.

Did this person he'd visualized stab himself? Or had someone stabbed him? This was the question he asked himself. It was all so confusing, he actually couldn't tell exactly how it had happened, although he was sure that the person was convinced that he was dying of internal bleeding. But Jimmy thinks that he survived.

Jimmy said, "The person involved might have been Dellschau. A coroner's report might tell if he had a scar."

Find a coroner's report on Dellschau, if one even existed. That was almost a hundred years ago ... *Good luck,* Pete thought.

"Oh, by the way, Pete," Jimmy said, "I talked to my doctor, who I had shown some photos of Dellschau's drawings. I asked him if he thought Dellschau was perhaps demented. His opinion was that Dellschau was very much in control of his senses, but that he might have had a stroke in the latter part of his life, judging from the sloppiness of Dellschau's last works."

"Nope," Pete agreed, "Dellschau wasn't crazy, but he was very crafty."

CHAPTER 29

Speculations and Ideas

*This Airship thing is really intriguing once you tie in the
Russell probability of elements beneath Hydrogen. Think
how the world would change if the stuff could be rediscovered.
Surely one out of the 26 [of the unknown elements] would
have the property [to make a machine the size of Dellschau's
Aeros lighter than air].*

— Jerry Decker of Vanguard Sciences

Over the years many interested people have looked at and studied Pete's
findings concerning Dellschau's story. One group who has studied, and
continues to study the Dellschau material, is KeelyNet [www.keelynet.com/
mainnew.htm], a study group sponsored by Vanguard Sciences. Most of Pete
and Jimmy's writings concerning Dellschau and his flying machines were first
posted by these serious-minded researchers on their Internet BBC.

One of the group's theories about the Sonora Aero Club and NYMZA is
that there were two, possibly three, groups experimenting with flying machines
during the 1800s. According to a report filed on their Internet web page, www.
keelynet.com,

*The Western group was based on the work of German immigrants
who founded the Sonora Aero Club that was controlled or
influenced by the mysterious NYMZA group from the east. Someone
in the Sonora Club had discovered a gas that had incredible lifting
power. We at Vanguard Sciences believe this gas to be a component
of hydrogen or more precisely a direct indication of elements with
less mass than hydrogen.*

*The Eastern group had aerial devices and technologies using
magnetic or neutral center principles as discovered by Keely and
possibly others who might have been either in association with him
or working independent of Keely.*

*Comments from the Western group indicate that attempts
were made to join forces with the Eastern group, [even though] the
Eastern group had the greatest potential for military uses, [while
the] Western group were Pacifist. Both groups were sworn to secrecy*

with the threat of death to members who even hinted of any desires to capitalize, release or otherwise promote their discoveries as a group. Both the Eastern and Western groups did not confine their researches to aerial technologies alone. Unfortunately, because of the secrecy involved, much of the information is lost or intentionally destroyed to prevent its use for "negative" purposes.

There is a great possibility that the groups survived into modern times and might still be playing a part in many of the UFO-type phenomena that continues today.

If such is the case, that the groups did not die out but in fact continued to advance their researches, they could by this time be at a point in their developments that would make them appear to us as advanced beings.

Would it not be to this mysterious group or groups' advantage to intentionally influence those working in such areas to create outlandish stories in order to help discredit the real researchers? And would they not also take the necessary steps to silence those coming too close to the truth?

Jerry Decker is one of the directors of Vanguard Sciences and a good friend to Dellschau research. Some of his observations about the subject were included in a letter to Jimmy Ward:

(1). As to the name NYMZA ... I could not rationalize the use of a foreign language, assuming the group was based in the USA. For that reason, it would seem English would be used. As you pointed out NY must surely stand for New York. Since these guys were inventors and mechanical types, the M must be Mechanical. A popular word in use in the 1800s was the term Zephyr that means "a breeze from the West." From a European perspective, a breeze from the West would indicate something coming from that part of the world. And as to the A, how about Association. Thus, it kind of fits to say that NYMZA = New York Mechanical Zephyr Association.

I could not find any other word in the dictionary with a first-letter Z that would work in that context. Probably wrong but one never knows.

(2). As to the mysterious gas NB, you said on the phone that it was highly flammable and must necessarily be lighter than hydrogen. Hydrogen has a mass of 1.008, so NB must be lower.

Walter Russell came up with an Octave Periodic Table of the Elements based on musical scales ... He says that the maximum of elements will be 144 and the scale shows 26 elements with less mass that Hydrogen. While this totally defies modern chemistry beliefs, who cares? He could be right.

If this stuff (any of 26 varieties) is present in mass or the atmosphere, then it must be capable of concentration and possess extraordinary lifting power (again increasing in lift potential as the mass number decreases).

(3). Gustave Le Bon was a famous scientist at the turn of the century (1890 – up). He investigated natural radioactivity with the use of a device called a spinthariscope. The spinthariscope was basically a transparent plate covered with phosphors, which would sparkle in the presence of low-level alpha emissions. From this he made hundreds of fascinating observations regarding atomic fission. His books were removed from all libraries shortly before and during WWII because they gave secrets relating to the Manhattan Project. We [Vanguard Sciences] just happen to have two of his books.

Le Bon found that distilled water which had been swished around in a flask in which mercury had been stored, would cause a piece of aluminum to become extremely hot when poured on the surface (note: water "tainted" with mercury) ... a form of fission generating tremendous heat. What makes this bit of information intriguing in regards to Dellschau's claims is that it appears that the generation of the NB gas occurs when it is dripped into the hollow drum and onto the lumps of black material (coal/carbon?). It can be either a catalyzing substance or actually generate heat through a low-level fissioning process.

Walter Russell said that all things "come from carbon and revert back to carbon when dying or dead." Thinking in alchemical terms, we can see how atomic fission could cause (coal/carbon) to transmute to the particular "milestone" of this NB gas. Of course we must keep in mind that certain chemical combinations (Epoxy part A mixed with Epoxy part B) will generate heat also, so by no means is the process a sure thing.

... This Airship thing is really intriguing once you tie in the Russell probability of elements beneath Hydrogen. Think how the world would change if the stuff could be rediscovered. Surely one out of the 26 would have the property [to make a machine lighter

than air].

Highly respected UFO research-writer Jerome Clark presented an interesting theory in a letter to Pete shortly after his series, *Secrets of the Airship*, appeared in *Fate Magazine*. He and fellow writer/researcher Loren Coleman had worked together examining the puzzling airship mystery and they had some ideas of their own regarding Dellschau and the Sonora Aero Club.

Throughout history innumerable groups, societies and cults, many of them secret, many not, have banded together around the idea that they in one way or another were in contact with "higher beings" who taught them things and oversaw their lives. Virtually every known religion assumes its adherents were and are guided in this manner. So do cults of magicians, spiritualists, contactees, etc. Some gifted scientists and inventors privately have believed that non-human entities helped them in their work. One of these was Thomas Edison, who is said to have credited mysterious "little people" with assisting him in making certain of his discoveries.

In the world of the 19th century no one had either the knowledge or the means successfully to fly heavier-than-air machines. Of that much we are sure. We are equally sure, on the other hand, that someone was doing just that and that most of those piloting the craft were ordinary mortals. Even if we reject Dellschau's account as senile ravings, we still must confront the twin "impossible" facts of airships and human occupants. If we do take Dellschau seriously, if only for a moment, we might postulate the following.

Suppose that in both Germany and the United States (specifically in California and New York) a secret society of brilliant scientists, technicians and inventors established contact with non-human agencies which told them how to construct aerial vessels, ordering the group to keep its work under wraps. Presumably the German and American branches were in communication with one another and around 1848 some of the Germans migrated in order to pool their efforts with those of their American cohorts.

Perhaps 1848 was a critical year. Perhaps the Eastern branch of the society had decided to market their airship; whether with or without the approval of their "superiors" we do not know. An advertisement from "R. Porter & Company" appeared on the East Coast with the news that soon airships would be freely available. For some unknown reason nothing came of the plan but by now

many of the Germans had set up shop near Sonora, California, with the Americans, and they would spend the next years conducting some incredible experiments.

Fig 29.1 Black and white photo of Dellschau's plate 2364 shows details of an Aero from below. The P.G. Navarro Collection.

There must have been a degree of dissension and dissatisfaction in the ranks as the group came to realize they might never be allowed to give their "aeros" to the world. They may have hoped that someone would arrive to defy the "superiors" and make the airship public property (not all that public, of course ... the group stood to collect an enormous fortune for their enterprise).

The Germans who stayed in their own country could have been responsible for the first 1850s airship flap. In the years after that, however, they too might have come over to America, which now was the center of aviation action. One of them might have been John Preast.

While airships appeared over America from time to time in

the years leading up to 1896, it was in that year that widespread, sustained flights became necessary, for whatever reason. In order to maintain secrecy at a period when airships for the first time would be observed widely, the society agreed to plant a series of conflicting, confusing claims to mislead outsiders. The ploy worked of course.

The "superiors," the non-human entities, had their own ships but they did not care to be seen and did their best to stay out of view while their human agents captured the headlines. Conceivably the human beings were little more than pawns in some cosmic game. The weirdest incidents (those putting airships in a paranormal framework) may well have been the really important ones, with the other, more mundane sightings were designed only to distract attention while the non-humans set about doing whatever they had intended to accomplish.

If Dellschau was lying, which is possible, then we must revise our theory only to exclude the German and Sonora angles. The existence of a secret society in contact with non-humans still can be inferred from a wide range of other evidence we have studied.

But to pursue our initial hypothesis to its conclusion, let us suppose that Dellschau retired to Houston late in the 19th century (as in fact he did) depressed and discouraged because it looked as though the whole amazing business forever would remain a secret. Still intimidated by the "superiors" and afraid to speak too directly, nonetheless he determined to leave the world a series of clues in hopes that someday a "Wonder Weaver" would find them and sew the entire dazzling fabric together.

Chapter 30

New Homes

I got a lot of pleasure and enjoyment owning and looking at Dellschau's work. I've done the research I was interested in doing, but for now, I'm out of the Dellschau business.

— Pete Navarro

During the next few years Pete was only able to work on the Dellschau material sporadically. He still conferred with Jimmy Ward on occasion, but little was added to what they had already uncovered. Most of their ideas, while plausible, remained unproven. They did collaborate on several articles on the subject, most published by Vanguard Sciences at www.KeelyNet.com.

Then Jimmy Ward died.

Pete and his family had moved into a smaller house and his eight Dellschau books took up quite a bit of closet space. Another problem was that they were beginning to deteriorate at a rapid pace and he really didn't have the know-how or finances to preserve them. He had just about arrived at the decision to get them into the hands of people who had the facilities and resources to protect them from further deterioration. With this in mind he made a phone call to Mrs. DeMenil's house to ask if perhaps she would like to purchase the eight books in his possession. After trying several times to call Mrs. DeMenil without success, he decided to drive over to the DeMenil mansion. He wanted to try and get another look at the books she had, and at the same time feel her out about possibly purchasing his books.

After parking his car in the rear parking lot he found his way to the small art collection room in the back of the large main house. He found the door open, so he stepped in. A woman he'd never met looked up from a pile of papers she was sorting at the small desk just inside the door and smiled. She introduced herself as Kathy Davidson and asked, "Can I help you?"

Pete explained who he was and that he was there to study Dellschau's books.

"Just a moment, I'll have to make a phone call to make sure it's all right."

Pete didn't catch whom she talked to on the phone, but after a short minute she hung up and told him it was all right.

After getting the books down from their storage shelf for Pete, she set him

at the small table he'd used before, and then excused herself. Pete spent the next two hours perusing the now familiar books. There was still a lot he hadn't touched upon. However, when Ms. Davidson returned and explained she had to close up and go home, Pete was satisfied with what additional information he had been able to get. He thanked her and left. He hadn't approached her about his books.

It was five years before he called Mrs. DeMenil's residence to see if he could look at the books again. Kathy Davidson was then in charge of the rare book collection. She remembered Pete and informed him that she was sorry but the books were now kept in a cold storage vault to keep them from disintegrating.

"However, we are in the process of microfilming all the books and I'm making arrangements for putting them on exhibition sometime in the near future," she added.

"I know what you mean about the books falling apart. I'm having the same problem with mine," Pete told her.

"Oh. You own some of Dellschau's works?" She seemed surprised. "I wasn't aware that there were any other Dellschau's out there. How did you get your hands on them?"

Fred explained about Fred Washington, a story she was unaware of.

"Mr. Navarro, would you please do me a favor? Could you send me information about your books and the things you found out? I might want to use your information in the showing I'm planning."

"Actually I'd like to sell the eight books I own along with all the information I have found regarding the books," Pete told her. "Do you think Mrs. DeMenil would be interested in purchasing them?"

"I'm not sure," she answered. But, I'll tell you what I'll do, Mr. Navarro.

If you'll send me a description of what you have, I'll present it to Mrs. DeMenil and we can go from there."

Pete agreed to do that and after a few more pleasantries, hung up.

A few days later he told Rudolph that he had decided to

Fig 30.1. A black and white photo of plate 2362. From the P.G. Navarro Collection.

sell the books.

"Don't sell them yet," Rudolph urged. "There's still a lot in those books that need closer study. At least take pictures of all the pages and reserve the rights to all material you've acquired through your research and study."

About a week later Pete received a phone call from Kathy Davidson informing him that Mrs. DeMenil wasn't interested in purchasing any more of the Dellschau books. Not because she didn't want them, but because she didn't have any more space in the cold storage room where they kept old and rare books. Pete understood perfectly ... storage was his problem also.

Then Pete received a letter from the San Antonio Museum Association of San Antonio, Texas. The letter explained that the Association had gotten his address from Mrs. DeMenil's secretary. They were interested in buying some of Dellschau's work. Mrs. DeMenil didn't want to sell hers, but she thought that Pete might want to sell his, and her secretary had passed his address along to them.

After several phone calls Pete agreed to take his books over to San Antonio so that the Museum Directors could examine them. Pete loaded his Dellschau books up in his car and took them the 250 miles to San Antonio ... the longest distance they'd ever traveled. Eventually they bought four of the eight.

Pete continued to try to sell the remainder of the books to Mrs. DeMenil without success. After her death he made an equally unsuccessfully try at selling them to the DeMenil Foundation. Finally Pete found a buyer. An art collector who wishes to remain anonymous offered to buy them from Pete. Pete's major concern was that Dellschau's works be preserved so that future generations could enjoy them. The collector agreed to preserve them properly.

Soon after Pete sold the remaining books, and because of several showings of Dellschau's drawings in art galleries and museums around the country, interest began to increase in Dellschau's work. Postings on the Internet have also made Dellschau a hot subject. Up until the present time hardly a month goes by that someone doesn't contact Pete, either a private collector or art gallery, looking for some of Dellschau's drawings to buy. Pete has developed a stock answer to all inquires:

I got a lot of pleasure and enjoyment owning and looking at Dellschau's work. I've done the research I was interested in doing. I'm sorry, but I'm out of the Dellschau business for now.

CHAPTER 31

Pete's Dilemma and
The Author Writes Himself into the Story

Don't believe everything I say.

— C. A. A. Dellschau

HOUSTON, TEXAS, 1998

If you didn't know exactly where the small blacktop lane leading into the tiny Washington Cemetery is located you'd probably miss it on the first pass. But Pete turned into the almost hidden lane leading to a set of double gates without any problem.

"You know, Dennis, it still amazes me that except for Sonora, the whole of Dellschau's story took place within a three-mile area here in Houston. And his final resting place is located right in the middle of that small area," Pete said, as he pulled into the cemetery proper.

It was my last day in Houston on my third research trip and it seemed fitting that Dellschau's grave was where I should end my research.

The small graveyard is located on a long rectangular shaped plot of land near downtown Houston just a few blocks east of where Fred Washington's old workshop had been. It is surrounded by old run-down buildings and weed-filled vacant lots.

Fig. 31.1. Dennis Crenshaw at the graveside of C.A.A Dellschau. Photo by P.G. Navarro.

"The first time I came here there was an old frame house over there," Pete pointed towards a small clearing on the left hand side as we entered the property. "An old man and an old woman by the name of Leona Tonn were the caretakers at the time and they lived there. They kept the plots of the families who paid them clean, but most of the graves were overgrown with weeds. I asked the old man if I could see the record

206

books. I explained that I was interested in Dellschau. He went inside the house and returned with a large record book. I found the hand-written entry without any trouble. C. A. A. Dellschau had died April 20, 1923. He had been buried in the Stelzig family plot."

Pete stopped the car about halfway into the narrow graveyard.

"Here we go, Dennis," he said as we stepped out of the air-conditioned car into the muggy Texas summer heat. "The final resting place of the mystery man Dellschau. The first time I came here the grass was grown up all around the tombstones, now they take better care of the place."

The bright glass silhouette of the American Tower Building could be seen in the distance. The modern skyscraper made a fitting backdrop for the grave of the futuristic mindset of the late C. A. A. Dellschau. His tombstone is a simple gray granite, upright plaque. There is a Christian cross in the middle. Just his name and the dates of his birth (June 4, 1830) and his death (April 20, 1923) are all that is carved on the stone. The stone cutter had misspelled Dellschau's name on his tombstone, spelling it *Dellschaw*. As in life, so in death, Dellschau seems to be trying to hide his secrets.

As Pete and I stood silently over the gravestone of the man who had mesmerized so many people over the years, there was one final piece of information that I needed to know before I began the writing of this book.

"Pete," I asked, "after all the years of study and research, what do you think, was Dellschau telling a true story?"

Pete looked at me with a shy little smile.

"You know, I studied those books for years, and I'll bet during all those

Fig. 31.2. The envelope Pete Navarro found in one of Dellschau's books. Could this be a clue that the whole Aero story is "not a bad joke?" Or was he addressing something in the letter that came in this envelope? Or even something on the envelope itself that he found amusing? Just another mysterious clue.

years I've changed my mind about whether Dellschau was telling a true story or not a dozen times. I realized something right from the start. You'll never know the full story unless you study all the books. I still believe that there are missing books. Probably between six and eight more. Maybe as many as 10. Let me explain.

"The earliest drawing in the 12 books I studied was dated April 3ʳᵈ, 1909, but the drawing's number was 1,900. The fact that plate number 1,900 was made in April 1909 would indicate that Dellschau had probably been making airship drawings long before the year 1909. Maybe as early as 1896 or 1897. When the Airship Mystery was in full swing.

"Dellschau produced an average of 22 plates a month between the years 1909 and 1921. That means that he was working on his books at least seven years earlier, in 1902 … only six years after the Airship Mystery years.

"It's my belief," Pete continued, "if the earlier books are ever found we will have all the answers. Until then it's all theory and speculation."

"But you have your own theory," I urged Pete.

"Yes I do. I believe that Dellschau left the answer in plain English scribbled on a used envelope he'd inserted into one of the books. It said simply 'It's a big joke.' That doesn't mean that I don't still have doubts. If it was a joke, who was he playing the joke on? The fact is that most elaborate hoaxes or "jokes" are always aimed at *someone*. So, who was Dellschau trying to fool? His books were found in the dump, by a stroke of luck and the keen eye of Fred Washington, otherwise no one would have seen them. That has always puzzled me."

"Probably the thing that bothers me the most is the fact that I still believe that some of Dellschau's machinery would and can actually work. How it works

Fig. 31.3 The bright glass silhouette of the American Tower Building could be seen in the distance. The modern skyscraper makes a fitting backdrop for the grave of the futuristic mindset of the late C. A. A. Dellschau.

still eludes me. But I'm positive that is probably the key to the whole thing, whether the machinery works or not. And I believe that information is available in the missing books."

"So to get back to your question. Yes, my theory is that it was all a hoax. But, I can change my mind if new information comes in. What stands out in my mind along with the 'it's a joke' envelope is one of Dellschau's encrypted messages, *Don't believe everything I say.*"

As Pete and I walked back to the car, I took one final look back over my shoulder at Dellschau's grave. I could almost see him lying there ... waiting. Most of his secrets were still secrets. There is still "Wonderer Weaving" to be done.

Part 4

The Wonder Weavers Findings:
"A Stock of Open Knowledge"

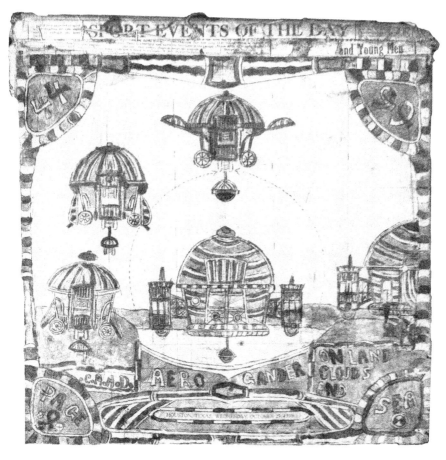

Fig. 32.1. A Black and White photo of plate 4499. Different views of the Aero Gander while in flight. The P.G. Navarro Collection

From P.G. Navarro's Unpublished Manuscript: The Dellschau Books

The Sonora Aero Club: Member Roster

You are not forgotten.

— C. A. A. Dellschau

As Pete studied the Dellschau books he began to recognize the various individuals and characters pictured in the airship drawings as members of the Aero Club. Before long he grew to recognize the physical and personal characteristics of each of Dellschau's friends and they became quite familiar to him, not unlike Pete's real friends and acquaintances.

Fig. 32.2. Peter Mennis.

Peter Mennis. According to Dellschau's writings, Peter Mennis designed and built the *Aero Goosey* in 1857, the very year he met him. This Aero was the prototype of all subsequent Aeros. The motors for the *Aero Goosey*, however, were made or invented in 1856. The work on the motors and even the Aero itself were started previous to the inception of the Aero Club. There are several factors that point to Mennis as being the originator and inventor of the first Aero. In plate 2002 is the following notation:

Goosey
Sonora, 1857 California
Have you never heard of Peter Mennis?
Goose and his offspring?
Peter I haven forgot you!

In plate 2009 is the notation: " ... *Peter Mennis' Goose, the mother of all!*"
Mennis was the most important member of the Aero Club. Other members were constantly seeking his assistance in matters concerning the design and

construction of their proposed aircraft. Assistance that he at times gave and at other times refused. This may have been due to a feeling, or attitude, that he was being taken advantage of. In one instance, he refused to help **Mike Gore**, another member, who had asked for his advice on the construction of certain parts of an Aero.

Regardless of his reluctance to co-operate with some of the other members, he was, nevertheless, well liked. Everyone in the club recognized his talent and ingenuity. Most important of all, Peter Mennis alone possessed the formula for making the *supe* or fuel that was used to produce the *NB* gas. This gas was used to give "lift" and to propel the Aeros. He guarded that secret religiously, even going so far as to refuse fuel to other members whose Aeros he felt were made from bad designs.

The ingredients used to manufacture *NB* gas remain the number one mystery of Dellschau's story. Mennis is also credited with inventing the gas chamber in which *NB* gas was produced.

The unusual constant needed to make any of these machines fly was *NB* gas, and it was shown in all the Aero drawings. The gas, in a sense, was a sort of anti-gravity substance, for it eliminated the weight, causing the ships to rise. It was also used as the propellant.

A drawing showing a cross-section view of the *Aero Immer* clearly indicates that the gas generated in the power chamber was used to turn a large wheel in the center of the airship, which in turn (by means of a chain or belt) turned the side-wheels, or paddles.

In 1908 Dellschau asked, "Is Peter Mennis' lift power forgotten?" — evidently referring to the fact that up until that time, the fuel that Peter Mennis had discovered or invented was still not known or used by modern aeronautical engineers.

Gasper Gordon, another member, once said regarding his own ideas for the *Aero Lowdown*, that although he considered his ideas to be good ones he actually needed Peter Mennis to assist him in order to properly develop those ideas. Then, Gordon believed, the other members would find out the truth regarding the capabilities of his proposed Aero. Gordon claimed that his proposed Aero design would work day or night, in storm or in lull, in rain or sunshine. Evidently no one would take him too seriously, as he had a penchant

Fig 32.3. Michael Gore.

for boasting. Mennis would have nothing to do with Gordon and his ideas and refused to work with him. Apparently he had doubts about the validity of his proposals. "The trap didn't catch" was what Dellschau wrote regarding this incident.

That Peter Mennis had actually co-operated in some of the club's major projects with other members is evidenced by the fact that he, together with **Robert Nixon**, **August Schoetler** and Mike Gore designed an *aeroform* that could be "fed" either from above or from below. The feeding problem referred to the intake of air into a compressor. Peter Mennis came up with the novel idea for a motor to compress air. Some of the members laughed at some of his suggestions regarding this motor, but later, they were not only able to apply his ideas and put them to use, but many of the other members took the *Air Press Motor* and added their own ideas to it.

George Newell was the second most important member of the Aero Club. Pete believes that George was the local leaader of NYMZA. If not the head man he was at least one of the chief representatives for the organization, of that Pete is sure.

George Newell seems to have been a very conscientious and considerate type of person, regardless of his likes or dislikes for the ideas or opinions of other members. He usually bent over backwards to help or to keep peace among them, but not always. For instance, Newell didn't like **Leonard Huff**, another member, for some reason, but this was probably something of a personal nature. Regardless of their disagreements, George Newell and Leonard Huff were able to work together and agree on some phases of the design for the *Aero Igoe*. They worked in good companionship on this Aero in spite of the fact that Newell did not approve of some of Huff's ideas, one of which was a mushroom-shaped balloon design for an airship. Even **R. Polak**, another member of the club, was not very acceptable of this idea and once flatly stated, "I don't like old man Huff's mushroom," and suggested that it be "straightened" out. The idea of a mushroom shape for a balloon was evidently the subject of much discussion, with the eventual conclusion that it was definitely not suitable. Therefore the idea was discarded. This recorded incident is a perfect example of a certain amount of friction, or clash of personalities, that existed among some of the members, even though their primary purpose was to work together in order to attain their single purpose … to develop navigable airships.

In 1858 Newell, in collaboration with Michael Gore, came up with a design for the *Aero Dart*. Another project that Newell and Gore collaborated on was the *Aero Michael*, which was designed that same year. The motor for the *Aero Goeit*, which was designed by **Adolf Goetz**, was the creation of Newell. This motor was made to "feed from below."

In 1858 Newell worked on an Aero, the *Careta*, which was based on a design of the *Aero Mio*. The names *Careta* and *Mio* show the influence of the California Spanish. Later, with the assistance of Dellschau he worked on an improved version of the same Aero. Newell also designed a gas motor that he called the *Volta*. The *Volta* was a motor that supplied lift power and was actually put to use on several of the Aeros.

Always a jokester, Newell once came up with a design called the *Aero Gitt*, which was strictly a gag. However, his joke may not have been as wild or ridiculous as it seemed at the time. In 1911, Dellschau commented on what Newell might have said had he been able to see the airplane's designs of 1911. Many of the "new" airplanes had features not too remote from Newell's ideas. George Newell and Mike Gore also collaborated on the design of the *Aero Michael*, which they hoped would take them across the plains to St. Louis, Missouri.

Gore had also designed the *Aero London*. This Aero was lost in a fire that destroyed most of the town of Columbia, California, in 1858.

August Schoetler was president of the Sonora Aero Club. He was depicted as having a mustache and wearing glasses. He usually wore a gray suit and a derby hat. A drawing of Peter Mennis and August Schoetler sitting on some rocks appears in plate 1912.

August was the designer and builder of the *Aero Trebla* in 1857. The *Trebla* was one of the craft that Dellschau claimed was actually flown. Plates 1602, #1603 and #1610 in Dellschau's books show different views of the *Aero Trebla*, one of which includes a caricature of Schoetler. He is also shown piloting the craft in plate 1602.

Another craft designed and flown by Schoetler was the *Aero Dora*. Mike Gore first conceived this Aero. He presented his idea to the club and it was accepted as a feasible airship design. Consequently Schoetler took the design and actually built a flying machine from the plans. Unfortunately, the *Dora* was one of those destroyed in one of the fires that plagued Columbia, California. It had been moved to Columbia from Sonora in preparation for a test flight in the landing field not too far from town.

Schoetler was not well liked by many of the other members of the club, probably because he seemed to have a certain animosity toward

Fig. 32.4. August Schoetler.

another member of the club, **Seor Juan Maria**. In contrast to Schoetler, Maria was well liked by most of the others. Schoetler was in favor of having Juan expelled from the club because he thought that his ideas were not original. Schoetler charged that Maria and another member, referred to only as **Jos**, had plagiarized others' ideas and presented them as their own. This however did not stop him from grabbing onto Seor Juan Maria's design of the *Aero Mio* in 1858 and incorporating some ideas of his own, coming up with an altered design, which he called the *Grand Mio*.

He also designed an aircraft called the *Aero Mary*. This Aero was probably built, but it is doubtful that it was ever flown.

Seor Juan Maria was probably a native Californian. As has already been mentioned Schoetler for some unknown reason, came to the conclusion that Juan Maria and his friend Jose were claiming to be the originators of some ideas which he believed to actually be the ideas of others. Schoetler was all for ousting them from membership in the club, however, justice prevailed and they remained members in good standing.

Juan Maria was the original designer of the *Aero Mio*, proposed in 1858. Evidently several members of the Club added their own innovations to the *Mio*. The drawings on plate 2067 show several persons examining the airship as it rests on the ground. These include Peter Mennis, with his little dog beside him as usual, Dr. Saxe, and three other people who remain unidentified. One of the innovations on this craft was a new type of air pressure motor.

Professor Carlos, who must have been a top member of NYMZA, once ordered Schoetler to build a flying machine that "must look awful dangerous."

Dellschau never made it clear whether he wanted the flying machine to look dangerous because he had intentions of having it presented as a war machine, or if he wanted to use it to impress on someone how dangerous a flying ship could be.

August Schoetler, however, did not care much for this idea and was not inclined to rush into this project, especially since he suspected that many of the other members of the Club were anxious to see him break his neck.

Schoetler was very critical of Peter Mennis' *Goosey* and began to find faults in its design and construction. He pointed out that since the *Goosey* did not have a proper cabin, the pilot was exposed to all kinds of weather. He proposed a weatherproof *Goosey*. Although a good idea, it was never implemented.

In retrospect, Dellschau remarked, in 1912 that if the *Goosey* with a cabin had been built it would have been "a fine machine." It was his belief that it could have been used for military purposes and could have been made bullet proof

as well as fireproof. He applauded August Schoetler for his fine design, which was called the *War Goose*.

In 1857 Schoetler and **Carl Braun** proposed a design for the *Aero Gander*. This model was never built because of a lack of funds. They had hopes that this model, which was probably another design, based on Peter Mennis' own *Goosey*, could be built and flown across the ocean.

Jacob Mischer, referred to as "Jake" by Dellschau, designed and built the *Aero Flyerless Gander*. Whether the name signifies that it was a pilotless aircraft or whether it was an error in spelling and means that it was a "fireless" Aero is open to conjecture. Nevertheless, the construction of this Aero cost Jacob a pile of money. He sent the Aero aloft on a 100-mile trip, successfully landing it on both dry land and on water. It is not clear whether it was sent aloft as a pilotless aircraft or whether it contained a pilot.

After the success with this particular Aero Jacob wanted to recoup his investment and decided to go against the rules of the club and use it to start making money. Of course this would bring the secret workings of the club into public view. Before he had a chance to put his plans into motion his aircraft was destroyed. Was it a deliberate move by members of the club or was it an accident? Dellschau never says, but he does hint that Jacob disappeared along with his aircraft. Murder? We can only speculate.

Alolf Goetz was the designer and builder of the *Aero Goett*, although George Newell designed the motor, which was made to feed "from below." Adolf was also the inventor of the *Wibbel Wabel*, the true *Goetz Automatic Ballancier*, which was a contraption that hung on a rope below the carriage of the Aero to give it balance and stability and designed after the one that caused the death of the original designer **Rex Weber**. This tragic incident caused Dellschau to make the comment, "Brother Goetz, what do you mean with your one man flying trap?" Dellschau also appealed to George Newell regarding Goetz' experiments, and was of the opinion that it was enough to have one man break his neck and that he didn't want to see anyone else trying to fly in one of Goetz' Aeros and end up dead.

Gastav Freyer. In 1858 Gastav Freyer, who was a new member of the Sonora Aero Club and a highly educated mechanic, came up with a novel idea he called the *Guardia*. According to the rules of the Club each member had to produce and present to the Club an idea that would contribute toward the development of an aircraft, or propose something that would be useful towards that purpose. His idea was a guard fence, or cage, all around the machine,

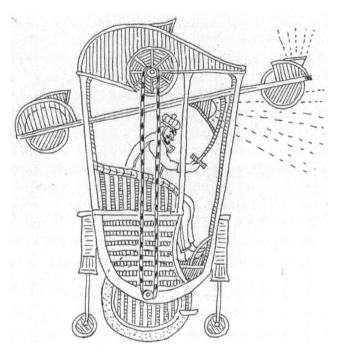

Fig. 32.5. A single-passenger Aero.

which was not only for the purpose of safety, but also was designed so that no matter how hard the landing the cabin, or gondola, would always remain upright.

At one of the meetings Gustav, in his broken English explained to the best of his ability the manner in which his invention would operate. After this discussion they all decided to retire to the bar, which was probably in the hotel where they held their meetings.

Because Gustav did not speak English very well Dellschau told him to try to learn better "American" so the others would not make fun of his accent. In his best-broken English he told Dellschau, "I learn to speak American as soon as you learn to write it."

Monsieur Jourdan, who was a Frenchman, designed various aircraft — among them the *Aero Jourdan* which had air pressure motors centralized on the machine. In making up the plans for the *Aero Jourdan* Dellschau apparently made revisions that did not suit Jourdan and caused him to complain.

In the year 1857 through the cooperation of all the members of the club, the *Aero Saturn* was proposed and built. But it was regarded as being too small. When Jourdan inquired as to why it was made so small that it could only carry one man, he was told, "Well, Monsieur Jourdan, I believe it is big enough for one man to break his neck."

With the aid of **Dr. Saxe**, Jourdan designed the *Aero Trump* as a war craft. Dellschau, reflecting back on this airship in 1908, made the observation that Jourdan and Saxe were no fools in having designed such a radical contraption as the *Aero Trump*. He was referring to their contention at that time that three hundred to four hundred foot long airships were possible and feasible, while other members of the club disagreed.

In 1859 Jourdan came up with an idea involving *center lifters* for the *Aero Jourdan*, which some members thought was a bad idea. But Jourdan insisted that his idea was a good one. He explained that center lifters were only receivers, or magazines, to catch the over expanded liftoff gas and would prevent an explosion of the balloons. He then suggested that they "come up with something better," referring to them as "you chucklers." In 1909 Dellschau wrote regarding Jourdan's idea, "Fifty years are gone and who laughs now?"

Carl Mueler and **Paul Somer** collaborated on the design of an Aero called the *Home Rondo*. The "Rondo" type aircraft was quite popular. **Robert Nixon** had originally proposed it in 1856 as the *Aero Rondo*. Working with Carl Mueler on still another design based on the ideas featured in the *Aero Rondo*, they came up with an Aero design they called the *Somers Rondo*. It was Dellschau who had taken some of the ideas incorporated in several of the Aeros and had put together a conglomerate that he called his own version of the *Aero Rondo*. Actually, it was Dellschau's combination of ideas, taken from the other members' airship designs that had inspired Somer and Mueler to work on their *Somers Rondo*. But these Rondo models were never built. That may be because of the interference of Dr. Saxe, one of the top members of the ultra-secret organization known as NYMZA.

Dr. Saxe was only in Sonora for a short period. He was probably there to inspect the Club's work and to allocate money for future projects. While in Sonora he asked Monsieur Jourdan if he would design an Aero that would be suitable for his particular needs. Jourdan replied, "My Dear Doctor, hand cash in advance and I fix you up. But cash first."

For whatever reason Dr. Saxe vetoed further work on the Rondo type craft. But that didn't discourage Somer and Mueler, who started work on another Rondo type design called the *Home Rondo*, wondering in the meantime just how long Dr. Saxe was going to remain in Sonora. George Newell, however, felt that this particular aircraft would never get off the

DR. SAXE

Fig. 32.6. Dr. Saxe.

219

ground. Peter Mennis had voiced a similar opinion regarding the original *Aero Rondo*. He remarked that the *Aero Rondo* was aptly named when they called it the "long stay" airship, because he wouldn't provide the gas for its lift power. Without the *supe* it certainly could not be airborne, thereby having to stay on the ground indefinitely.

Dr. Weisbach was an M. D. The club built an aircraft that they called the *Aero Soso* and they took Dr. Weisbach for a ride in it. The good Doctor had once suggested that a doctor should have an Aero in which to make house calls, so the *Soso* was their answer to his suggestion. As a joke they called it the "Pill Factory" and had this name painted in large letters on the side of the balloon of the aircraft. Dr. Weisbach dreamed up the *Aero Avant*. His design was equipped with "planes," flat wing-like extensions on the sides of the Aero's body that could be removed if desired.

Another design thought up by Weisbach was the *Aero Cita*. Peter Mennis did not approve of Dr. Weisbach's design, stating, "this Aero would bring great harm to the world." In what way it would harm the world was not stated. In regards to criticism of his Aero design, Dr. Weisbach said, "Let them break their necks, it won't hurt us doctors."

Christian Axel Von Romeling. If Von Romeling was a member of the Sonora Aero Club at all, he was probably not a member during the late 1850s when the group was experimenting in the Sonora-Columbia area. There is a notation that may indicate that Romeling was a member of the club during a much later period, from 1879 to 1889. Von Roemeling became a good friend of Dellschau. In 1909 Charlie Dellschau dedicated some of his drawings to Christian "out of friendship."

The *Aero Axel* was named after Von Roemeling, even though it is doubtful that he had anything to do with the actual design of the craft. Dellschau's drawings of this machine were probably copied from diagrams made by another member named **Thomas C. Williams**. However, Dellschau himself had presented some of the ideas. Further study of the plans for the *Aero Axel* brought comment from Williams regarding the weatherproof qualities of the airship. He stated that they would have trouble with snow, since the motors were in a central position. He proposed placing the motors on the sides of the Aero so that snow would not settle on them. Dellschau, accordingly, revised the plans to suit Williams.

The drawings of the *Aero Axel* give a lot of information on the principles of the operation and the function of different devices on this airship, which probably apply to the function of similar devices on other Aeros. There was no

smoking permitted aboard this airship. The wheels of the *Axel* were on a hinged mechanism that separated when the airship landed on the ground and then came together below the ship as it rose up from the ground. When landing the wheels and paddles were not lifted nor lowered. To insure a soft landing there is a knee-action mechanism in the center of the airship's carriage that acts as a shock absorber.

The air pressure motor of the *Aero Axel* is shown in detail in plate 1953. This motor seems to consist of a paddlewheel contained within a box with trap doors on the top that permit, or impede, the passage of air into the box. It is not clear just how this "motor" functions. There is a message on this plate that reads:

"Burst after burst, but no go without fire motors. Let them blow to cinders. Serves those smart fools right. But has the people below be always in danger of life and loosing homes by careless firebugs? Can they see the ever being ready motor-power - a rising of falling balloons will generate - harmless to all purposes and parties? - Rise pressure - fall pressure- counter pressure - and - read - wind- all doing their upmost - and no getting out on a trip!"

It may be that actual experiments were conducted on an Air Pressure Motor that was to be "fireless." Apparently the early fireless air pressure motor was not successful, for it is indicated that it would not "go" without fire.

Jack Schubert. In 1858 Jacke Schubert proposed a design "a la Brother Andre." It's possible that this is in honor of Dr. Andrew Soloman, who, history tells us, was experimenting with and actually flew a directionally controlled airship in New Jersey during this period. Jack's design was merely an elaboration of the Aero design that had originally been proposed by Carl Schubert, another member, probably Jack's brother.

Tosh Wilson. It is not known exactly who Tosh Wilson was, nor whether he was a member of the Sonora Aero Club or not, but Dellschau makes mention of him and his "crew." Dellschau also mentions the *Aero EE* in connection with Wilson. This airship was designed for carrying a payload of up to 30,000 pounds in passengers, baggage and freight. Dellschau claims this airship was actually built.

P. Constant and **Max Miser.** P. Constant and his friend Max Miser never were satisfied with Peter Mennis' parachute-type device for landing the *Aero Goosey.* They felt they could improve on the design with their weatherproof *Constant Falleasy* device which they claimed could be used in crossing the plains, thus avoiding the ever-present danger of outlaw and Indian attacks.

They also proposed a device, which they called the *Constant Parra*. This was probably some type of parachute to be incorporated into the Aero's design. Constant stated that this device would be "no trouble" and gave a demonstration of how he would apply the device to Peter Mennis' *Goosey*. However, they needed Mennis' assistance in the construction of the device and Mennis, for some unknown reason, refused to help them. Their suggestion was evidently not accepted, and even Dellschau said of his ideas, "Away with your dangerous parra" and to add emphasis he repeated, "I say, away with your Parra cumbrance." Constant's device, nevertheless, was later incorporated into the Aero designed by Max Miser, the *Aero Buster*, which was later renamed *Max Miser's Constant Aero Buster*.

Louis Caro, Sr. proposed the Aero called the *Desjetnich*. It was evidently modeled after Peter Mennis' *Goosey*. Dellschau presented a comparison of the two designs in two sets of drawings he made for one of his books.

His son Louis' favorite remark was "There is nothing new on Earth and there is nothing new in Heaven." He aspired to build bigger and better airships, some as large as four hundred feet long. He reflected upon the long, long trip they had made to reach their base camp in California and longed for adequate transportation facilities for making such cross-country trips. He felt he had been sent to, and left in, Sonora "for mitigation." It appears that he was exiled to Sonora on orders of NYMZA. Dellschau never explains exactly what he did to get on the wrong side of the higher-ups in the secret group, but it must have been serious, because Caro was very bitter over the whole deal.

Edward Hartung proposed the *Aero Sicher*. The word Sicher means, "secure" or safe, so literally translated, the name for this Aero is *Aero Safe*. In spite of its name, however, this Aero was considered by the club authorities to be dangerous ... if it would even get off the ground. So its construction was denied. "Forbidden forever," wrote Dellschau in regards to this decision. Nonetheless, August Schoetler, the Club's idea man, later worked on this same airship design in collaboration with Hartung, and they eventually came up with an alternative design they called the *Long Distance Sicher*.

Fig 32.7. Julius "Shovel" Koch.

Mr. Huff worked on the *Aero Igoe* in company with George Newell. The *Aero Igoe* was designed to land safely on water. Dellschau discussed the design and possible construction of this aircraft with Leonard in 1858 and then made the necessary drawings for it. Dellschau referred to Huff as "that good and forward brother Leonard Huff," meaning that he was advanced in his ideas. One such idea was a mushroom shape for the balloon on the Aeros. Both John Newell and Dellschau were against the mushroom design, but as Dellschau said regarding his personal attitude toward Huff's idea, "The best work will always find adverse critics." However, many of the members were adamantly critical of the idea of a mushroom shaped balloon and it was discarded as "not suitable." Another of Huff's ideas was the design for a device called *Piloty*, which was probably used for piloting or steering Aeros. In 1909 Dellschau wrote, in cryptic form, "If Huff was alive today, what would he say … Goit boys, forwards!"

A. Klotz proposed the *Aeromir*, a design that was built and tested, however its true performance in the air remained in doubt because of adverse weather conditions that caused the flight tests to be cut short. The weather had been clear when they began the tests but it began to rain while the test flight was in progress and further tests had to be postponed. The machine contained a "single wheel motor" and was designed for long trips.

Krause proposed a device called a *Sucker Kicker*, which was used on Mike Gore's *Aero Dora*. This was a device that pushed compressed air through a tube, something on the order of a supercharger. Peter Mennis made a similar device that was called a *Cloudstepp*.

Julius "Shovel" Koch. In 1858 a proposition was made by the Sonora Aero Club membership for someone to come up with an automatic device that could be used for easy descent of the *Aero Goosey*, the Aero that had been designed by Peter Mennis several years previously. A young man named Julius Koch designed a device he called the *Ever-ready Automatic Falleasy Goosey*. His idea was readily accepted. Julius Koch was also known as "Shovel" Koch because of his curious habit of always carrying a shovel. According to one drawing he was a blond-haired young man who smoked a pipe. A notation in one corner of the plate reads, "And Shovel Koch is not forgotten."

Thomas Gray designed an airship called the *Doobela* (plate 1645), which was actually designed just to tease Mike Gore. It was intended to satirize some of Gore's ideas, especially his design for the *Doobely*, and was probably not a practical design. Dellschau also refers to Thomas Gray as **Thomas Grau** and

Thomas Graves. It is most likely that the man's real name was Gray since the actual translation of Grau is Gray.

Jacob Horn designed his own version of the *Aero Dora*, which was another in a long list of Aeros designed after Peter Mennis' ever-popular airship, the *Goosey*. Actually, the idea for this type of aircraft originated with Mike Gore and was later used by Ernest Kraus, who made the first design for the *Aero Dora*, which was equipped with the supercharger known as a *Sucker Kicker*. In studying Jacob Horn's design for this Aero, there was a question as to where the motors should be located. Horn's suggestion was that they be "put below" to balance the airship.

August Immer Sr. proposed the *Aero Immer*. He made some changes on his design of the *Immer* and later came up with the *Long Distance Aero Immer* that was probably constructed in Columbia in 1858. His son, **Heinrich Immer** helped with the construction of this airship. Another son, **Carl Immer**, was also a member of the Sonora Aero Club but nothing is known about him except his name.

A. B. Kahn was the designer of the *Aero Ony*, a model that operated without the use of fire or gas. It was designed in 1857 and had a *self-motor*. The design for this aircraft looked fine on paper, but Dellschau was of the opinion that there was "little hope" of it actually flying. Kahn also proposed a larger version of this Aero for long trips, but it is doubtful that either of his proposed Aero designs ever saw the light of day. A study of his plans by the members of the club only served to reinforce their opinion that his Aero design was a dangerous one and that the cost of building it would be prohibitive.

Wilhelm Jaekel proposed a Revised Version of the *Aero Rondo* in 1858. "No fear of weight" he stated, obviously referring to the large lifting capacity of this airship. The design team of Paul Somer and Carl Mueller had originally proposed the *Aero Rondo* in 1857 but once again, as with the other proposals for the Rondo class aircraft, the NYMZA representative Dr. Saxe suppressed, or refused, to approve the construction or development of this airship. In plate 2006 is to be found the following lines: "Dr. Saxe suppressed *Aero Rondo*. Serves him right!! — 1857."

Emiehl Mentes. In 1857, Emiehl Mentes took his proposal before the board members of the Club and the *Aero Condor* was the result. Dellschau made several drawings of this model. He took a few liberties with it, incorporating

many ideas of his own, but still leaving the original ideas proposed by Emiehl. Later the same year, Jourdan proposed a smaller version of the *Aero Condor*, which Dellschau referred to as the *Jourdan-sized Aero Condor*. It was called the *Condor Jourdan*.

Gus Baumann submitted a design for an airship he called the *Aero Norma*. This design caused a few squabbles among the members in their club meeting discussions. This Aero contained an *Air Chamber* which was similar, in some ways, to a chamber designed by another club member, Marthin Karo, and was used for containing a substance known as *float* which was some kind of lifting agent used by some of the Aeros. The chamber originally designed by Karo was called the *Mathikaros Haub*. Haube is German for "hood." Hoods were domed chambers into which the compressed air, or gas, was forced to give the Aero lift.

Max Miser proposed the *Aero Buster*, to which was added P. Constant's *Parra* gadget after much Club debate. Later, when the design for the *Aero*

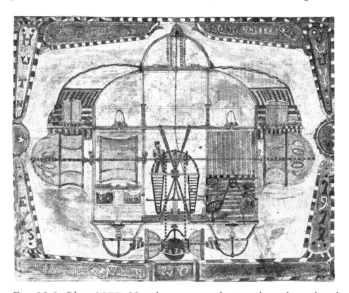

Fig. 32.8. Plate 2277. Note how power plant and machine details stand out when converted to black and white. P. G. Navarro Collection.

Buster was completed, Max Miser remarked that if this Aero was ever built, he wouldn't want anyone else up there with him.

"I am enough to break my neck," he said, and then added confidently, "but Buster won't do that, boys."

He renamed it *Max Miser's Constant Aero Buster*. This Aero was evidently built but before trying it out he and Constant were asked to appear before the board to make a statement regarding the feasibility of their aircraft.

Now you Constant, and you Max Miser they were asked, *Do you both swear that your contraption is weather proof?* They were also asked if it was *fall-proof* and whether it was a better aircraft than Peter Mennis' *Goosey*. They were reminded of what had befallen Peter Mennis during one of his trial runs in his Goose. That he had once fallen asleep after landing the *Goosey* and when he awoke the next morning had found himself snowbound and unable to take off again. Of course, the two men assured the board that all was well.

However, because it lacked the power chamber and fuel which only Peter Mennis could provide, and since Peter Mennis was unwilling to help them, nor tell them how to make the fuel, their airship never got off the ground. Dellschau remarked in 1912 that had they had gasoline in those days it would have probably "filled the bill" and would have made its success possible.

C. A. A. Dellschau was the draftsman and historian of the Sonora Aero Club, and the real mystery man of the group.

These are most of the members of the Sonora Aero Club that Pete was able to piece together from Dellschau's hidden writings. The more Pete searched for proof that these people actually existed, the less he found. If Dellschau's story is true, then even the coded names are fictitious. But if the story is only fabrication, then why did Dellschau add so much detail with such consistency?

And why did he go to Sonora in the first place? How did he happen to become so involved with the Aero Club? What was his connection to NYMZA? These questions remain mysteries.

CHAPTER 33

From P.G. Navarro's Unpublished Manuscript:
The Dellschau Books

Plate Notes

Plate 1601 is the first plate, or page, in the earliest dated book of the twelve. This first drawing depicts a slender man with a large black mustache wearing a brown derby hat who I assume to be Dellschau himself talking to Mike Gore who has red side-whiskers and wears a white hat. The caption reads: *Mike, we never were good friends, but say I haven't done you justice in the Aero Five. Good bye, Mike.*

This obviously was Dellschau talking with Mike Gore regarding his Aero design called the *Aero Five.* Dellschau shows various features of the Aero *Five* in plate 1601 that show details, but not the whole Aero. I suspect that he may have depicted drawings of the complete Aero *Five* in previous plates. He states that the drawings in this plate showing details of the Aero *Five* were made by him *After Michael Gore and Others.* One of the drawings is a top view of *Aero Five* showing the *Air Pressure Motor.*

Plate 1602 shows drawing #1 of August Schoetler's *Trebla.* Dellschau had written a notation in German that stated that the drawings of this Aero were made from "friendship notes." Evidently from notes he had made, with Schoetler's friendly cooperation, during the designing of this Aero.

Plates 1603 and 1610 show different views of the *Aero Trebla,* one of which includes a picture of a man in a brown derby hat, wearing glasses, who may be a caricature of August Schoetler. This man is the pilot of the aircraft, which according to a notation in plate 1602, was actually built by Schoetler. Another notation commenting upon this particular aero design says, *A machine coming up to those requirements would be a corker. Goe it boys.* A man aboard the machine is saying *The dickens.* Another man says *Nix domeraur.*

In plate 1607 is drawing #1 of an Aero called the *Chinese Aero,* by Oscar Marthin in 1858. It also mentions *Hidden Wings,* which was an idea that was proposed by Marthin in 1858.

Plate 1611 also has a drawing of the *Trebla*, built in 1857. *August Schoetler, builder*, is repeated in this plate. It should be noted that Schoetler is twice referred to as "builder" and not just "proposer" of this Aero. This may indicate that the *Aero Trebla* was actually built.

Evidently the idea of designing an airship equipped with wings had occurred to the group while working on previous airship models, but it wasn't until Oscar Marthin brought the subject to the board with a proposal involving "Hidden Wings" that the subject was taken up by the members and put to a study of feasibility. This is taken up in plate 1612. Marthin's idea was to have wings on the airship which could be hidden or folded on the back of the aircraft when "at rest," and "expanded" or extended when in flight.

Other members of the club evidently scorned this idea, although George Newell, half in fun, went along with Oscar Marthin's idea. Dellschau, in turn, decided to tackle the problem and began to work on the drawings for this Aero. This plate contains drawing #1.

Plate 1613 contains Drawing #2 of this Aero which Dellschau refers to as the *Doobeline*. He states that *NB* gas is to be used for "pushing wings out." About those hidden wings Dellschau said, *Hidden to secure them from being exposed to gunshots.*

He states that they had a harangue on the same subject in 1858. But that the problem then was how to make an Aero of that sort and be able to house it. That is, how would they make it so it would fit in a hangar? He said that *Oscar Marthin was laughed at by the members present, but Brother George were to his succor, half for fun and half for scorn.*

Regarding the hidden wing idea Dellschau also states the following:

> *He fly his wings hidden on its back at rest, but expandet when a-fly … and every bird hides his wings when at rest. But the question here is; how can you fly with hidden wings. Now I assure you Brother Marthin places them above or on a dooly between two lifters. Possibly even hidden for good. Now I shall work on above problem, scorn or no scorn.*

It is clear what Dellschau is trying to convey with the above statement. He is saying that if you are to build an airship that has "hidden wings," how is the ship to utilize these wings, when you know that even birds fold their wings back when at rest. But, when the wings are extended, they are no longer "hidden." Why was he so concerned with the wings being hidden?

228

In plate 1612 Dellschau wrote in code, *Reads just like* NYMZA *Club Work* [but] *They cannot do a thing today without fire motors … 10 - 15 - 100 horsepower … [and] a hundred thousand dollars in their minds.* He also states that *NB* gas would be used on this Aero for pushing the wings out and *not* to force the lift power into the lift-power holes. This used a different *NB* gas supply *which are separately filled, always ready for work.* Evidently the *NB* gas was used only for pushing the wings out, or to extend them from their place on top of the Aero while at rest and ready for flight.

In plate 1614, which contains drawing #3 of the *Doobenlin,* Dellschau makes the remark that *Not much hidden … but hard to hit.* Obviously the hidden wings idea was to protect them from gunfire.

Plates 1615 through 1621 contain additional drawings of the Aero's hidden wings. Dellschau states that he made the drawings from material that was submitted by various club members and he took from this material whatever suited his purposes and intentions. In his last drawing of the Aero he uses the symbol **X** which means "Aero" and he puts "OK" next to the symbol. This indicates that the design for this Aero had been "Okayed" as is shown in his final drawing of the airship.

Plates 1622 through 1629 contain drawings of the *Aero Peter,* which was designed by Colonel Titus.

Plate 1630 contains a drawing of the *Aero Goosey* that shows Peter Mennis aboard the craft. Dellschau states that he made this drawing "out of friendship," evidently out of friendly regard for Peter Mennis, who, as may be seen from the above, was also held in such high esteem as to have an Aero named after him.

Julius Koch's *Ever Ready Automatic Falleasy Goosey*

The above long-named device was the result of a proposition made by the club members (but more specifically by NYMZA) who suggested that a device be made which would be automatic and would assure easy descent of the *Aero Goosey.* Up until this time, the *Aero Goosey* had been rigged with a hydraulic-type landing device installed by Peter Mennis, but was evidently not considered very effective, or suitable.

Julius Koch's idea for this type of contraption was the *Ever Ready Automatic Falleasy,* to which he appended the word *Goosey* to show that it was a new type of Aero, once the *Falleasy* device had been incorporated into its design.

229

Julius Koch's proposition was evidently accepted and applied to Peter Mennis' *Goosey* as *plate 1633* shows a drawing of the Aero *Goosey* with the new *Falleasy* device (made in 1858, a great year for Aeros, since many of the aircraft designed and built by the Sonora Aero Club were made in that year). The caption to this picture of the *Goosey* states that it was made *After Julius Koch's proposition"* It shows Peter Mennis inside the tent that is used to cover the Aero while at rest. With him is his dog and cat.

Plate 1634 has drawing #1 of the *Axel.* Christian Axel Roemeling, who was a member of the Sonora Aero Club for a period of 10 years (1879-1889), designed this Aero. It is in this plate that Dellschau first makes mention of the qualities of *NB* gas to *nagate weight.* His notation reads, *Defins tube to have just as enough to negate the weight, to make her float.*

Van Roemeling's *Axel* was his idea for an *Army Aero.* There are eight different drawings of the *Axel,* showing several views of it. One is a view of the aircraft as seen from above. Another shows the Aero in flight and another shows the Aero with its landing lights shining down toward the ground. The light beam is directed downward through the hole in the center of the carriage deck. One of the drawings is Dellschau's own combination of the best features of the various Aeros which had been incorporated into Von Roemeling's *Axel.* Note that in these plates Dellschau does not refer to the airship as anything but *Axel.* Further on down, in plates 1944 to 1959, Dellschau starts another series of drawings of the *Aero Axel,* which is probably an improved version of the original *Axel* design.

In plate 1644 Dellschau recalls that Professor Carlos ordered August Schoetler to build a flying machine. Following are his words:

> *Lion you hollered fine! You have affected a great program. Who will blame you? Money is the world's master, and I certainly wish you luck.*

> *Time is here where awful things are simply possible and have been so, long time ago!*

> *Well, I never shall forget professor Carlos' words, ordering from August Schoetler's flying machine. Schoetler, the machine must look awful dangerous. Must look so, I say — or there is no money to be made with it.*

The dear good people up here, are anxious [as] anything to see me break my neck.

Well I left them wait a while! Yes, August, money is trump, and fine advertising a great art. To earn it.
"Bou -ze!

In plate 1642 is a drawing of what appears to be a likeness of Dr. Weisbach holding a cane in his hand, and there is a wing over his right shoulder. Only one wing is shown, as he is standing with his back next to one of the border designs on the plate, which covers the other wing. Why are there wings on this person?

In plate 1645 is shown the *Doobela*, by Thomas Gray Sr. It is designated as *Sonora Aero Club work to tease M. Gore.* Evidently the Aero *Doobela* was just a gag to tease Michael Gore. There are actually ten drawings devoted to this gag design, which, according to what we can interpret of Dellschau's notations concerning the design may have wound up in their "Museum" of gag airships. The idea of making this gag Aero design was intended to satirize Michael Gore's ideas for an Aero which he had proposed earlier (i.e., the *Doobely*), designed in 1858.

The *Covert Goose*

There are nine drawings of the *Covert Goose,* which means, "covered Goose." It was proposed by Arthur Gregh and was an airship with a cover. The various drawings show the airship from several positions, including a view from below. There is also a "Broad Center Cut" which is a cross-section of the airship and shows interior construction. In drawing #6 is shown the *operators seat*, which is the pilots seat.

In plate 1666 is to be found Dellschau's name, with *Der Weber* as a sort of title after his name. *Der Weber* means "The Weaver." Does this tell us that he is just a "weaver" or "spinner" of tall tales? Or does it mean that he is just weaving all the data into his scrapbooks, so that a future "wonder weaver" or researcher will have to unriddle his yarn, which may be a dubiously true story?

In plate 1668 is the remark by Peter Mennis, when he refuses to help another member of the club (Gasar Gordon) because he felt that if he were

to give Gordon his little finger, Gordon would wind up taking all of him. In other words, he felt that he was being taken advantage of, and he refused to cooperate with his colleague.

In plate 1668 is also the first idea for the *Aero Dora*. Michael Gore initially conceived this Aero in 1858. He presented his idea to the Club and it was accepted as a very feasible airship design. Consequently August Schoetler took this airship design and actually built a flying model. This Aero, unfortunately, was destroyed in one of the fires which plagued the town of Columbia, where it had been taken for flight testing in the landing field not too far from town. There was another *Aero Dora* designed later by Jacob Horn, which was modeled after Peter Mennis' *Goosey* (*plate 2462*).

It should be noted that most of the proposals and ideas for airship design by various members of the Sonora Aero Club are dated 1858. Was this actually the case? Were they actually more active in the year 1858 in designing and thinking up those Aero ideas — or was it that Dellschau only used this year (1858) to designate the year that the club was founded or established in Sonora, California? This year is incorporated with the club initials or Sonora, California, in several ways throughout the bookplates.

There is a possibility that the members of the club may have worked on some of their ideas for Aero designs previous to the year 1858, but had not formed a local club until that year, their parent organization being NYMZA, the larger society or organization to which they were affiliated. An example of earlier dates can be found in plates 2400, 2426, and 2482 (in reference to Peter Mennis' *Goosey*). Plates 2508 and 2510, which have proposals by George Newell, with earlier dates; also plate 4533 dated the earliest —1856 re: the Aero *Rondo*; and 1857 in plates 1834-6 in reference to Frederich Wilhelm Schultze's *Crippel Wagon*. In making reference to F. W. Schultze's *Crippel Wagon* (also known as the *Hydrowhir Auto*) it is evident that Dellschau, in his later years, made recollection of this particular invention, which seems to have actually been constructed, and may have been a sort of auto, or land vehicle which was later reconstructed for use as an Aero.

Who ever heard of F. W. Schultze's Crippel Wagon? asks Dellschau in plate 1834.

According to further notations in plate 1834, F.W. Schultze's vehicle probably worked on a principle of compressed air, and contained *hydro wheels,* or wheels that had water in them. The water in the wheels may have been utilized as a method of propulsion when air pressure was applied in some manner, which caused the wheel to turn, thus setting the vehicle in motion.

In the year 1837, Dellschau tells us, Schultze invented the *Flydrows*. This was a type of supercharger. Twenty years later, in 1857, August Schoetler designed his *Air Squeezers,* which was a device similar to Schultze's *Flydrows*. Dellschau made drawings of each for comparison purposes. It was in 1857 that August Schoetler took Schultze's *Crippel Wagon* and converted it into an airship. Adding a balloon and other aerial equipment to the land vehicle to make it airborne. In plate 1835 is a drawing of the *Crippel Wagon "Schoetlerized."*

The *Crippel Wagon* was eventually sold to someone in England, minus the balloon, which Dellschau called the *silkragg*. Schultze's wife kept the silk material from the balloon. This bit of information gives us some idea of the fabric, or material that was used for making the balloons, which was silk. Whether silk was used for *all* other models is not specified, but it is definite that it was used for the *Crippel Wagon*.

The *Aero Berlin* and the Mysterious "W"

Heinrich Schroeder, whom Dellschau gives the title *Fixibus*, proposed the Aero *Berlin*. In plate 1679 is drawing #1 of the *Aero Berlin*. It shows Peter Mennis flying the aircraft. The mysterious letter W also appears in this plate. It should be noted that Dellschau gives unusual emphasis to the letter W, which he has inserted in various places in many of the plates. What is the significance of the letter W? The W is either shown in its English alphabetical form, in the stylized form, or in cipher form.

Why does Dellschau give prominence to this letter? Does it have something to do with the "Wonder Weavers"? Or is it just a symbol for something that has yet to be deciphered?

Wonder Weavers

Ever since Rudolph undertook to translate the message in plate 2048 and came up with the "Wonder Weaver," which we understand to mean the person, or persons, who "weaves," or "wonders" (or is it wanders?) through a maze in order to arrive at a clear understanding of things — as in solving a riddle — we have, more or less applied this designation "Wonder Weavers" to ourselves, since we will be the ones to whom Dellschau has directed this particular message. The message, in essence reads:

> *You, Wonder Weaver … will unriddle these messages. They are my stock of open knowledge. They … will end like all the others … with good intentions, but too weak willed to assign … put to work.*

According to our interpretation of the above lines, the researchers, or whoever endeavors to study and decipher the meaning of Dellschau's writings is the "Wonder Weaver"; who either "wonders" and weaves the story which Dellschau has spun for him or he is a person who "weaves wonders"; that is, he writes tales or stories to amaze others, In this case it is Dellschau's story which is being unriddled and presented to others, so they may know what has either transpired in the past (if actual) or, so they may know what a fantasy of science-fiction he has been able to put together.

Of course the initials for Wonder Weaver would be W.W. These letters, or just the plain letter W in normal form, or in cipher form may be found in several pages of Dellschau's book, either by itself, or in combination with another letter of the alphabet.

In plate 1627 are found the ciphers after Dellschau's signature. This is the cipher for the letters "S" and "W." The letter "S" is found alone in cipher in plate 1923. The cipher "W" by itself is to be found in plate 1980, as a symbol of some sort, under skull and crossbones

But the most amazing is the one in plate 1909, which shows two W's incorporated into the name of the Society. The initials themselves may not have anything to do with *Wonder Weavers* but nonetheless the mention of *Wonder Weavers* in Dellschau's writings and his use of the W's throughout several of his books seem to indicate a connection, as though Dellschau *knew* that eventually someone would endeavor to translate all that he had written and would be, in reality, the *Wonder Weaver*, to whom he directed his words.

It should be noted that historically there is the case of the ancient Cathars and other Eastern European people who are believed to have introduced their esoteric beliefs (such as witchcraft) into Europe. Many of these people were weavers, and spread their beliefs in Western Europe as they wandered or migrated to these areas, bringing their skills with them.

The X Symbol and Other Unsolved Mysteries of Dellschau's Code

While we're on the subject of mysterious letters and their meanings we should look at two other letters of the alphabet given prominence throughout Dellschau's work. They are the letters X and V, both of which are encircled. The circled X's are found in profusion throughout the books. In plate 4390 there are circled X's on either side of the year 1856. Were they used here strictly for decorative purposes, or do they have a meaning? In plate 4375 we read: "Keep the X." It is obvious that this statement refers to keeping the X, but just exactly what does the X represent? Were they used here strictly for decorative purposes, or do they have a meaning?

There is another puzzler that has the V, the X and an M surrounding the numeral 70 on three sides. What does this mean?

There are some other equally puzzling items that seem to have no connection to anything, other than to serve as "fillers" or as decorative motifs in the plates, or pages.

Some examples: In plate 4694, what does "48-58" stand for? Does it indicate a period of years?

In plate 4676 there are the letters T H M? Are these someone's initials?

The word LUDER is mentioned several times in the German text messages. What, or who is Luder? Is it just an exclamation, such as "holy smoke!" or something of that sort?

More on the *Aero Berlin*

There are eight different drawings of the *Aero Berlin*. (*plates 1679* to *#1689*). The *Aero Berlin* was a small aircraft. It could be steered on water as well as in the air.

The *Aero Berlin* was later designed as a long-distance vessel. But since this design was the supposed creation of Professor Max Des Jertnich, the fictional character that was created by someone in the club, it is presumed that this Aero design was made more or less in the nature of a joke or hoax. In plate 1688 is to be found the notation: *NYMZA — A HOAX — LONG DISTANCE AERO BERLIN.* Does this mean that the Aero design itself was a hoax or that NYMZA was a hoax? It is more probable that it refers to the *Long Distance Aero Berlin* since there is a notation in plate 1689, which states that Des Jehtnich *testing Heinrich Schroeder* made this Aero design. As we already know, Des Jehtnich was certainly a hoax, since he was strictly a fictional or imaginary character whose very name des jehrnich means (literally) "It won't go."

There is another drawing of the *Aero Berlin* in plate 1692 which has the statement reading, *None Des Jehtnich.* This would indicate that this particular Aero is not another of Des Jehtnich jokes but a design of the *real Aero Berlin,* which was designed by Schroeder.

The *Aero Goeit*

Plate 1700 shows the *Aero Goeit* from above, and also the layout of the deck. Plates 1702 and 1703 show the Goeit motor *after George Newell.* Plate 2306 features two views of the *Goet.* One view of the front of the craft, the other a cut-a-way view.

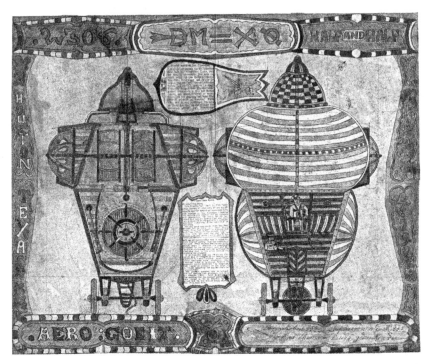

Fig. 33.1 Black and white photo of plate 2306. A "half and half" view of the Aero Goeit. The P. G. Navarro Collection.

The *Aero Cinquo*

This Aero was the creation of Anthon Krueger. In plate 1736 is drawing #3 of the *Aero Cinquo*. This Aero was probably 15 feet high. In plate 1743 is to be found the notation relating to the time when the military made an effort to convince the club members to produce aircraft which would be used for war purposes. It reads:

> *And who are you to question our board? Now what makes practical military airship 10 or 100 miles an hour?? Hell! Those acting officers act just like racetrack gamblers. No such questions asked, [such] as; bulletproof ... good gas reservoir ... fallease ... anti ballast! What did they say? — Holy Red Tape!*
>
> *"Yes, when the weather suits — gas can be got when reaching camp! And what say I [to] that long legged Prussian officer? Just more train ... we got too much [of that] already.*

Another line further down has one of Peter Mennis' philosophical sayings. It

reads: *No fire for ... or on my Goose ... because fire and gas are like two lovers. They will meet.* Evidently the *Goosey* did not use fire for purposes of propulsion.

The *Aero Dora*

The *Aero Dora* was evidently one of the most favorable of the Aero designs, with the exception of the *Aero Goosey.* This Aero design was first envisioned by Ernest Kraus and was later elaborated upon by other members of the club. In plate 1755 is drawing #1 of the *Aero Dora with sucker kicker.* Plate 1760 shows another drawing of the *Aero Dora with sucker kicker altered.* Plate 1765 shows a comparison of the *sucker kicker* and the *cloud steppe* as rigged for use on the *Aero Dora.* The *Aero Dora* was later designed as a war Aero and was called the *War Dora.*

The *War Aero*

The *War Aero* was a design that was a combination of ideas by various members in the Club. In plate 1783 is another design incorporating the ideas of Dr. Saxe, Mike Gore, Peter Mennis, and others. Plate 1788 shows the *War Aero* at rest and in flight.

In plate 1794 is shown a *Free Studia After Other Workers* and is a cross-sectional view of the Aero. Dellschau gives himself the title of *Grandscheiser* in this plate.

The *Aero Careta*

George Newell designed this Aero in 1858 (plate 1797). In plates 1801 and 1802 are drawings showing a comparison between the *Aero Goosey* and the *Aero Careta.*

The *Aero Here*

The *Aero Here* was an Aero designed after much club debate. Dellschau made several drawings of this Aero and left blank spaces where words or notations could be put later (to designate the function of different parts of the Aero, I presume). In plate 1813 there is a drawing of *Aero Here.* There are no words on this page. There is only the notation reading *Words in Lines.*

In plate 1815 is the *Aero Here* with the *Cloudstepp* device. There is the notation *Drawn After Club work — Words put in Lines.* This may indicate that this particular drawing was made after having had a meeting with other Club

members. Then afterwards, the words describing the Aeros, or whatever, were inserted.

The *Trebla*

The *Trebla* was not designated as an Aero until further work was completed on its design by August Schoetler in 1857. Dellschau states that the *Trebla* was a new design — a type of sports model. Hel also states that this model was actually built later on, although there were a few misgivings as to its performance in the air.

Dellschau makes the remark that August Schoetler would break his neck yet flying his *Aero Trebla* (plate 1823). It is definitely established, in plate 1822, that August Schoetler was president of the Sonora Aero Club. In plate 1821 is the notation *Trebla — August Schoetler, builder and owner.*

Lift Power

In plate 1780 is a notation in which Dellschau asks, *Is Peter Mennis' Lift Power forgotten forever?* This question was asked in 1908, when the advent of the aeroplane had just about given the swan song to the future development of lighter-than aircraft. Although there was still a lot of experimenting being done with airships and lighter-than aircraft at that time, the development of the propeller driven airplane had practically eliminated the use of gas containers to lift an aircraft. This may be the reason that Dellschau asks the question of whether the "lifting" power or *NB* gas would be forgotten forever, since airplanes would not use it.

The notation definitely establishes that there was a lift power of some sort, which was used by members of the Sonora Aero Club to lift their Aeros into the air. This lift power, whether it was the *NB* gas or some other agent, was evidently not taken into serious consideration by the aeronautical engineers of the period during which the aeroplane was emerging as the up and coming invention for aerial transportation. It may be that no one was acquainted with this lift power other than the members of the Sonora Aero Club. If the club members kept this secret gas under wraps, it is no wonder that the technicians and engineers of that time were not aware of it. The secret may have remained with Peter Mennis, who was reluctant to divulge the formula for producing the gas. In either case, if the formula was lost or kept secret by the club it is very likely that it has not been re-discovered by our present day technicians or chemical engineers and may remain a lost or "forgotten" chemical discovery until someone else stumbles onto the right formula.

The *Aero Lowdown*

Gaspar Gordon proposed this Aero in 1858 (plate 1826). Gordon claimed that his proposed Aero design would work day or night, in storm or in lull, in rain or shine. Evidently no one took him too seriously, as he was known as a braggart. He suggested that Peter Mennis join him in the construction of this Aero. Peter Mennis, however, did not care to go join him. According to Dellschau, Peter Mennis was too well acquainted with Gordon's smooth talking techniques to fall for his "trap."

The *Volta*

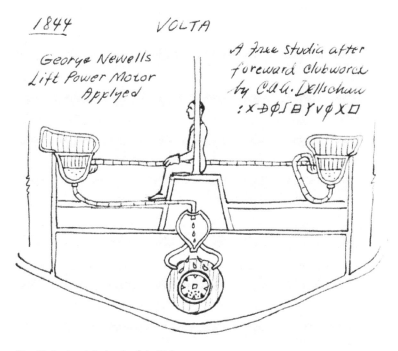

Fig. 33.2. A quick sketch of the Volta.

This was a lift-power motor invented by George Newell. Plate 1839 shows the motor, with the notation, *George Newell's Gas Motor applied*. Another drawing states, *Geo. Newell's Lift Motor Applied*. In plate 1841 is the *Volta* — *Lift Power aplyet*.

Plates 1828 through 1844 contain drawings of Newell's *Volta*, which apparently, was a gas motor. It was used to supply the lift power and is shown in use in several of the drawings.

The *Aero Trump*

Monsieur Jourdan designed this Aero as a war craft. In plate 1850 is Dellschau's cryptic notation *Spye,* which leads one to wonder whether he was indeed a spy. It may be that this designation merely suggests that he was an "observant," and that as the historian of the Sonora Aero Club he observed all that took place within his immediate area and recorded it. But, perhaps he really was a spy. If so, was he a spy for some government agency? On this same page, plate 1850, there is a line in French, which reads, *Trump Monsieur Jourdan pour la guerre.* Another line in English reads, *My revenge trump by Spye C. A. A. Dellschau.*

Plate 1851 shows the *Aero Trump* with a bomb bay or waste disposal opening. The title line on this plate is *Droppings — Aero Trump.* There is also a quoted line that reads *The people below needs protection for all this nuisance, I say!* This evidently refers to the "droppings" which must be the waste, garbage or bombs dropped through the deck opening, evidently without regard for the people below.

Dellschau makes the comment that Jourdan and Dr. Saxe are certainly no fools. It was Dr Saxe who helped Jourdan in his design for the *Aero Trump* which was considered to be quite a radical idea for an Aero. Dellschau states that in view of what he had seen of aircraft design in the year 1908 their ideas were really not too wild. The *Revenge Trump* was an Aero designed by Dellschau himself, which he probably designed after a study of Jourdan's *Aero Trump.*

The *Aeros Des Jeht Nich*

An Aero design, or model, called the *Des Jehtnich* was proposed and outlined by Louis Caro, Sr. and evidently modeled after Peter Mennis' *Goose.* In plate 1876 Dellschau presented a comparison of the two designs. There is also a comparison on the Aero *Des Hehtnich* and the *Aero Goose* in plate 1875. The name "Des Jehtnich means (literally) "the airship that won't go." The series that shows the design for the aero Des Jeht Nich starts with plate 1876. If Dellschau was copying from original airship drafting drawings then there is the possibility that the different drawings and notations included on this series of drawings of this Aero were made by different persons. This comes to mind because there are about a half-dozen variations in the spelling of the name of this Aero. *"Jeht Nich"* is the way it is spelled in plate 1856. It should be noted that a total of ten plates, from 1859 to 1868, are missing from this book. In plate 1872 the Aero is called *Dasa Gehtnicht.* In plate 1875 it is called the *Aero Das Jeht Nicht.* In plate 1880; *Aberdessethnich.* The word "Aber" means "again,"

so the line reads, Again, the Dessethnich.

In plate 1873 it is the *Desjethnich*.

Dellschau also stated that he worked up a drawing of this Aero from whatever suited him best and that he believed that he had *hit the nail on the head*.

Read the next plate, he states further, *and see how smart they are*. The "next" plate though, is drawing #4 of the *Aero Berlin*, showing an inside view of the Aero.

In plate 1856 is the following, as written by Dellschau:

> *How would our members laugh, over the deeds of today's Aeronauts — Nothing new under the heaven, says Brother Louis Caro. They build them, with and without using gasses ... but 300 - 400 - feet long. Nay, nay, never!*

> *Yes, Dr. Saxe and Jourdan swearet for fool fun. All over us, but who of our members, did not say, say No Sir — won't go! Now Keiser Wilhelm wants sleeping rooms attached to his balloons. Say Jourdan, can't you supply his majesty? Now next dropping thing from above shall be unlawful in war or peacetime.*

> *No bombs — no packages — no stinkeys. Well, who cares for the laws — up in the clouds?*

> *Forbidden fruit tastes very sweet. For instance, the spys a flying general a ammunition train right under him. He let something droppe, to hear it boom, and burn it did! All play things yet — good for time goe by, and money, yes money always pay for the funn, and money earned only for the mackers and Booler too, And now, my friends, Good Bye.*
>
> *CAAD*

There is also an account in German on this plate, but it's probably the same account as the above, which is in English. The above account, supposedly made by Louis Caro and written down by Dellschau may explain why the airship, which he proposed and designed later, was called the *Aero DesJehtnich*. It seems that they were contemplating the designing and construction of a 300- or 400-foot long airship. "It won't go," they said. But Dr. Saxe and Jourdan said it could be done. It is possible that they went ahead and built such an airship,

or at least they went ahead with the building plans. Reference is made to the dirigibles invented in Germany for the use of Kaiser Wilhelm (for war purposes, of course). Dellschau, knowing that these dirigibles would be eventually used for war, also visualized the probable uses of airships by the criminal element for the purpose of evading the law, for smuggling diamonds and for evading payment of duties (plate 1887).

The *Aero Goosey*

The most popular Aero, the *Goosey* was actually built by Peter Mennis in 1857 in Tuolumne County, California (plate 1878). *Nothing new on earth, says Brother Caro.* Dellschau repeats this line on this plate.

Old friends and their deeds not forgotten (plate 1879). This line tells us that Dellschau has not forgotten the deeds of his friends during their days in California as members of the Sonora Aero Club, and he therefore intended to preserve the memory of his friends by writing about some of their doings and achievements. He writes about Peter Mennis and his *Goosey* as stated by Louis Caro, Jr.:

> *Flying today he says with gas, heat or without either … did you ever hear of Mennis? Peter flew for years, in lull (calm) or blow, in* [his] *Goosey, like air a good old buggy trapp.* [We take this to mean he flew in the *Goose* like it was a buggy.] *When at rest to take his nap … in* [the] *goose … fixit to a tent, and do like money spent!*
>
> *Now today, with machine only. But too fit in fine weather — What a tent? Blow, you storm, don't ruin my house, or you kill me like a mouse and good luck to be in harbor resting.*
>
> *I do hurcan her best.*
>
> *… and out here on a long, long tripp, her in the enemy's grip, what becomes of heath of gas? I do say, sher of all you class … how do I long for transportation! To be left here for mitigation!*
>
> *Hell fire, what a fix, yes resultat, a further flyinf — Nix!. Well, all such troubles quick or hard, the greatest do — is surely a 400 feet balloon to land!*
>
> *Angly Sicer to safe to fiss to find a place to stoppe and life! And you find out!*
>
> *Louis Caro, Junior.*

What the above means is a bit hard to fathom, but the gist of the message

is that there was really nothing new about some of the latest developments in aeronautics. Hadn't anyone ever heard of Peter Mennis, who flew for years, in calm and stormy weather in his *Aero Goosey*? When at rest he used his tent-like shelter that was designed into his Aero. He used to nap in the tent, which meant he saved the money he would have spent for lodging.

In the year 1908 there was yet to be built an aircraft that provided the protection against the weather that the *Goosey* had. That is why Louis Caro states that *today, with machine only* it is fit only for fine weather. And they would be lucky to be in the harbor resting if a storm was to come up. *I do say, sher of all you class.* Here he says that he is sure that all his colleagues will agree that they long for an airship design which will have all the features of the *Goosey* but that would be larger, safer, and easier to land and to lift. There is one discrepancy in this account. According to Dellschau these words were attributed to Louis Caro, as is indicated by his name at the end of the statement. If this is true, then was Louis Caro still alive in 1908 to be able to comment on the fact that "today's" aircraft aren't as well protected as the *Goosey* was? There is nothing in Dellschau's notations which might indicate that he wasn't. If he was still alive, then there is a good possibility that Dellschau was still in touch with at least this one other member of the Sonora Aero Club as late as 1908. Or, Dellschau incorporated his own thoughts into Louis Caro's statement.

The *Aero Rondo*

Several members of the club evidently had a try at designing an Aero with the specifications required for this particular aircraft, but the main designer of this Aero was Wilhelm Jaekel.

Plate 1707 has drawing #1 of the Aero *Rondo*. *No fear of weight* is the notation accompanying this drawing.

Plate 1708 has another drawing of the *Aero Rondo*. It also shows Peter Mennis on the ground , waving at the airship above him and saying, *now land if you can.*

Plate 1719 shows drawings of airships equipped with the *Cloudsteppe* devices. There is also a variation of Wm. Jackel's *Aero Rondo*.

Plate 1722 shows the *Rondo's Cloudsteppe.*

The *Aero Hector*

The *Aero Hector* was a variation of the *Aero Rondo*. It is designated as a *Far reaching Aero Rondo and claiming originality of Joe Boulart.* Plates 1724 through

1731 contain drawings of the *Aero Hector*, which Josef Boulart claimed as his own idea for a Rondo-type Aero.

The *Aero Igoe*

The *Aero Igoe* was *a studia after* NYMZA *principles, strictly by C. A. A. Dellschau* (plate 1881). In plate 1882 it is stated that this was *a free studia after the good and forward brother, L. Huff.*

The proposer of this aircraft was Leonard Huff. He later proposed the *Aero Long Igoe*, which was in the shape of a mushroom (plate 1889). R. Polak, another member of the club, stated that he did not like *Old man Huff's mushroom*. He suggested straightening it.

There is an account in both English and German (plate 1887), which tells us of the uses to which airships might be put to by the criminal element.

> *There stands below a custom house to collect lots of taxes — Stand there, not in my way. Come right up here and doo collect for fetching diamonds overland. If not, my dear appraiser — we going fast somewhere — we not telling you!*
>
> *There files the burglars' windy craft with lots* [of] *luckre, stolen. What does he care for policeman up here? And let me tell you … well you laugh. Have you a bank or a store below? If sso, the time might come when you won't laugh. Nor swear!*

Gasevor

I do not presume to know what a *Gasevor* might be, but from the information contained in plate 1892 it seems to be a page, or plate, which Dellschau devoted to a collection of short notes which he must have taken from a diary or journal. It seems to be a reserve of bits of miscellaneous information of happenings and events that occurred within the Club membership. A few of these bits of information are:

Brother Newman is in the Club ohes of moneydom.

Peter Mennis saying fits to a point.

Let me give Mike Gore my little finger — and — he got me — soul and body."

They got him — and they throw him overboard.

The best work will find adverse critics, and so did Huffs.

Lionel Huff's mushroom idea did not suit Dellschau either. In plate 1896 is the notation: *George Newell contra Huff Igoe. Me too!*

In plate 1895 is a phrase that reads, *"Now, mister critics — Huff's mushroom didn't suit. Where lay the fault now?"*

A cryptogram in plate 1894, containing a drawing of the Aero *Igoe* reads, *If Huff was alive today, what would he say … how go it boys … forwarts!*

The *Aero Honeymoon*

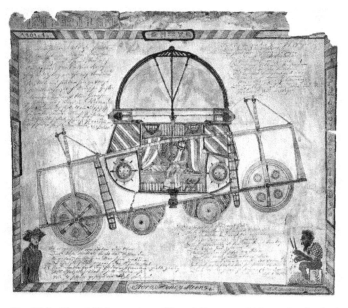

Fig. 33.3. Plate 1901 contains a "Broad Center and Motor Cut," which is a cross-section drawing of the Aero showing the workings of the motor, or power unit. The P. G. Navarro Collection.

Plate 1901 contains a drawing of the *Aero Honeymoon*. It also has a lot of German writing. It is hard to make out the individual letters in the German longhand as it is written in a very small and fine handwriting. It has the date April 9, 1909.

Fig. 33.4. Plate 1905 contains a drawing showing another cross-section of the aircraft and its "lights," which are called flashlights. The P. G. Navarro Collection.

The other light contains what looks like a gas flame and has the year 1858 over it. Inside the reflector is what appears to be an incandescent light bulb and it has the notation *today* on it. On the beam of this light is the name *Carl Amsler* and *PULL PUSH SHUT OFF OR ON*. An object in the center of the aircraft contains the notation *Oculus* and *Droppe*. Note the ciphers after Dellschau's signature in the lower right-hand corner. This coded cipher is the abbreviation for "Grandscheiser," or "Head Man."

Fig. 33.5. A close-up from a black and white photo of Dellschau's signature anda coded message from plate 1905. The P. G. Navarro Collection.

246

The *Aero Honeymoon* was eventually an airship that could be used for many purposes. The notation at the top of plate 1905 reads *Peace — War — Bliss Aero Honeymoon — for different uses and sizes ...* "

In plate 1902 is the notation, *Oster Sontag* [Easter Sunday] and *Honeymoon on Earth.*

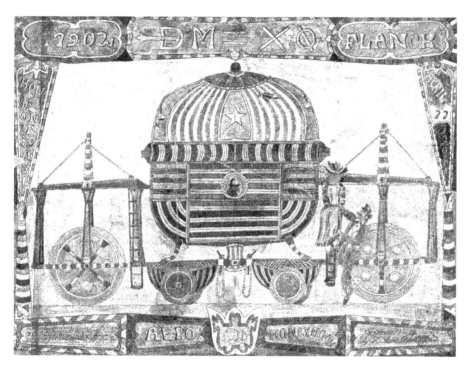

Fig. 33.6. Black and white photo of plate#1902. Another view of the Aero Honeymoon. From the P. G. Navarro Collection.

Aeros B and C

Plate 1910 contains two drawings showing a cross-section view of the *Aero B.* The airship is shown on the ground with the balloon partially deflated, with the notation *down.* The other drawing shows the balloon fully inflated with the notation *up.* This airship contains a compartment for *Ammunition* as well as one for *grub.* It also had a toilet for washing and shaving and (as is shown in plate 1911) it also has several bunks and a mess hall. It has lights, one of which is stationary and throws the light beam downward only. Another light rotates, throwing the beam in a circular motion. The lights, or lanterns, are attached

to the outside of the airship on the sides of the hull. This airship was evidently designed primarily as an aerial warship and carried a contingent of about eight persons.

In plate 1912 is a design of the *Aero C*. This drawing is numbered 12 and continues to number 15, although there are no drawings for numbers 8 or 10. All the drawings thus numbered are designated as being in the same category or class of Aero as the *Aero Honeymoon*, but adapted for different purposes. *Aero C*, in plate 1912, for example, was a design proposed by Dellschau himself, and shows the interior, with a table for eating with stools attached to the table. There is also a place for *stores* that has a warning sign on the door reading *No Smoking.*

There is a strange picture in plate 1910 which is a puzzler. This picture appears above one of the airships, the *Aero B* and has a sketch of a bearded, sage-looking person (like an ancient Greek philosopher) and the ciphers =**X** above his head. What is the significance of this?

In plate 1913 are shown the internal workings of the motor, in cross section. The heading at the top of this plate reads, *Gasoir.* It evidently shows the manner in which the *NB* gas is distributed throughout the different compartments of the airship, for operation of the moving parts as well as for providing the lift for it.

Plate 1914 contains three drawings showing the deck of *Aero C* along with views of the aircraft from above and below. It was from these two views that I was able to get an idea of the purpose of the paddle wheels (or propellers) that are opposite ends of the steering frame.

Upon looking at the drawings of these airships, I wondered about the precarious balance by which these craft remain upright while standing on the ground.

Since the main support of the airship's carriage seems to be the center pivot, or oculus, what is to keep the ship from toppling over on its side when its resting on the ground? Did the balloon at the top contain enough of the lifting agent, even when partially deflated, to keep it upright?

The answer to the above question, or at least a partial answer, was obtained from the perusal of plate 1910. This plate shows the *Aero B* with its landing gear, or legs, extended from the sides of the ship to support it while it is resting on the ground. The legs seem to be retractable on the order of a hydraulic system or spring action.

Plate 1916 contains two drawings of the *Aero Honeymoon C,* and shows

the airship resting on the ground with its sidelights beaming down to Earth. The balloon at the top is partially depressed, or deflated. The other drawing shows the airship is equipped with long legs or landing gear, which push in (or retract) when landing, probably acting as shock absorbers. They pull out from their hollow casings when the ship is in flight. The end view of this airship resembles a NASA Lunar Lander.

It is to be noted when looking at these drawings that the trapdoor affair above the paddlewheel is open as the airship takes to the air, but it is closed while the ship is at rest.

Plate 1917 has a drawing of the interior of the *Aero Honeymoon C* and contains details of the rigging connected with the balloons and the gas valves. The word *Aviatora* is at the top right of the page and may refer to the operating equipment, which consists of ropes and pulleys which are operated by one of the two men in the ship's control cabin. Crude, but operational.

The steering gear is shown in plate 1918 in large detail. It is the box at each end of the steering frame containing the paddle wheels and paddles; and the trap door device, which Dellschau calls the *wind and counter pressure fender*. This steering gear device, presumably, controls the movement of the aircraft while in the air, and is, in effect, the directional or navigating device.

The *Aero Moyke*

This Aero is quite different from the *Aero Honeymoon*, although it embodies some of the same principles of design that are used in the latter. This model has *wind and counter-pressure fenders* on the ends as well as on the top of the steering box. There is a notation in code in the upper right hand corner of the page which reads, *Now, My. Young, what do you think of Michael Gore now?"* The cipher for the letter W appears after Dellschau's name in this plate (plate 1921).

Plate 1922 has two cross-section views of the *Aero Moyke*. One is a center *broadcut*, the other is a *Fore and Back Cross Cut*. The *NB* gas powers the motors on this aircraft. The as yet unidentified *soupe* drops down on the *motor roller*, producing the *NB* gas which creates the pressure, which moves the rotor. This gas goes up through a conduit, or duct to the balloon or dome at the top of the aircraft. The gas also goes down the flexible hose to the tank underneath the ship to which are attached the paddlewheels (and landing gear) and thus moves the wheels (for taxiing on the ground and flying through the air).

A peculiar thing about the Aero designs is that, unlike the airplane, they do not utilize a propeller for the purpose of propulsion or acceleration. All

the Aero designs are peculiar in this respect. What they utilize in place of the propeller is a paddle-wheel-like device contained in a box, which supposedly cuts into the air (as a propeller blade) and moves the aircraft in the desired direction by having this attachment function also as a steering device.

The *Aero Newell*

This Aero was a flying machine of tremendous size. It utilized two large motors (or energy converters) to produce the motive power as well as the gas to fill the two large cigar shaped balloons on either side or the cabin, which is located in the center of the airship. The airship had a deck or walkway, with a railing all around the balloons (plate 1926).

Plate 1929 contains a drawing of the *Aero Newell,* showing the *Outside Flank* or side view of the ship. Flying in the sky above this Aero may be seen a model of the *Goosey* and the *Aero Trebla,* two small type aircraft. A notation on this page reads:

> *Sonora Aero Club — 1858*
> *George Newell's Proposition*
> *"Don't believe every word I say."*

The date on this plate is May 28, 1909. In plate 1930 that shows drawing #4 of the *Aero Newell* are some notations that read:

> *If our Club would meet today, what would they propound now?*
> *A free studia after a club debate. By C. A. A. Dellschau*

Plate 1937 contains a cross-section of the *Aero Newell,* showing the motor. It also shows storage and toilet compartments. There are also news clippings on this page about the Wright Brothers, and how the rulers of Europe paid them homage before they received any public recognition from any of their fellow countrymen. Dellschau calls these news clippings *Press Blooms.*

Plate 1941: This shows the motor and the method by which the fuel tanks are lowered and raised in order to inject fuel into the motor chamber or to stop the flow of fuel. It also shows one of the balloons deflated. Also shown is the crosswalk between the two balloons.

Plate 1942 contains the drawing #11 of the *Aero Newell.* The notations on

this page read:

> *Every word I speak here is weigt like — your gold dust!*
> *Laugh as much as you please!! — You find out — I say!!!*
>
> *When George Newell turnet his jocke loose, never tougt of some*
> *members take him on!*

The two statements above may refer to the fact that George Newell's *Aero Newell* may have been an Aero design that was made strictly as a joke or a gag. But evidently some of the members took his ideas for such an Aero design seriously and may have concentrated upon actually making a working model of this aircraft.

The *Aero Axel*

The *Aero Axel* was the next Aero to emerge from the fertile minds of two of the Club's members. Although the *Aero Axel* may have been an original idea for an Aero by Christian Axel Roemeling, most of the drawings that Dellschau, made of this airship were copied from diagrams made by Thomas C. Williams. But, they also contained ideas that had been presented by Dellschau himself.

Further study by these three men of the plans for this Aero brought a comment by Williams regarding the weatherproof qualities of this airship. He was afraid they would have trouble with snow settling upon the motors, and possibly causing motor failure. Therefore, he proposed that the motors be placed on the sides of the aircraft instead. Dellschau eventually agreed with this suggestion and proceeded to revise the plans accordingly.

It is entirely possible that Christian Axel Roemeling may not have had anything to do with the designing of the *Aero Axel* and that Dellschau only named it that in honor of his friend Roemeling, which, as the notations in this series indicate, was probably Dellschau's best friend during those days. If Roemeling was a member of the Sonora Aero Club, he was probably not a member during the period when the group was experimenting in Sonora during the 1850s. There is a notation that may indicate that Roemeling was a member of the Club at a much later period, during the years 1879 to 1889. Christian Von Roemeling was a married man. In 1909 Dellschau dedicated some of his drawings to him "out of friendship" (plate 1952).

Air Pressure Motor

Fig. 33.8. One of several different models of an Air Press Motor.

The air pressure motor, or side motors, of the *Aero Axel* are shown in detail in plate 1553. This motor seems to consist of a paddle wheel contained within a box with trap doors on the top that permit or deny the passage of air into the box. It's not clear to me just how this type of motor functions. There is a message that reads:

> *Burst after burst, but no go without fire motors. Let them blow to cinders. Serves those smart fools right. But has the people below be always in danger of life and loosing homes by careless, crazy firebugs? Can't they see the ever being ready motor-power — a rising or falling balloon will generate — harmless to all purposes and partys? — Rise pressure — fall pressure — counter pressure — and — read — wind — all doing their utmost - - and no getting out on a trip!*

It might be that the actual experiments may have been conducted on an *Air Pressure Motor* that was to be "fireless." Apparently the early air pressure motor was not successful, for it is indicated that it would not go without *fire*.

Side Motors

The *side motors*, as proposed by Thomas C. Williams, were located on the sides of the aircraft. The reason for locating the motors on the sides was to prevent snow from accumulating atop the motors. The motors were connected with the power generating units (the rollers in the chamber where the fuel is injected and converted into gas). The notations on the bottom of plate 1954, dated July 11, 1909, read:

> *Looking at the plates of Aero Axel, my friend Williams say it weather proof all right in rain, yes — but my dear friend, how*

in a big snow storm — you have snow over your centra position motor — to have your machine horse de combat! The right location of them motors is central flank and snow can't settle — I took the hint and this is the result of Williams advise.

C.A.A. Dellschau — Chap.

Fig. 33. 9. Black and white photo of plate 1957. The P. G. Navarro Collection.

The plates following after the *Aero Axel* have drawings of other aircraft, one of which is *Jourdan's Doobely*, with air pressure motor (plate 1962) and the *Aero Jourdon.*

These were designed by Monsieur Jourdan and have a centralized air pressure motor, much to the displeasure of Dellschau and Williams, who preferred to have the motors on the sides. In making the drawings for the *Aero Jourdan* Dellschau apparently made some revisions in Jourdan's design, which Jourdan evidently objected to, for Dellschau states *Brother Jourdan had kicked* about it. But, he also says, *Wouldn't Jourdan kick — without Williams advice?*

The *Aero Condor*

In 1857 Emiehl Mentes brought up his proposal before the Sonora Aero Club and the *Aero Condor* was the result. Dellschau made several drawings of this Aero *with much libertys on my park* he states. He refers to Emiehl Mentes as the Number 1 braggart. Why? There were several other tries at similar Aero designs based upon the original by Mentes. One who tried to design a similar Aero was Frederich Wilhelm Schultze. The other was Monsieur Jourdan, who designed a larger airship of similar construction. This larger aircraft was called the *Jourdan sized Aero Condor.*

In plate 1983, which contains drawing #10 of the *Aero Condor Jourdan,* there are two interesting news clippings; one contains an item concerning an invention that seems to fit in with the type of *air pressure motors* that are in Dellschau's Airships. Unfortunately, as with most of Dellschau's *Press Blooms,* the newspaper this report was clipped from is not listed. The clipping reads:

BIG INDUSTRIAL REVOLUTION IS AT HAND IF THIS INVENTION PANS OUT AS PER CLAIMS

Air the Only Power Needed

Cincinnati, Ohio - Aug. 28 (1909) H.C. Busby has just been allowed a patent on a device which he claims will revolutionize the world's industry. [...] Busby's invention is a system of compressed air applied as power to machinery. [...] He claims that his device will compress air, and derive its own power from the compression from the air itself. It is a system of valves and vacuums through and into which the air is driven and expelled. [...] He asserts that no other form of power is needed.

The compressed air device may be attached to any ordinary engines, the fire drawn and the steam cut off and the air will run the engine is his claim.

The *Aero Peter*

This Aero was also known as the *Doobeleen Peter.* It was proposed and designed by Max Heiss in 1858. Since this airship is obviously named after Peter Mennis, a sketch of Peter with a pipe in his mouth is shown in the bottom center of plate 1991.

Plate 1996, dated September 10, 1909, shows a view from above of the

Doobeleene Peter. This model has a rudder device on each end of the ship, which turns at an angle of about 45 degrees to each side. The rudder also moves up and down at an angle of about 18 to 20 degrees.

The drawings on plate 1993 show a "front" or "rear" view of the airship in flight. It also shows Peter Mennis on the ground firing a gun towards the sky, probably in glee or exhilaration.

In plate 1994 the gas compartment of the *Aero Peter* is shown. It will be noted that some of the gas is being expelled (from jets) out the sides of the airships gas chambers (or balloons); the fuel is being injected into the chamber on one side, but not the other.

More on the *Aero Rondo*

Plate 1999 starts another series of drawings of the *Aero Rondo. Taken from all what suited my purpose,* it says.

This is Paul Somers' *Rondo,* but it seems that other members of the club had a hand in the final, accepted design for his aircraft. Carl Mueler, and Dr. Saxe seem to have had a say in its final design. It may be that the *Rondo* designed by Somers was not large enough to accommodate a person of Dr. Saxe's proportions. Dr. Saxe was more than merely chubby and that is probably why Dellschau states, *Dr. Saxe squeezed Aero Rondo — Serves him right — 1857.*

There is a device in one of the upright ducts in this Aero which seems to turn inside the chamber, above the trough where the fuel is contained. It seems to consist of some tubing that is formed into a half loop. When the tube is arched upward it is going, when it is downward it is at rest. What is its function?

The *Aero Jourdan*

Beginning with plate 2024 is a series of drawings Dellschau calls the *Anatomy of the Aero Jourdan.* He states that this was *A Free Studia 50 years ago* and that it was an airship design made after Jourdan's own specifications. This was *no joke,* he says. *Fifty years are gone and who laughs now?* he asks in plate 2025.

In plate 2022 he says:

> *Jourdan's princip after his own specifications. Well you all laugh to high, a nut for you! How will some of you shake your skulls if I tell*

you the Center Lifters only is receiver and magazine — to catch the over expandet Liftpower or Gas from getting lost, or explode the baggs! Laugh now Brethren!!! Laugh.

The cryptic writing in plate 2024 reads, *I can ride the highest wave of any ocean on Earth, and I move myself on land.*

There are several drawings that show the cabin space arrangements in this aircraft, as well as mess hall and deck space. This is a huge aircraft with two decks and six lifters.

The *Aero Hunter*

This was an Aero design by Carl Schubert. It is a two-man craft. The drawings on plate 2037 shows Michael Gore on board with another person, who is at the controls, and may be Carl Schubert.

Dellschau states that the three drawings were made as *free studia after NYMZA work — 1858.*

One of the strangest vignettes to be found in all of Dellschau's books may be the one that appears on plate 2039. It is a drawing of the devil, who is looking down at the scene below through a rip in the fabric of the sky, as though he was looking down through an opening into this world from another dimension. This drawing also has a drawing of Peter Mennis with his black dog, a small Cocker Spaniel.

The cross-section view on plate 2044 shows the aircraft's motor section. It illustrates the manner in which the fuel is injected into the energy-producing chamber. The fuel is shown not only to be dropping onto the motor drum as in most diagrams of the Aero motors, but also to be dropping down below the drum onto the bottom of the chamber, which is built to go all around the lower section of the Aero, like an elongated doughnut. This craft was designed to land on water as well as land. That is the reason why the lower section to which the wheels are attached is made like a platoon boat. There was definitely no smoking allowed aboard this airship, as may be seen by two "No Smoking" signs that are posted on the bulkheads at opposite ends of the airship.

The *Aero Hurray* and *Jacke's Aero Hunter*

Plate 1054: The *Aero Hurray* was an airship design by Jacke Schubert, who was probably Carl Schubert's brother. This model had a large balloon — or gas dome — at the top. It had flat fin tails in the rear. A hollow, elongated ring

ran all around the balloons at the base. This ring contained gas that could be pushed up into the balloon by means of valves and air pressure fans or released through valves on the sides of the ring. Releasing the gas would collapse the balloon (or bag) when the airship was on the ground. Jacke also designed an Aero on the same lines as his brother's *Aero Hunter*. It was called *Jacke's Aero Hunter*. It was made *A La Brother Andree* and was equipped with a retractable landing gear.

The *Aero Mio*

Juan Maria proposed this series. The drawing in plate 2067 shows several people examining the airship as it rests on the ground. These include Peter Mennis with his gun strapped on his side as usual and his little dog, Michael

Fig. 33.10. Blowup of the Aero Mio featuring several of the members of the Sonora Aero Club. From the P. G. Navarro Collection.

Gore with his umbrella, Dr. Saxe with his baton and satchel, and three other persons whom I have not identified, although one may be Juan Maria.

Plate 2073 shows the *Air Pressure motors of Juan Maria's Aero Mio*. Dellschau made the drawings of the *Aero Mio* by recollection. The *Aero Mio* was evidently a type of aircraft upon which several members of the Club worked their own innovations. August Schoetler came up with his own *Mio* design that he called the *Long Distance Aero Mio*.

The *Aero Immer*

The *Aero Immer* was proposed by August Immer, Senior. After that came the *Long Distance Immer* which was designed and probably constructed at Columbia, California, in 1858. It is stated in plate 2095 that the *Aero Immer* was the *prop*, which could mean "property" or "proposal" of Carl Inner and Son Heinrich.

There is the probability that the *Aero Immer* was actually built and flown, but Dellschau still gives credit to Peter Mennis' *Goosey* for the success of all subsequent flying models. He refers to the *Goosey* as the *Mother of All*. Plate 2101 is the last plate in this first of eight books. It contains drawing #1 of an Airship design proposed by George Newell. It is a front view of the aircraft. The caption reads, *A Joke ... Aero ... Wont Goe ... George Newell proposer.*

There are about 198 pages or "plates" missing after plate 2101. They are plate 2102 through plate 2300. This is evidently one of the missing books.

The *Aero Goeit*

The next book starts with plate 2301, dated March 22, 1911, to plate 2399 dated August 22, 1911. This series has the information pertaining to the *Aero Goeit*, which was proposed, designed and probably even built by Adolf Goetz. There are some phrases that I presume to be in German, which read as follows, *Wauh shalman weute dauon sagen * man hat goetz dama ls aus gelascht wie heute.*

In this series can be found the story of Adolf Goetz's Aero, which was accidentally caught in the branches of a giant California redwood tree by its *ballancier,* a contraption that hung underneath the Aero for balancing purposes. This caused the sudden death of its pilot, who fell from the Aero and broke his neck. Dellschau admonished Goetz for building such a *flying trap.*

What is the significance of the cross-bones and skull in plate 2313 with the initials A.G. underneath? Does it mean that Adolf Goetz's Aero was a death trap?

The combination of drawings and news clippings in plate 2308 are very significant, as they illustrate the club members' views regarding the use of aircraft for peaceful purposes as opposed to their use by military agencies, which would use them for the purpose of war.

Dellschau includes a drawing of a black cat in several of his drawings, the significance of which remains unknown to us. In this plate there is a black cat, and some men who are talking, probably about the latest newspaper reports about the imminence of war. There are several newspaper clippings about the

subject of war and the use of aircraft for war purposes. This drawing (or collage) takes half of this pag, and is entitled *from your point of view.* On the other half of the page is another collage that depicts a man and a woman carrying suitcases and golf clubs who are apparently going off on a pleasure trip. The caption for this is *our point of view.*

The *Aero Jacke*

This Aero, which is written down as the *Jacke* was designed by Jachob Loerty, and in the first plate of this series, plate 2307, it is referred to as the *Aero Jacke.* The mysterious ciphers =**X** appear in plate 2321. They are the ciphers for the letters M and Z. What do they mean?

Plate 2322 shows the *Aero Jacke's* interior, with several compartments, which are labeled *Gas Room, Kitchen and Eating,* and *Magic in Sitting Room.* Dellschau called it *A free studia after others.*

In plate 2325 are shown four compartments which are designated *Magazin, Setting Room, Sitting* and *Pys Supe.*

In plate 2325 are two excellent drawings that show the *Aero Jacke Lifter.* It clearly demonstrates the method by which the liquid fuel is injected by gravity into the gas-producing chamber. The gas is then pushed our into the domed-shaped balloon on top of what appears to be a cylinder-shaped aircraft and gives it the necessary lift to make it airborne. There are a number of valves and gas exhaust vents that may be used to hold or release the gas as desired. It seems to be a very ingenious device and might work only if the gas had the potency for "negating weight" as is claimed by Dellschau in some of the other notations, since the area which contains the gas for lifting purposes is drastically out of proportion to the volume which we deem necessary to lift an aircraft of

Fig. 33.11. *A black and white photo of plate 2343 featuring a view of the Aero Nora from below and above. The P. G. Navarro Collection.*

the size portrayed in these drawings.

The *Aero Nora*

This Aero was proposed by Heinrich Busch, Sr. and had a device called the *fall retard*. It was an awning-like device that acted as a sort of parachute to break the fall of the airship in its descent to earth.

The drawings show the *Aero Nora* on the ground and in the air. As the craft

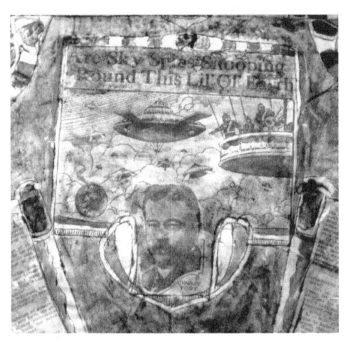

Fig. 33.15. A black and white photo of plate 2378 features a drawing of the Aero Myself. The P. G. Navarro Collection.

takes to the air you can plainly see the *falleasy* device extending downward. Plate 2343 features a view of the *Aero Nora* from above and below.

The Aero Called *Myself*

The Aero in plate 2378 was probably designed and proposed by Dellschau himself, and he was proud enough of his creation to name it *Myself*. He also referred to this Aero as *Myn Baby*.

It was one of the first Aero designs to catch my eye when I was first looking

at the scrapbooks. It seemed to be a type of aircraft with features that were rather strange, but clear enough that they might give me clues as to its method of operation. Of course, I wasn't able to solve this riddle, but I conjectured upon many points relative to the probable use of certain of its devices and the mechanics involved before I came to the conclusion that a lot more study had to be done upon these strange aircraft before their true nature of operation could be fathomed.

Dellschau made several drawings of this aircraft, including some in which he incorporated some ideas originally proposed by Jourdan. He called the results of this combination of ideas the *Myself a la Jourdan*.

The *Aero Warrior*

There are six different drawings of this Aero, which includes details of its *deck lay*. In plate 2394 notations designate the use of different areas of the *deck lay*, such as, *above store, Force Connection, Loiter Room, Magazin, Grubz,* and *Passage hall,* etc.

The *Aero Mary*

Apparently the *Aero Mary* was an airship that was actually built. The word *macker,* which appears in plate 2412, would signify that this model was actually built. August Schoetler is designated as the maker. It also explains the "Mr." which appears after Schoetler's name in plate 2401. This is probably an abbreviation for the word "maker" in Dellschau's curious style.

In plate 2414 there is a coded word which reads, *Eigner,* or "owner." It seems evident that the *Aero Mary* was actually built and that August Schoetler was the owner.

The *Aero Avant*

Did Dr. Weisbach dream up this Aero design? Plate 2420 contains a drawing of the doctor asleep aboard the airship. Perhaps that is the reason for the question, *what does Dr. Weisbach dream?*

This airship was equipped with "planes" which could be removed. Perhaps the drawings in plate 2427 just illustrates what could be done with this Aero if it was equipped with these "planes" which were extensions, like wings, but were shaped like cylinders which were attached to the sides of the aircraft. The *Aero Avant* is shown with and without these "planes."

Another Aero design that was probably thought up by Dr. Weisbach was

the *Aero Cita*. Peter Mennis evidently did not approve of this design and was of the opinion that it would *bring great harm* to the world. Dr. Weisbach's reply to this remark by Peter Mennis was that they should go ahead and break their necks, it certainly wouldn't hurt *us doctors*.

It may be that Dr. Weisbach was trying to induce the club members to design a safer aircraft, or a safety device that would prevent the accidents, which had already claimed the lives of several of the club members.

More on the *Aero Dora*

Dellschau had worked on drawings of the *Aero Dora* in his earlier books from 1908. This was the airship that was designed by Michael Gore in 1858. Dellschau remarked that Gore was *Still alive, still drinking schnaps whiskey and told to fly to heaven … "Go to it," I told him."*

Ernest Kraus proposed another design for the *Aero Dora*. This Aero contained a *sucker kicker* device invented by Kraus (plate 1759).

In 1911 Dellschau made another series of drawings of yet another *Aero Dora* that had been designed by Jacob Horn. This Aero was designed *to suit the times* (plate 2475). There seems to be a question as to where they should locate the motors on this particular Aero design. In plate 2470 Jacob suggested that they be put below to balance the airship.

The *Aero Babymyn*

This was an Aero that was proposed by Gastav Kolbe.

The *Aero Saturn*

August Schoetler is designated as the owner of this aircraft. It was a small one-man Aero that was actually built, according to the notation found in plate 2526, which states that Schoetler was the builder of this aircraft.

This Aero was evidently regarded as being too small. Monsieur Jourdan inquired of Schoetler why he had designed and built such a small aircraft, which could carry only one man. Schoetler's answer to this question was that he believed that the aircraft was big enough for one man to break his neck.

Michael Gore's caustic remark regarding Schoetler's *Aero Saturn* was that *Them Dutch* were going at it in a small scale, and that he would *get them yet*.

The *Aero Saturn*, however, may have been just what Dr. Saxe had been looking for, a small, single-seat aircraft, which he could use to make the rounds called for in his profession. In plate 2527 Dr. Saxe is shown flying the Aero.

The caption reads, *My dear Doctor, cash in advance and I fix you up to fit your needs — but cash first.*

One thing that is noticeable throughout most of Dellschau's books is his lament upon their scarcity, or need, of money.

The *Aero Constant* and *Constant's Parra*

The *Parra* was a type of parachute contraption that P. Constant proposed in 1858 and suggested that it be used on Peter Mennis' *Goosey*. This suggestion was turned down on the grounds that the contraption was dangerous.

Fifty-four years later, in 1912, Dellschau pasted a news clipping in his scrapbook (plate 2538) that contained a story concerning an idea for a parachute for the whole airplane. Dellschau's comment regarding this idea reads, *for the parra of today, look above.*

In plate 2540 is a drawing of the *Aero Constant* at rest. It shows a picture of a man with a knapsack on his back climbing a ladder up to the Aero's cabin. A cross-section of the interior shows another man in bed asleep, with a pipe in his mouth. The caption reads, *I came home and went on board … and found the boss asleep … and smoking.*

There are "No Smoking" signs aboard this aircraft, so evidently it was a serious breach of the safety rules to be smoking aboard the airship, even if you were the boss.

The Death Symbol

In plate 2544 are *Press Blumen* or *Press Blooms*, which is what Dellschau called the news clippings he included on his plates. This plate contains symbols for the name of the secret society NYMZA and the cross-bones and the reference to death, which Dellschau used quite often, as though he had a certain obsession with the subject.

The symbol of the skull and cross-bones may be found in plate 2575. It also contains German Language news clippings, a skull and cross-bones with wings attached and the caption which reads, *Ber Luftchiffer*, which means the airman. Cryptic writing on this page reads,

So Waes Immrynd
Sowrd es Bleiben

This death symbol is also on plate 1980, with a letter W, in cipher, underneath. The symbol is also found in plates 4651, 4600, 4417 and in one

plate with no number (following plate 4518).

In plate 4417 it is shown with a circled X and a smaller circled V below the skull and cross-bones.

There is a decorative design that has the words *Do Mino Est*, which is Latin and means "God Exists." So we presume from this that whatever else he might have been, Dellschau was a believer in the existence of God.

In plate 2594 there is information concerning the Aero called the *Long Distance Sicher*, proposed by Edward Hartung. One notation complete with what appears to be cross-bones and skulls reads, *We … will … fall*, along with another notation that reads *Forbidden, for ever*.

The statement above could mean that there was doubt about the *Aero Sicher's* reliability in the air. They were afraid the airship might crash due to faulty design or some other reason. Therefore they were forbidden to construct it.

Who is Pauline?

In plate 2033 Dellschau asks, *Nay Pauline, where is Des Jehtnich?*
In another plate he wrote in cipher, *Have then shown, nay Pauline*.
In plate 2072 is the notation in cipher, *Nay Paula*.

Central Motor Started

In plate 4612 is a picture (cross-section) showing the *Central Motor Starter*, by Michael Gore.

Throughout my close examinations of all of the plates I found nothing that would show just how the Airpress motors, motor starters or air chambers actually work. Nor have I found any notations to designate what the various parts and machinery are supposed to do.

It may be that all this information is actually contained in a separate book, which would have the names of, and give the proper function of the different parts. I say this because there is a scrap-book (belonging to the DeMenil Foundation) that has a drawing of several Aeros, but there were places in the drawings that should contain identifying information but were left blank. I'm positive that Dellschau left his complete story in puzzle form spread throughout his books. We just don't have access to all the clues.

Addendum:

In having some new prints made of the color photos I had taken several years ago I have noticed that there are certain details in some of the original Dellschau drawings I had photographed (which are now part of the Witte Museum Collection), that I seemed to have overlooked.

There is the *Aero Condor* drawing #4 for instance, that shows the aircraft floating on water. It has wheels that are partly submerged, but the entire construction is on a float between the wheels. The wheels are extended and are in a position directly under the two motors that are on either side of the aircraft. They are connected to pulleys on the motors by a belt. A hose dangles from each motor and dips in and out of the water as the motors seesaw up and down from the center post of the aircraft.

There is a cartouche at the lower right of the picture with some writing on it but it is quite illegible in the photo.

The plate is dated August 17, 1909, and shows a man standing with one foot on a ladder that leads up to the carriage, which is like a large basket in which are a bunk and some provisions that are under the bunk. One is a large bottle that may contain water. This can be seen from a cut-away, or crosscut of the basket (or gondola) that rests under the gas bag (or balloon) that lifts the Aero.

In the background is a small blimp-like aircraft that is up in the air. It is a different style from the Aero designs and looks more like a regular balloon in flight, with a basket underneath, except that it is oval shaped like a blimp.

Another photo of the *Aero Condor* (drawing #7) shows it at rest on the ground. It has a float that rests between the wheels. The wheels are closer together and the belt that connects them to the pulleys is lax. (They are not stretched as on the other photo.) The motors are on an even keel and the hoses that extend from them towards the ground are held slightly above the surface of the ground by the bottom rungs of the latter on both sides.

The plate is dated August 26, 1909. Peter Mennis is shown on board the aircraft and two other men are standing on the ground beside it. The man on the right appears to be George Newell.

There are spotlights with the light beaming down upon the ground, although they are just about two feet above the surface. They seem to be connected to a wire or rope that extends up to the top edge and into the interior of the gondola. Were these electrically generated lights?

On the border is a cartouche that reads *A free studia after Emill Mentes' proposal. Sonora Aero Club 1857. By C. A. A. Dellschau.*

Update: Letter from Pete Navarro to Dennis Crenshaw
"A Further Study of Dellschau Drawings."

In continuing to look for further material relating to the Dellschau matter, including the review of field notes and journals (or diary) entries, I came upon an account I had written in December 26, 1996, which I now find may have some significance upon the matter (or method) by which Dellschau might have come upon some of the material he wrote about. The following is as written by me:

December 26, 1996 — Continuing to make further studies of the original Dellschau drawings still available [for Pete's review], I decided to have a closer look at Drawing #1 of plate 3117 of the *Aero Jake*. This drawing had been in back of *plate 2316* (which showed Peter Mennis and his dog on a ladder at the side of the *Aero Goet,* which was drawing #12 and probably the last drawing of this series). It is dated April 20, 1911. The *Aero Goet* is shown standing next to the *Aero Goosey,* for comparison.

I had framed this drawing in 1984 and given it to Jimmy Ward as a gift. It had been hanging on the wall of his living room until after his death in 1995 when his mother gave it back to me.

Just two days ago (December 24th) I had decided to have a look at the drawing on the backside, which had remained hidden for 12 years, and decided to reverse the page and show that side for awhile. It was now hanging on the wall of my study, exposed to full view. I marveled at some of the details that I hadn't observed before.

One of the things that I noticed about this particular drawing was that it clearly showed where Dellschau had made his drawing in paper that was smaller and lighter than the sturdier material he used as the "plate" or "page" upon which he would paste the completed drawing, including not only the drawing of the Aero, but also the colorful decorated border that appeared in all of his drawings. When he completed pasting in the picture of the Aero and any other item he saw fit to add to the page (some of which were newspaper clippings, which he called "Press Blooms," the finished "plate" would then comprise another page for his scrapbook.

This one was the *Aero Jake,* which he inscribed as being "A Free Studia After Forward Work." It was drawing #1 of a new series, and was dated March 22, 1911. The finished work was actually a collage that incorporated news clippings with the mixed-media watercolor and ink drawings of the Aero and the fancily patterned border. The news clippings were in German, except for one, which was in English. This clipping was an account of a German dirigible-

balloon that was named the Percival VI. The news report was from Brunswick, Germany, and told of the end of an intended flight from Berlin to Amsterdam, which met with an accident about 10 miles from Brunswick when the free end of a rope that dangled from the aircraft caught in the branches of a giant birch tree and gave a yank that broke her balance and an immediate descent had been fairly well accomplished.

This incident sounded to me like one of the incidents that were related by Dellschau in one of his scrapbooks, regarding the *Aero Goetz,* and makes me wonder if perhaps Dellschau drew upon stories and news reports he read in newspapers and magazines to spice up the accounts he wrote about in his scrapbooks. In his story about *Aero Goetz* he tells about an accident that occurred when a device called a "ballancier" got caught in the branches of a giant redwood tree (see Prelude). This aircraft had come crashing down, resulting in the death of the pilot, who had suffered a broken neck. Dellschau had also pasted in a halftone picture of an Aeroplane of that period.

But the most amazing thing is that the news clipping that was pasted in the drawing of the *Aero Jake,* which is numbered plate 2317 had the date of March 22, 1911. The story Dellschau wrote concerning the accident in which the pilot of the *Aero Goetz* was killed was dated April 14, 1911 … just about 23 days after the account of the German accident near Brunswick. He also drew skull and crossbones with the initials "A.G." (for Adolph Goetz) and censured him by writing, "Brother Goetz, you greedy cuss. What do you mean with your one man flying trap?" He then directed his complaint to George Newell and wrote: "Brother Newell. I mean one man is enough to break his neck."

What do you think of that?

Pete

CHAPTER 34

Insights into the Workings of The Sonora Aero Club and The Process Whereby an Aero Proposal Was Chosen For Further Study

An Unpublished Paper by P.G. Navarro

The *Aero Dora* was an original design by Ernest Klaus. This aircraft was equipped with a device called a *Sucker Kicker*.

Michael Gore proposed some changes in the design for the *Aero Dora* which had the approval of Heinrich Schroeder. What these changes were is not stated.

The *Sucker Kicker* was a device that was used to push compressed air through a tube. Peter Mennis had designed a similar device which was called the *Cloudstepp*.

In plate 1772 is shown a comparison of Peter Mennis' *Cloudstepp* and the *Aero Dora*, rigged with a *Sucker Kicker*. What was the purpose of this device? How did it operate? If it was used to push compressed air into a tube, what was the compressed air used for? Was it the motive power? All questions begging to be answered.

In the case of the *Aero Dora* it may be seen that Michael Gore was the original proposer of that particular airship. He only proposed it. Ernest Kraus made the first original design of the *Aero Dora*.

About the proposal for the *Aero Dora* in 1858 Hy Schroeder had this to say [in Dellschau's notes]:

> Brothers, I tell you Mick's Dora is a fine idea! But can he hold the Dora in wind on Earth? Or on water, can she be steered? And what type of a barn to shelter her when not on duty?
>
> I shall fix the Berlin so as to be small and low enough to easy harbor her, and she to be able to hold Liftpower among and more as need for, and be able to be steered on water. Like any other ship. I won't say amen — but I say Come!
>
> <div align="right">Hy Schroeder
Fixabus</div>

What is the interpretation of Hy Schroeder's statement, which he obviously

made at a meeting of the Club members to decide on the merits of Mike Gore's proposal for a design which he called *Dora?*

He was of the opinion that the idea for what was probably an unusually large craft was a fine idea. But he wondered how it could be anchored on the ground in a high wind. He wondered about the size of the hanger where it could be sheltered when not in use. He wondered also if the airship could be steered on water. (Evidently Gore's design, or proposal, called for a craft that could land on water.)

Around the same time Schroeder had proposed a similar aircraft which he called the *Berlin*. But his design would be much smaller. It would be small and low enough to make it easy for it to be harbored. It would be large enough, though, for it to hold enough of the Liftpower, produced fuel for its use and to carry extra fuel if needed for a substantial flight. His airship proposal could be steerable in water, just like any other ship. In other words the *Aero Berlin* would be not only an aircraft, but it would also be a water vessel. A vehicle that could be steered on water like a regular ship, or boat and through the air with ease.

I won't say amen [whereby] he evidently means that he won't say that the idea for the *Dora* should be discontinued … *But I say come!*

His title is *Fixibus*, which means "Idea-Man." So Hy Schroeder was an idea-man. A person who was able to analyze the ideas proposed by others and arrive at a definite conclusion as to the feasibility of such proposals.

After Schroeder's presentation for the *Aero Berlin* in 1858 Professor Des Jehtnich made a proposal for a *Long Distance Aero Berlin*, which was in the nature of a joke. He was teasing Hy (Heinrich Schroeder) when he said he proposed the *Long Distance Aero Berlin*. According to Dellschau:

> *Yes Brother Schroeder, he said. You have told us where the faults of Gore's work lie. You propose new improvements for a small carrier, but a one man carrier might be what you desire. But for me. I want to construct a flier to carry several men and supplies to travel day and night, in sunshine or storm, and to go around the world. You hear me?*
>
> *To go around the Earth! You hear me! Amen.*

In plate 1612, where Dellschau writes concerning the Aero with "Hidden Wings," he makes reference to the discussion they had regarding the *Dora*, and how they could house (or construct a hanger) large enough to accommodate an aircraft of that size. The following is what he wrote: *we had in 1858 a harangue on the same object, that is, how to make the Aero of that sort easier to house.*

From the above statement it is evident that the idea for the construction of

the *Dora* was conceived earlier than the idea for the construction of an Aero with "Hidden Wings." (Actually it was not the idea that predated it, but the proposal of such an idea, as presented to the Club.)

The *Aero Dora,* which was originally designed by Ernest Kraus but proposed by Michael Gore, was eventually built by August Schroeder in 1858. This should give us some clue as to what the procedure was in order for the Sonora Aero Club members to decide which proposals to eventually build.

A peek at the concern of Dellschau for the right person getting credit for their ideas can be found in the case of the *Aero Rondo* and the *Aero Hecter.*

The *Aero Rondo* was proposed by Wilhelm Jaeckel in 1858. Later on, Joe Boulart presented his idea for what was called the *Aero Hector.* Dellschau saw in the design the same ideas as were incorporated in the design by Wilhelm Jaeckel and referred to Joe Boulart's Aero as the *Far Reaching Aero Rondo* and stated that Boulart claimed originality in its design, when actually its design seemed to be based on the proposal presented by Jaeckel. Dellschau made several drawings of the *Aero Hector* as a free study of Josef Boulart's ideas. Dellschau still referred to Boulart as the *clamant* to this idea, not the originator.

There seems to have been several disagreements as to who had originated some of the ideas for the proposed design and construction of some of the other Aeros also.

One of them was the *Aero Mio,* which was proposed by Senor Juan Maria in 1858. Later in that same year August Schoetler had elaborated upon Maria's design for the *Aero Mio* and came up with the *Grand Mio.* Here again Dellschau was dubious about Juan Maria's claim to originality in the designing of the Aero *Mio.* He says, *Now you, Jose and Juan Maria claim to be the originators.*

Jose (last name unknown) and Juan Maria were two Spanish members of the Sonora Aero Club. They were probably native Californians. Although Juan Maria was the one who proposed the *Aero Mio,* it was probably a joint effort of his and Jose's which produced the final design for this Aero. Juan Maria also designed several *Air Pressure Motors.* (plate 2073.)

The evidence that the group of men belonging to the Sonora Aero Club were members of a Society which was governed by certain rules and regulations which all members were subject to and by which they were forced to comply is located in plate 2627.

This concerns Gastav Freyer, who was a well-educated mechanic and a member of the club. According to the "Rules and Bylaws" of the "Society" he was forced to produce something that could be discussed by the membership. His turn came and he had to come up with something. He therefore came up with an idea for a sort of "guard fence" that could be built all around the airship. Dellschau refers to Freyer's idea as an "enormous" idea, probably in sarcasm.

Gustav Freyer, according to Dellschau, had most likely suggested this idea more as a joke than as a serious proposition, for evidently he did not have any other ideas to contribute. He had stepped to the blackboard, took up a piece of chalk, drew a sketch on the blackboard and said,

> "Brothers, you all know I an not quite a professor," and looking straight at some of the members, he continued, " [But] I'll give you a nut to crack. My idea is to put a guard fence all around the machine, so that if it falls, it will land easy and always be safe … and to keep some of you smarties from falling over, or to keep you from drowning if you fall on water.
> "Let her somersault and you will [remain] perpendicular. I mean with your head up, and your feet on the floor."

Gustav Freyer was probably anxious to get this over with. As a member of the Club he was bound by the rules of the Society to produce something that could be worked on, or commented on, and he was probably not much of an idea man. His main talent was in mechanics and he was anxious to leave as soon as he presented his idea. He said,

> Well some of you may have to treat me [to a drink]. For I'll tell you the truth, I am busted and dry as a fish.

So they all went to the bar and treated Freyer to a drink.

When Dellschau made the drawings for Freyer's idea, (which was called the *Guarda)* he showed an Aero with a guard fence all around it. His comment on it was, *There she goes. Break your bones!*

In plate 1611 reference is made to August Schoetler, who is referred to as the builder of the *Trebla.*

In plate 1644 Dellschau writes the following in which August Schoetler is mentioned again as a builder of flying machines: *Well, I never shall forget Professor*

Carlos' words ordering from August Schoetler a flying machine.

It's quite obvious that, while others proposed or designed different Aeros, Schoetler was an actual builder of the machines.

In writing about the above order for a Aero, Dellschau continues by stating that the Professor told Schoetler,

> *Schoetler, the machine must look awful dangerous! Must look so, I say! Or there is no money to be made with it.*
> *The dear good people up here are anxious* [as] *anything, to see me break my neck.*
> *Well, I left them wait a while! Yes, August, money is the trump, and fine advertising a great art. To earn it. Bou=ze!*

What does it mean when mention is made of the "dear good people"? Why are they anxious to see him break his neck? It seems that the Professor is telling Schoetler that he wants him to build an Aero that will look dangerous. Why?

Dellschau also says that *the time is here when awful things are simply possible* [to do] *and have been so a long time ago.*

What does this sentence mean?

Peter Mennis' *Goosey* was probably designed and built in 1857. News clippings pasted into plates 1939 and 1940 contain pictures and articles about the Wright Brothers and their Aeroplane. Dellschau's comments here is *Goosey beats them all — 1857.*

The following shows that the Club members were not always serious and were not above having fun with each other.

George Newell proposed the *Aero Newell* in 1857. According to Dellschau, George Newell was probably not very serious when he proposed the design for this aircraft, which was of huge proportions. Dellschau writes in plate 1929,

> *Sonora Aero Club — 1858*
> *George Newell's Proposition*
> *Don't believe every word I say.*

He probably meant that George Newell had proposed the huge Aero, but probably only as a joke … so don't believe everything he says, regarding its

feasibility. Further on he writes, *Every word I speak here is weight, like your gold dust! Laugh as much as you please! You'll find out, I say!!!*

Evidently, George Newell refers to the fact that the airship which he had designed was heavy. He compares the weight to "your gold dust." (Of course, it stands to reason, that some members of the Sonora Aero Club spent at least some of their time panning for gold.)[1] Dellschau remarks that *When George turned his joke loose* [he] *never thought of some members taking him in.*

By the above, I presume he meant that George Newell never thought that his proposal would be taken seriously. But apparently it was, and some of the members actually proceeded to work and develop the design.

In 1858, when Newell proposed another design for an Aero, they thought he was again making a joke, but this time he was serious about his design. Some of the members told him that his Aero *won't go.* And that it was *a joke.* But he was serious about this design and told his colleagues, *You Dutch smarties, you don't know it all. I'll open your peepers!*

It's obvious that George Newell was dead by 1910, because Dellschau notes the latest aircraft developments in those years and remarks, *If George was living, would he not open his peepers?*

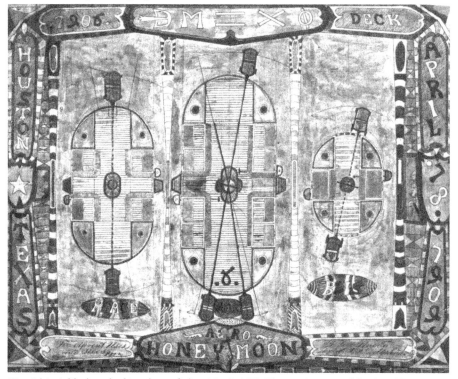

Fig. 34.1. A black and white photo of plate 1906. A "deck" view drawing of the Aero Honeymoon. From the P. G. Navarro Collection.

273

Another Aero that was actually built according to Dellschau was Jachob Mischer's *Aero Gander*. It was actually flown, according to Dellschau, and made a trial run of over 100 miles, which demonstrated that it could be done. It could fly up to the clouds and could come safely down on either land or water. Dellschau states, *But no pay was there by Bro.*

I take the above line to mean that there was no pay (or compensation) by the Brotherhood to Jacob Mischer for the amount of money he had spent on constructing the Aero. Dellschau states that the *Aero Gander* was built by Mischer and that it had *cost him a pile of money.*

He also stated that Mischer's aim in constructing the airship was to make money with it. (It seems that the Brotherhood did not approve of the members making a profit with their inventions. Or it was probably the fact that they wanted the airships to remain a secret for the time being and any profitable use would surely expose them to outsiders.)

But Jacob Mischer intended to profit from his invention. He decided to fix it up as a *gambling hall.*

> But a box of matches sent Jachob and the Gander up to heaven as flame and smoke … goodbye Jacob.

The inference that I get from the above sentence is that Jacob Mischer, not having abided by the rules or orders of the Brotherhood, was summarily dealt with. His Aero, as well as himself were probably destroyed in a fire that was deliberately set.

To substantiate this there is another notation in plate 2399 (some of which is illegible) which indicates that the *Aero Gander* was either constructed or proposed in 1854. There is also an indication that this Airship came to a bad end.

Who actually designed the Aero *Gander,* Peter Mennis or Jachob Mischer?

In plate 1953 Dellschau writes about the *Aerial Pressure Motor.* In this plate Dellschau seems to be commenting upon the efforts of the early aviation pioneers to develop an engine to fly their airplane. He seems to be stating that even though the experiments with gasoline motors are being conducted, so as to fly the experimental aircraft, that they still require ignition system type

motors, whereas the motors used on the Aeros did not use ignition or fire to move them.

He refers to modern (1910) aviators as "fire-bugs." He felt that the people below would always be in danger of losing their homes due to an aircraft flying overhead and dropping incendiary material overboard. In comparison, he states that their motors would enable an airship to rise or land (and travel overhead) without causing harm or injury to anyone due to fire.

The *Ever-being Ready Motor* would generate the power to give lift to the airship. It would enable it to fly, and there would be no necessity to get out during the trip. (He probably meant that you wouldn't have to bail out, because of any trouble with the engine.)

In plate 2006 is information regarding the *Aero Rondo*, which was proposed by Paul Somer and Carl Mueller. A line here reads, *Dr. Saxe Suppressed Aero Rondo. Serves him Right – 1857.*

According to other notations throughout Dellschau's work Dr. Saxe was evidently a *big wheel* in the NYMZA organization. Does the above mean that Dr. Saxe suppressed or vetoed the *Aero Rondo?* If so, why?

In plate 2010 is a design for the *Aero Rondo.* There is a line that reads, *How long Dr. Saxe come up there?*

It seems that Dr. Saxe visited the Sonora area to report to NYMZA the happenings and accomplishments of the club and Dellschau was asking, "How long Dr. Saxe was going to be in the area?"

There was still the consideration of money in connection with the design and construction of the Aeros by some members of the club.

Evidently Dr. Saxe had asked one of the members to design him an Aero suitable for his particular needs. To this Jourdan remarked, *My dear Doctor, hard cash in advance and I fix you up to fit your needs. But cash first.*

It's obvious that Dr. Saxe had something to do with suppressing or refusing to "OK" construction of the *Aero Rondo.* But what did some of the other members have against it?

Paul Somers and Carl Mueller were the proposers of the *Home Rondo,* an Aero designed for long distance flights. They intended to use *NB* gas to power it. What did Dellschau mean by *Geo. Newell Gas, all over!* Did he mean that a gas which had been used by Newell was not satisfactory?

Peter Mennis makes the remark that the *Aero Rondo* was aptly named when they called it a *Long Stay* airship, because if he didn't provide the fuel for its lifting power it certainly wouldn't get off the ground.

There are very few clues about NYMZA, although Dellschau used the symbols prominently on almost every plate. In plate 2550 Dellschau wrote (in reference to Max Miser and P. Constant's *Aero Buster*), *A NYMZA Club debate study.*

I take the above statement to mean that — in this case anyway — the decision to build the Aero had been discussed by the secretive society rather than the usual Sonora Club debates. Why *this* Aero? And why did Dellschau point the fact out so clearly?

In plate 2513 there is a notation that reads, *1857 — Gasoline not known. Today we see it work. Why wouldn't it make Peter Mennis' soupe?*

Does Dellschau mean "why can't Peter Mennis' fuel be made from gasoline?" It seems that Mennis not only had the formula for making the fuel and *NB* gas, but he also had the plans for constructing the chamber in which the fuel was converted into the elusive gas. This, along with other plans for constructing a one-man Aero, the *Goosey*, which was probably the nucleus of the organization that eventually became the Sonora Aero Club. There is evidence to denote that a Sonora Aero Club actually existed, although by the year 1909 it was only a memory in Dellschau's mind because in plate 1930 he states, *If our Club could meet today, what would they propound now?*

In another paragraph he states, *A free studia after a Club debate, By C.A.A Dellschau.*

In the above statement it may seem that he either drew, or pasted in drawings, of previously made studies that he had made of the Aeros. If these studies were made after a club debate then it stands to reason that he is referring to a meeting of the Sonora Aero Club which could not meet in 1909, since it obviously did not have any members to hold meetings. It seems clear enough that Dellschau was writing about something that actually occurred in the past. While there is much that screams out that the Dellschau secrets are nothing more than figments of his imagination, a few things nag at the back of our brains. 1) The discourse between the different members, with arguments, discussion and even jokes all ring true of a group of people working together on a project. 2) Dellschau doesn't make himself the "genius inventor." Just the opposite. He paints himself as a mere observer and scribe. 3) Another air of truth comes through when he disagrees with the other Club members over one point or another.

The true fact is, Dellschau may have been the only surviving member of the Sonora Aero Club by the year 1909. And, he did have a secret, a secret he was

compelled to tell. As Dellschau wrote, *Here is my stock of knowledge.*

Endnotes

1. One member who evidently engaged in digging for gold was Julius Koch. He was also referred to as "Shovel Koch" because he was always carrying a shovel with him. It is reasonable to presume that since Sonora and Columbia in the 1850s was a bustling gold mining town, anyone with a shovel must have been engaged in gold mining, and Julius "Shovel" Koch probably dug up his share of it.

From P.G. Navarro's Unpublished Manuscript: "The Riddle of Dellschau's Books" And an Update on Missing Plates

The last book of the 12 I have studied is probably the smallest of the Dellschau scrapbooks. It measures 17" by 19" and is about 2" thick, although it is almost an inch thicker at the binding where it is reinforced with several thicknesses of cardboard and strips of newspaper. The covers are made from pieces of cardboard from a millinery store and from a box from Levy Bros. Drygoods Co. The pieces of cardboard are sewn together with heavy string. And the two covers can be tied together with shoestrings.

The paste-ups and drawings in this book are crudest of all, and do not have the artistic quality that is found in the other books. The pages are not in proper numerical order and the pages vary in size throughout the book. The paste-ups are not neatly done and seem to be the work of a person whose faculties are beginning to fail him.

The first page — dated June 28, 1921 — is a small one, measuring only 91/2" by 121/2". It does not have a plate number. It contains a drawing of an Airpress Motor. The word *Airpress* appears under the drawing.

Irrelevant Material

In Plate 5059 there are news clippings that seem to have been pasted onto the pages of the book just to fill up space. They have nothing to say concerning aeronautics, and some are even incomplete. Some are pasted upside down and may contain irrelevant material or information. Why were they pasted in? Is it an indication of the deterioration of the mind of C. A. A. Dellschau, who was now over 90 years old?

There is a confusion of plate numbers after plate 5090, which is followed by plate 4825, this page is a title page and is marked as Page 1 of a series that follows all the way to 183.

Page #1 of this series is dated March 18, 1921. It reads:

Aeroy
Clubworks
Cutts
Has — will — may. Bees

The above may be interpreted as stating that in this series are cuts (or drawings and news clippings) that were done or collected by the Aeroy Club. Aeroy was the original name of the Sonora Aero Club, which was sometimes shown in Dellschau's books by a pictograph of a circled X, a crown, and a club.

The bookends with plate 5236 which was probably the last of Dellschau's plates, his last drawing being plate 5235, dated July 24, 1921.

After reviewing the twelve books that exist, and taking into account the number of pages (or plates as Dellschau called them) missing (about 2,000), I have come to the conclusion that there must be at least eight books, and possibly as many as ten books, unaccounted for.

It is these missing books which, I believe, contain the answer as to whether NYMZA (or the Sonora Aero Club) ever actually existed other than in Dellschau's imagination. As to the possibility of Dellschau's fabulous futuristic flying machines actually being able to fly … you decide.

Update

Most people assume that Dellschau's more than 2,000 missing drawings are forever lost, turned into methane gas in Houston's White Oak dump. A logical assumption, I agree, except that:

Thirty years after Fred Washington found the books containing Dellschau's drawings in the dump, eight more of Dellschau's drawings mysteriously appeared in an art gallery in Waxahachie, Texas. Drawings that were not in the twelve books that Pete had studied. In a letter concerning the incident Pete wrote:

Dear Dennis,

As you know, in my research of all twelve of the Dellschau books (or scrapbooks) that were at one time in the exclusive possession of three individuals: 1) Mr. Fred Washington; 2) Mrs. DeMenil; 3) myself, P.G. Navarro, I had made a complete listing of all pages that were actually in those books. And also made a note of all that were missing.

Therefore, when in the fall of 1998 I received 8 photos with drawings of Dellschau's Aeros from an art gallery in Waxahachie, Texas requesting my assistance in deciphering the coded inscriptions and other esoteric writing contained in them. And also that any information pertaining to the strange craft and the Press Blooms that I could submit to them would be greatly appreciated. I readily discovered that the plate numbers on the 8 drawings corresponded with the eight pages that I had listed as MISSING from the books I had studied.

The actual plate numbers were #2365 and #2366. Also #2392 and #2393. As you can see, the two sets of numbers were the front and back of two folios. The other Plates were #2585, #2586, #2630 and 2631; two more folios.

I found it interesting to note that if those eight drawings (representing four folios) that had been missing from one of Mrs. DeMenil's books had all of a sudden turned up to be in the possession of an Art Gallery, then there was a possibility that other *Plates (or pages) that were listed as missing might eventually appear as single pages (front and back). For it appeared to me that those particular pages had been either removed purposely from the books prior to my examination of them; or they had been found loose and separated from the bound books* before *they were sold to Mrs. De Menil.*

It also occurred to me at the time that this would infer that there were more than just four pages missing by being purposely removed, for I had a complete list of all pages existing or missing, and these included the series from #1859 to #1868 (ten plates) and also some that ran haphazardly from the #2100 series up to the #2300 series, that comprised almost an entire book of missing pages. This led me to wonder ... who is it that has these missing pages? (I was able to get additional information that gave an accounting of two other folios that were among the missing. These two folios (four plates) were presumably given to the husband of the curator of old books at the DeMenil home (name withheld), but it turns out that these Plates were later destroyed in a fire and were lost without being identified by Plate number.

Getting back to the two Plates that were at the Art Gallery, I learned they had been sold to the gallery by the same person named above (the curator) who claimed that these eight Plates were selective Plates that had been given to her by Mrs. DeMenil (now deceased) before she (the curator) was even married.

Makes me wonder how many more Plates will gradually emerge from the purgatory of missing Dellschau Drawings ??

PGN

The Waxahachie Plates

From Correspondence from Pete Navarro to the owners of the found Plates.

Plate 2366, Drawing #14, Dated July 1, 1911

This Plate shows two cross-section views of the Aero dubbed *Myself*, or perhaps it means that he (Dellschau) designed it himself. The vertical wording on the right reads, *My Idea*, which may verify it. Is that a likeness of himself standing between the two Aero drawings? It could be. A likeness of the Doctor is at the left where a vertical line of words reads *Nay Doctaw!* (This refers to Dr. Carl Weisbach.) The man standing on the right with the top hat and an umbrella appears to be Moyke (or Moike) although he also resembles George Newell. The only difference [is that] he Moike has red hair and Newell is blonde, but both of them seem to be fancy dressers. The ciphers at the top reads *NYMZA*, which is the acronym of the Society that was behind the Sonora Aero Club. The caption underneath reads *A free Studia — Drawn by C. C. A. Dellschau.*

Plate 2365, Dated August 22, 1911

This Plate shows a view of the Aero *Mynbaby* (meaning "My Baby") as seen *From Below*. The objects sticking out from the top left and bottom right are the landing gear (wheels). The caption reads:
A — Wheels Outside
B — Inside

The year "1858" appears in the lower left corner of the page.

Plate 2392, Drawing #2, Dated August 11, 1911

This is a drawing of the *Aero Warrior*. Dellschau spells it *Warior*. It shows the *Flank* side. The lettering on the left reads *A Free Studia* in plain English, and in code, *Fallen Lassen*. Which I presume means the Aero's descent has lessened as it FALLS toward the ground … or that they are getting a "LESSON" in landing the Aero. The writing on the right reads *Drawn by C. A. A. Dellschau.*

Plate 2393, Drawing #3, Dated Monday, August 14, 1911

This shows another view (Front and Rear) of the *Aero Warrior*.

Plate 2630, Dated August 25, 1912

This Plate shows two drawings separated by a colorful motif (or pillar) that contains a drawing of a motor behind it. This motor has exhaust openings at the top where *NB* gas is released and a propeller on one end. (This is a very unusual mechanism which appears nowhere in any of the other Dellschau drawings.) There is the name of Peter Mennis and August Schoetler underneath this device and the phrase reading *In their graves, but not forgotten,* which leads me to believe that this motor was designed because they had both died before this contraption was completed.

The drawing on the left side shows two cross-section views of a converter, which was probably designed by Robert Nixon. (The name Robert Nixon appears between the two sections. On the right side is a drawing of a *pressure motor*. The name George Newell is at the top and a picture of Moike (his name is above the picture) shows him standing by the motor. He has red hair, wears a white top hat and carries an umbrella under his arm. It is evident that Newell and Moike designed this motor. But why does Dellschau give more prominence to Newell than to Moike? (George Newell's name is in large bold type while Moike's is in lower case.) The cartouche on top right tells you to *COMPARE* the two types of motors.

Plate 2631, Dated August 26, 1912

This Plate contains *Press Blooms* (news clippings or magazine articles). The article is from *Scientific American* and is headlined "The Aeroplane in the Military Maneuvers."

It tells about Lt. Scott of the U.S. Army, who won the $5,000 Michelin

prize for dropping a bomb from an Aeroplane at the height of 2,400 feet and having succeeded in hitting a specified target with eight of the projectiles.

Plate 2585, Drawing #6, Dated June 27, 1912

This is a drawing showing two views of the deck of the *Aero Sicher*, which was designed jointly by Edward Hartung and August Schoetler, with slight modification made by each as shown in drawings A (by Hartung), and on B (by Schoetler). The caption on the lower right reads *Deck A and B drawn by C. A. A. Dellschau.* Along the border on the right are the initials NYMZA in code.

Plate 2586, Drawing #7, Dated June 29, 1912

This drawing shows two versions of the *Aero Sicher*. Version A was designed by Edward Hartung and version B was designed by August Schoetler. The caption at upper left reads *A — Enter Front Or Rear.* Caption at upper right reads *B — Enter at Flank.*

As of the publishing of this book no other Dellschau drawings have been reported to have been found.

Future updates and additional information can be found on our web site: www.secretsofdellschau.com.

Fig. 35.1. Plate 2367.

Acknowledgments

First I want to thank the members of my very understanding family for their support of my obsession of researching and writing about "weird stuff" all these years. I also would be making a mistake if I didn't make note of my companion and number one fan, Marsha Ward, for being there for me through the ups and downs of getting a book ready for publication. I am also very grateful for the undying support of Pete Navarro and his family for all the help and support they have given me in assembling all of the pieces of this incredible story. I especially want to mention Pete's son (and my good friend) Steve, who brought Pete and I together and urged us to join forces to get the Dellschau story out there for other people to enjoy. Steve also graciously suggested that I move to Houston, Texas, and share his home with him during the very critical early stages of researching and writing this book. I must not forget a tip of the hat to my friend and associate Rick "Oz" Osman who helped me with background work during my personal research into the Dellschau story including taking a trip to Sonora, California to check out facts which needed to be confirmed when I couldn't go there in person.

I also wish to thank Lucius Farish (now retired) of the UFO Clipping Service, Jerry Decker the Director of Vanguard Sciences (www.keelynet.com) and UFO researcher/writer Jerome Clark for their personal insight and help in researching and understanding the airship history of Dellschau's time. Thanks to Robert Dellschau in Germany who exchanged many e-mails with me during a period of trying to trace Dellschau's Germany roots. I now have a real understanding of the devastation of family and personal records that occurred during the destructive years of WWII. It's a shame the problems that now causes the German people when trying to track their family history. Also I must include a thank you to Stephen Ramano, private art collector of Brooklyn, for his help and unlimited access to his large collection of original Dellschau drawings and his great Dellschau web site (http://www.charlesdellschau.com/).

There is always someone that every writer feels was the pivot point in going ahead with a writing project. I have two. The first is my friend Jeff Braun who jumped in to help finance the project. But the person I feel we all owe gratitude to more than anyone for making it possible to hold this book in our hands is my very good friend James Moseley editor and publisher of the longest running UFO publication in the world, *Saucer Smear*. Were it not for his

persistent pushing and probing the community for someone to come forward and publish *The Secrets of Dellschau* the manuscript might still be gathering dust in my filing cabinet.

Unfortunately, two of the people extremely important to the Dellschau story are not here for me to thank. Both wanted to see Dellschau's story in public hands. These two, of course, are Fred Washington and Jimmy Ward. Were it not for Mr. Washington there would be no secrets of Dellschau to ponder. And had Jimmy Ward lived I believe he would be the person sitting here composing this thank you page instead of me. I am 100% positive that he would have been the person to have written this book. I only hope that I have told the story in a way that he would have enjoyed reading it. I'm sure I would have enjoyed his firsthand account.

And finally, to those who did the work: I want to thank Dennis Stacy and his group at Anomalist Books. First, Dennis for listening to James and following through by taking a look at my manuscript. Thanks to everyone else at Anomalist for believing in us and *The Secrets of Dellschau*. And last, but not least, I want to say that we were so lucky to have Crystal Hollis as our final editor. It was smooth sailing through choppy seas with her at the wheel. Lisa Bastian also provided additional proofreading.

Thanks!

Dennis Crenshaw
4/28/09
Jacksonville, Florida USA

Made in United States
North Haven, CT
28 July 2023

39644778R00157